Creativity
in Museum
Practice

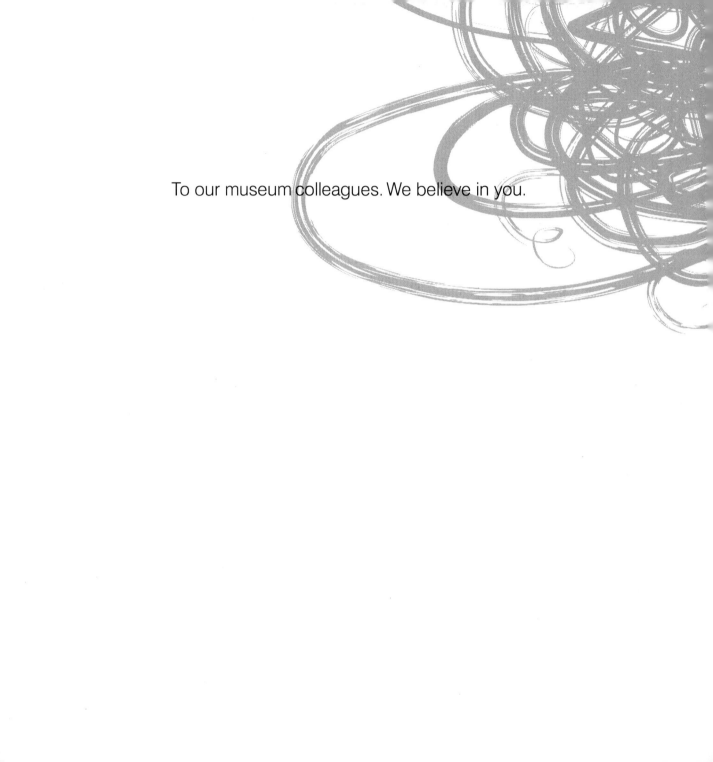

To our museum colleagues. We believe in you.

Creativity
in Museum
Practice

Linda Norris and Rainey Tisdale

Left Coast Press Inc.

Walnut Creek, California

LEFT COAST PRESS, INC.
1630 North Main Street, #400
Walnut Creek, CA 94596
http://www.LCoastPress.com

ISBN 978-1-61132-307-8 hardcover
ISBN 978-1-61132-308-5 paperback
ISBN 978-1-61132-309-2 institutional eBook
ISBN 978-1-61132-703-8 consumer eBook

Library of Congress Cataloging-in-Publication Data

Norris, Linda.
 Creativity in museum practice / Linda Norris, Rainey Tisdale.
 pages cm
 Summary: "With this book museum professionals can learn how to unleash creative potential throughout their institution. Drawing from a wide range of research on creativity as well as insights from today's most creative museum leaders, the authors present a set of practical principles about how museum workers at any level—not just those in "creative positions"—can make a place for creativity in their daily practice. Replete with creativity exercises and stories from the field, the book guides readers in developing an internal culture of creative learning, as well as delivering increased value to museum audiences"—Provided by publisher.
 Includes bibliographical references and index.
 ISBN 978-1-61132-307-8 (hardback)—ISBN 978-1-61132-308-5 (paperback)—ISBN 978-1-61132-309-2 (institutional eBook)—ISBN 978-1-61132-703-8 (consumer eBook)
 1. Museum techniques—Social aspects. 2. Creative thinking. I. Tisdale, Rainey. II. Title.
 AM7.N67 2013
 069'.4—dc23
 2013029489

Printed in the United States of America

♾™ The paper used in this publication meets the minimum requirements of American National Standard for Information Sciences—Permanence of Paper for Printed Library Materials, ANSI/NISO Z39.48–1992.

Contents

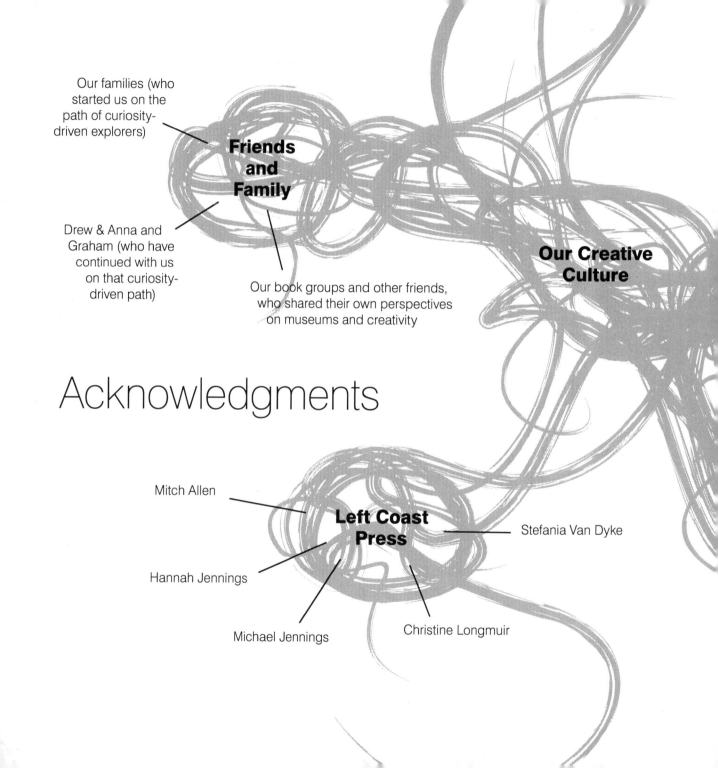

Our families (who started us on the path of curiosity-driven explorers)

Friends and Family

Drew & Anna and Graham (who have continued with us on that curiosity-driven path)

Our book groups and other friends, who shared their own perspectives on museums and creativity

Our Creative Culture

Acknowledgments

Mitch Allen

Left Coast Press

Stefania Van Dyke

Hannah Jennings

Michael Jennings

Christine Longmuir

Our conference
meet-up
participants

Everyone we interviewed

Everyone who
shared a creative
practice story

The Gang of Five

**Our Colleagues
Who Contributed
to This Project**

All the people who
sent us interesting
things to read

Our peer reviewers,
who helped us make
the manuscript
so much stronger

The Crash Course
in Creativity team

Our M&C Peeps

Museums—near and far, large and small—that inspired us

Our Creativity Heroes—
all the people we've
encountered,
famous and not,
who approach
their lives with a
creative spirit

**Our
Inspirations**

The Fulbright Program,
which broadened our view

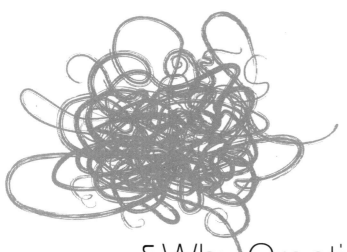

Introduction Why Creativity Matters in Museum Work

There is a scene in the 1984 cult classic heavy metal band mockumentary *This Is Spinal Tap* where lead guitarist Nigel Tufnel (played by Christopher Guest) is showing director Marty DiBergi (played by Rob Reiner) the tools of his trade, his guitar collection, with all the intensity of a veteran curator. He tells DiBergi about each piece: what makes it special and how he uses it to make great music. They get to a Marshall amplifier, and Tufnel explains that it's an exceptional amp because the volume knob doesn't just go to ten, it goes to eleven. When you are performing live and you need that extra kick, you can turn it all the way up to eleven and really knock the socks off the audience. DiBergi tries to reason with Tufnel that you can have amps with a volume knob that goes to ten that make the same amount of noise, but Tufnel won't have it. He knows he has a magic amp.

Wouldn't it be amazing if museums had a magic amp, one that made our work reverberate and resound through the stadium of public life with all the power and gusto of an electric guitar cranked up to eleven? In fact we have such a magic amp: it is creativity.

On the walls and in the storage of museums, large and small, art and history, science and archaeology, are tangible signs of human creativity. Whether it's inventing the more perfect fishing jig, illustrating a scientific principle, or seeing the world the way no artist had before—it's all evidence of our human impulse to solve problems and create new ideas. For centuries now museums have been spending countless hours and enormous resources collecting and preserving this evidence of human creativity. But are they ignoring the creative capacity sitting right in front of them, in their own workers? We believe the daily creative life of museum workers behind the scenes both needs and deserves more attention in order for museums to reach their full potential.

"Creativity" is a word that gets thrown around a lot these days, and it means different things to different people. So what exactly do we mean by creativity in museum practice? For the purposes of this book, creative museums—and creative museum workers—produce new ideas and new ways of seeing things that add value either internally (to the staff and to operations behind the scenes) or externally (to a public audience). Creative museum practice includes idea generation in any museum department (inventing bold new interpretive methods, management techniques, or even

fundraising strategies), creative problem solving (finding a graceful way to move past entrenched challenges), and—what most people think of first—artistic creativity (making the museum aesthetically appealing).

Let's unpack this definition a little. First, note the words "new" and "value." Creativity is about moving humankind forward, building on what has come before. An idea does not have to be mind-blowingly transformative to be creative, but it does have to be at least a little new, even if it is simply an established idea applied in a new way at your organization, or a new combination of two previous concepts. And it is not enough to have a new idea if it doesn't add value—problem-solving value, social value, intellectual value, aesthetic value. Second, this definition encompasses both back and front of the house: staff and the public. The creative impulse is often not as evident in our offices as it is in our galleries. It's time to change that. We need to build creative cultures in our conference rooms, our collections storage areas, our staff lounges, and our boardrooms to support our missions more fully and move our institutions forward. And third, this definition doesn't just refer to artistic creativity; it conceives of creativity broadly, across all museum sizes, disciplines, and departments. In other words, we're not letting anyone off the hook. There was a time when a lot of museums—history, natural history, archaeology—assumed that creativity is only for contemporary art museums, or when museum development officers or registrars or administrators might have argued that creativity is only for exhibition designers, or when tiny volunteer-run museums felt they could leave it to the big guys. That time has passed.

This book explores how to unleash the creative potential of all museum workers and all museums in the service of a more creative society. We wrote it because we believe that each of you—whether you're a curator, a marketing manager, an educator, or a security guard; whether you're just starting out in your career or running the show—has a deep well of creative energy, an amp that goes to eleven, just waiting to be tapped. And once you figure out how to tap it, you establish a win-win situation with far-reaching effects: your own work gets stronger and more rewarding, and your museum becomes a significantly more interesting place to spend forty hours of each week—not just for you, but also for your co-workers. Your colleagues throughout the field stand to benefit, too, as they look to your work for inspiration. But most importantly, society wins, because creative

museums help kids, parents, teachers, workers, seniors, civic leaders—everyone—uncover their own creative passions and use them to solve nagging problems, make discoveries, invent useful and beautiful new things, build fulfilling careers, and connect more meaningfully with each other.

Over the past five to ten years there has been a wealth of new literature on the importance of creativity—to the for-profit sector, to education, to fuel economic growth. We started paying attention to this literature and looking for ways to connect it to our museum work. The more we read, the more excited we got about the potential for our colleagues to develop enriching work lives and better serve the public through creative practice. The more we read, the more we understood that creativity is not a lightning bolt that strikes a few lucky people randomly, seemingly from nowhere; it has a method, and it is a practice. Museums need creativity now more than ever—so many museums are taking three steps forward and two steps back as they struggle with really hard, entrenched problems: how to serve a broader and more diverse audience, how to build capacity, how to encourage meaningful participation, how to care for ever-expanding collections, how to articulate public value. Moreover, while the growing professionalization of our field has been beneficial in many ways, it has increased the pressure for museums to conform, to aim for a well-defined standard practice with less room for breaking new ground. So we embarked on this project together—to figure out what it would mean to infuse our field with creativity at every level, and to develop a toolkit that would allow each of you to join us in building museums that are creative from the inside out.

Creativity is likely to emerge as one of the defining trends of the twenty-first century, not just for museums but across our society. On one hand, the Information Revolution has brought about a sweeping democratization of creativity as new tools for cross-pollinating knowledge and sharing ideas become widely available to millions of people. On the other hand, that same Information Revolution is changing the world around us so rapidly in so many other ways that the standard operating manuals no longer apply. Globalization, new technology, and a culture that both connects and disconnects us at the same time present a wide array of shifting challenges—to individuals and institutions—requiring flexibility and constant improvisation. Some business leaders now believe the tried and true strategic planning process is useless—five year plans become obsolete almost from the moment they are printed.[1]

Consequently, as Tim Brown puts it in *Change by Design*, "innovation has become nothing less than a survival strategy."[2] Since creativity is such a powerful tool in responding quickly and effectively to changing realities, it has become an essential skill for the twenty-first-century workforce, and every corporate CEO and college president is currently trying to figure out how to encourage more of it. In the face of these societal transformations, because museums steward vast collections of creative inspiration and are wired to nurture creative thinking through free-choice learning, they are uniquely positioned to become the creative beating hearts of their communities—to fulfill a vital role in helping public audiences tap their creative potential, individually and collectively.

What exactly does it mean to be a creative beating heart of your community? For some museums, it means that nurturing creativity in members of the public is your raison d'être, your guiding mission. But even when encouraging creativity is not your museum's explicit mission, it can still be woven through everything that you do, the way we currently weave lifelong learning through all museum work. In this sense creative practice becomes both a value and a life skill to model to your audience, whether your museum exists to illuminate archaeology, decorative arts, or Jurassic technology. Our society needs museums to help members of the public learn how to be creative, lifelong learners because our formal education system is largely failing at this task. But we cannot truly understand how to facilitate creativity in our audiences until we learn how to be creative ourselves behind the scenes.

Behind the scenes at a creative museum, everywhere you look people are learning and exploring, taking in new information from many different sources to help them do their jobs better. They have spent time figuring out what the optimal conditions are for maintaining their creative practice, individually and as a team, and they structure their day accordingly—whether it's solo reflection, small group problem solving, or staff-wide exploration. The staff of a creative museum—paid and volunteer—experiments and supports each other in taking creative risks. Ideas—whether they are about brand new projects or ways to make old projects more effective—are a valued commodity to be nurtured and celebrated throughout the museum. And the space there behind the scenes is just as interesting as the space for the public, with stuff to look at, explore with, and use. Make no mistake, creative practice is a lot of hard work, and creative workers still experience setbacks—it's not

that everything about the museum is suddenly perfect. But they are engaged in rewarding, meaningful work that leads to self-actualization, and they have many tools to overcome those setbacks and solve problems that get in their way. Therefore, a creative museum is an energizing and supportive environment in which to continuously improve skills and experience forward momentum.

Imagine if every museum were such a creative museum, a unique, special place—wholly different from every other museum on the planet yet united in waving the creativity flag high. Imagine if the museum brand stood for creativity. Does this vision sound impossible to attain? We don't think it is. In fact, we think it is the museum field's greatest hope for demonstrating value to society. In the twenty-first century, museums can provide the spark, the connection, the burst of new ideas—for the public and for ourselves—to create museums that not just survive, but thrive. Now we can be connecting places where our public audience's creative impulse can be nurtured and encouraged. We can work with our limited resources—but with increased creative teamwork—to become the creative beating heart of our communities; indeed, the heart of an entire creative society.

What to Expect from This Book

This book is one part manifesto to three parts tool kit. In reading it you will come to understand the case for creativity, but more importantly, you will learn how to do it. Creativity does involve a lot of doing and a lot of practice. Your creative muscles are like any other muscle—the more you use them, the stronger they get. To help you move from thinking to doing, set apart from the main text throughout each chapter you will find two different types of sidebars:

 Your Creative Practice: stories from colleagues across the field, in their own words, about what has worked— for themselves and for their museums;

 Try This: concrete no-cost or low-cost activities you can experiment with to jumpstart your creative practice.

Use these sidebars (and the Get Going Game, p. 213) to envision and plan your first steps forward and revisit them whenever you need inspiration for what to do next.

This book is structured around different contexts for creativity: individual, institutional, field-wide, and community-wide. You will learn how to develop your own creative muscles, but more importantly, you will also explore how to embed creative practice throughout the organization you work with—an effort that can be undertaken no matter where you fall on the organizational chart. But it doesn't stop there—you will also have a chance to consider the field-wide infrastructure that lifts all museum boats at once, and the end goal: strengthening creativity in our public audiences. Ultimately, creativity needs to shift from individual practice to institutional culture to field-wide value to do the most good for the public—an entire network of creative people can generate exponentially more creative energy than one person working in isolation.

You should expect that reading this book will prompt you to consider your own tolerance level for risk and change. Creativity nearly always involves failure and the willingness to learn from failure. Creative people almost never get it right the first time. But when they do finally get it right, they get it really, really right. The creative path is a lot less familiar and safe than the same-old, same-old, the-way-we-have-always-done-it path. But the creative path can *transform* institutions; in fact, we have seen it do so. Moreover, we have yet to come across a creative museum that is closing its doors. All the evidence suggests that creativity makes for a stronger institution. To their communities and to their supporters, museums increasingly need to demonstrate value. And in today's rapidly shifting world, there is not much value in playing it safe and doing things the same old way they've always been done.

What you should not expect is that this book will give you the ideas. Creativity is not about copying whole-cloth from your colleagues—that doesn't get us very far as a field. You have to practice coming up with the ideas yourself, the proverbial learning how to fish. So instead, this book offers a lot of strategies for finding your own new ideas and solutions, and for putting those ideas to work through a process of experimentation, refinement, and reflection. You can use the tools provided here to chart your own creative path, a path of learning and growth, a path that takes you to new and interesting places.

You can consume this book the conventional way, from cover to cover, if that suits you best, but there are other equally valid approaches. You could read a section each morning before you start work, and then consider how it applies to your own situation throughout the course of the day. Or you might think about your own biggest creativity challenges and prioritize those sections, experimenting with the corresponding Try This activities before you move on. You might read it together with your colleagues, book group style, discussing a chapter at a time. Or, you might open it to any page and just try something. Reading this book will not turn you into the Picasso or the Einstein of the museum world overnight, nor will it turn your institution into the Walker Art Center or the Exploratorium overnight either. But over time a series of small changes will indeed lead you to meaningful, rewarding creative successes.

All we want you to do is try something. And then try something else. The change starts with you. Turn yourself up to eleven.

Creativity means to push open the heavy, groaning doorway to life.

Daisaku Ikeda

Chapter

1 Your Creative Practice

Over the past five to ten years there has been an outpouring of new thinking about creativity. From neuroscience research on creativity and the brain, to the pioneering human-centered design at IDEO and Stanford's d.school, to blog posts and TED Talks on remixing ideas and building a culture of experimentation. This work is starting to be embraced by many for-profit companies, and by many segments of society at large. Meanwhile, there has been some attention to creativity in our field—it was the theme of the 2012 American Alliance of Museums (AAM) conference and the topic of a *Journal of Museum Education* issue in 2005 and an *Exhibitionist* issue in 1999—but for the most part all this new thinking about creative practice as a way of working has not yet broadly infiltrated the museum community. Museum workers do not share a common vocabulary for discussing what creativity means in our field, nor a common set of best practices for doing it, the way we do for other issues—like museum ethics, community engagement, or risk management—that affect our everyday work. This chapter is about developing that common language, and about each of you understanding the role creativity can play in your own life.

The principles of creative practice outlined in this chapter apply to both museum workers and museum audiences. In fact, they apply to all human beings across the planet, because humans are by nature creative animals. Some of this theory relates to individuals as they seek to enable and enhance the creative potential of their own brains. And some of it sets up a topic to be explored in more detail in the next chapter: How can each of us help build creative institutional cultures where, instead of stifling new ideas, workers feed off each other's creativity?

For museum workers, an important element of creative practice is learning to deviate from the pack—effectively and mindfully—to develop your own special way of helping your museum bring people and objects together. Museums operate in a rule-bound field, which results in many institutions that look and feel the same—institutions that stick to the recipe, that copy instead of elaborate. In our vision for creative museums, each institution is like no other place on earth. Therefore, this chapter is less about the fine details—what color you should paint your walls, for example—and more about the big picture. We want to set you off in the right direction for your creative practice but leave enough wiggle room for you to find your own way of being creative in your own unique work situation. With that in mind, let's take a walk through some creativity theory.

Anyone Can Learn to Be More Creative

In his popular 2012 TED Talk, IDEO founder and Stanford d.school professor David Kelley tells the story of watching his best friend Brian lose his creative confidence in the third grade. He points to Brian as an example of a problem he encounters regularly in his work: people who were told when they were young that they weren't creative, and consequently shut down that part of themselves. Later in the talk Kelley describes watching countless people like Brian rediscover their creativity through the d.school's collaborative process, which is designed to produce a series of small successes that reestablish creative confidence. He says, "I really believe that when people gain this confidence . . . that they actually start working on the things that are really important in their lives; we see people quit what they're doing and go in new directions."[1]

Organizational psychologist and leading creativity researcher Teresa Amabile, in a 2004 interview for *Fast Company*, was asked to list major myths in our popular understanding of how creativity works. She ranked "Creativity comes from creative types" as the number one myth. Then she repeated what she regularly asserts in her scholarly research: "Almost all of the research in this field shows that anyone with normal intelligence is capable of doing some degree of creative work."[2] Countless other creativity experts have made similar statements. To make sure we are all on the same page, here is a sampling of the kind of assertions we routinely read when researching this book:

- Neuroscientist and director of the Stanford Technology Ventures Program Tina Seelig: "After a dozen years teaching courses on creativity and innovation, I can confidently assert that creativity can be enhanced."[3]
- Psychologist Arthur Cropley: "It is not necessary to conceptualize creativity as something for a small group of gifted people. It is important for everyone."[4]
- Social scientists Donald Treffinger, Scott Isaksen, and Brian Dorval: "Creative potentials exist among all people. . . . Through personal assessment and deliberate intervention, in the form of training or instruction, individuals can make better use of their creative styles, enhance their level of creative accomplishment, and thus realize more fully their creative potentials."[5]

■ Education, arts, and creativity advocate Ken Robinson: "If someone tells you they cannot read or write, you don't assume that they are not capable of reading and writing, but that they haven't been taught how. It is the same with creativity."[6]

Let's be crystal clear: creativity is not something that only certain people are born with. It's also not something that's confined solely to artistic pursuits. There is a strong consensus in the research that creativity is open to everyone, in every field, and that whatever your current level of creativity, it can be strengthened. Moreover, creativity doesn't involve an either-or proposition: you don't have to give up other skills in order to make room for creativity. Instead, it complements and enhances whatever other talents you bring to the table.

So how come we aren't all creative? As kids, we start out primed for creativity. We start out curious about the world, comfortable with imaginative play, eager to make connections as we learn. But then along the way many of us, like David Kelley's friend Brian, find doors getting shut. Bit by bit, for a number of reasons, many of us lose our curiosity and our creative confidence. One of the biggest problems here in the United States (and in many other parts of the world, too) is that our formal educational system does a poor job of nurturing creativity. Kids enter with a deep capacity for creativity, and the majority leave with their creative confidence and their intrinsic love of learning battered—by memorization and standardized tests, continual focus on only one right answer, compartmentalized knowledge, and classrooms where the art materials, toys, and other tools for exploration get put away around the age of seven. That's one of the reasons museums are so important, to serve as a counterpoint to this experience of formal schooling by providing free-choice learning environments that nurture curiosity and creativity.

Another problem is that the myth cited above—that the world breaks down into creatives and non-creatives—goes back centuries and centuries. Many people persist in believing it, and much of our everyday lives is structured to delineate the difference between the two. That means that as we graduate from formal schooling and enter the working world, we are likely to end up in situations where we are pigeonholed as one or the other. We get stuck in workplaces that only value creativity for certain kinds of workers—artists, designers, architects—or don't value it at all. The psychologist Raymond Nickerson put it this way: "Most of us fail to realize the potential we have—which may be great—primarily because of lack of exposure to circumstances and conditions that are supportive

to its development."[7] A third problem is that creativity does require motivation and a certain amount of mental energy. You have to want to be creative, and you have to make space in your life to practice. If you are working two jobs (both of which have been pegged as uncreative) to put food on the table for your family, it is hard to find the surplus attention to devote to creative practice.

Each of these three problems is exacerbated by a fourth problem, which is that if you have not personally experienced the satisfaction of sustained creative success and its potential to make your work better, it can be difficult to understand what the fuss is all about. It's not that all the people in leadership positions in schools and workplaces are actively opposed to creativity; it's just that many of them haven't been exposed to it in a way that tangibly demonstrates its transformative power. Nonetheless, its transformative power is real. Many experts would say that once you experience creative practice, you want it in your life forever. Working hard creatively is more fun, and has bigger rewards, than working uncreatively. Creativity leads to high levels of satisfaction and self-actualization. It feels good to produce something new and useful to the world—you want to do it again and again. The psychologist Mihaly Csikszentmihalyi is best known for developing the concept of *flow*, a highly pleasurable mental state of heightened creativity and engagement brought on by equally high levels of challenge, skill, and interest. He asserts, "When we are involved in [creativity] we feel that we are living more fully than during the rest of life."[8] Tim Brown writes in *Change by Design* that those who work in a creative culture

> are likely to become more deeply engaged, more highly motivated, and more wildly productive than they ever have been before. They will show up early and stay late because of the enormous satisfaction they get from giving form to new ideas and putting them out to the world. Once they have experienced this feeling, few people will ever be willing to give it up.[9]

In fact, we think creativity is an inalienable human right, as in life, liberty, and the pursuit of creativity—not just for knowledge workers like us but for everyone—service workers, factory workers, garbage collectors, homeless people. The goal of this book is to help you experience that transformative power yourself so that you can then spread it—to your colleagues, to your visitors, and to other museums.

And that's the wonderful thing about living in the twenty-first century: creativity *is* spreading. At the same time that we are experiencing a democratization of museums—and culture in general—we

are also experiencing a democratization of creativity. Yes, for centuries there has been a popular perception that only certain people or certain professions could be creative. But now, bit by bit, more and more people are starting to realize not only that creativity is open to everyone, but also that it's an imperative if we're going to build a sustainable future. In a 2013 poll commissioned by *Time*, the Motion Picture Association of America, and Microsoft, 65 percent of respondents agreed that "creativity is central to America's role as a global leader," and 62 percent said that "creativity is more important to success in the workplace than they anticipated when they were in school."[10] The Information Revolution is putting into the hands of many people all sorts of tools for creativity—new ways to gain deep knowledge in any subject, software and apps for tinkering and experimenting, platforms for cross-pollinating information. The wealth of new literature in the past five years alone is a testament to this growing movement. Indeed, this book is a part of the movement, too.

In the preface to his 2012 revised edition of *The Rise of the Creative Class*, Richard Florida writes, "The essential task before us is to unleash the creative energies, talent, and potential of everyone—to build a society that acknowledges and nurtures the creativity of each and every human being." As the Industrial Age recedes further and further in our rearview mirror, Florida predicts that what we now think of as the Creative Economy will evolve further into the Creative Society, in which "each and every worker is recognized and empowered as a source of creativity—when their talents are nurtured, their passions harnessed, and they are appropriately rewarded for their contributions."[11] Museums have a central role to play in building this Creative Society. We can be the unleashers, the acknowledgers, the nurturers, the empowerers of creativity. But only if we first find and nurture the creative spirit in ourselves, and only if we embrace change and new modes of working and thinking.

It's important to emphasize that no museum worker gets a free pass if we want museums to reach their potential as singular, awesome places that feed a Creative Society; we all must do the hard but rewarding work of establishing our creative confidence, and then come together to build institutions that thrive as creative teams. A creative museum practice will come more naturally to some of you than to others. That's okay; it's simply the reality of our current society—many of you had experiences like David Kelley's friend Brian's somewhere along the way. But it means you will need to help each other out, to be brave and open in your own practice and encouraging of your fellow workers as they develop theirs. It will be worth it. It will be transformative. So let's get started.

Try This:
Take Twyla Tharp's Creativity Inventory

Twyla Tharp's fascinating book *The Creative Habit: Learn It and Use It for Life* includes this insightful list of questions to develop what's called a creative autobiography, under the rationale that you have to have strong self-awareness in order to fully mine your inner creative resources. The questions might not look like much on paper but you'd be surprised at the connections they help you draw once you start thinking about them all together. Rainey tries to revisit Tharp's inventory once every few years as a way of understanding how her creative practice evolves over time, and we encourage you to do the same. You might begin by considering how you would define creativity, using either our definition or another that works for you. And remember, there are no right and wrong answers here. If you are unsure of your response, put it aside and return to it later.

1. What is the first creative moment you remember?
2. Was anyone there to witness or appreciate it?
3. What is the best idea you've ever had?

4. What made it great in your mind?
5. What is the dumbest idea?
6. What made it stupid?
7. Can you connect the dots that led you to this idea?
8. What is your creative ambition?
9. What are the obstacles to this ambition?
10. What are the vital steps to achieving this ambition?
11. How do you begin your day?
12. What are your habits? What patterns do you repeat?
13. Describe your first successful creative act.
14. Describe your second successful creative act.
15. Compare them.
16. What are your attitudes toward: Money? Power? Praise? Rivals? Work? Play?
17. Which artists do you admire most?
18. Why are they your role models?
19. What do you and your role models have in common?
20. Does anyone in your life regularly inspire you?
21. Who is your muse?
22. Define muse.

23. When confronted with superior intelligence or talent, how do you respond?

24. When faced with stupidity, hostility, intransigence, laziness, or indifference in others, how do you respond?

25. When faced with impending success or threat of failure, how do you respond?

26. When you work, do you love the process or the result?

27. At what moments do you feel your reach exceeds your grasp?

28. What is your ideal creative activity?

29. What is your greatest fear?

30. What is the likelihood of either of the answers to the previous two questions happening?

31. Which of your answers would you most like to change?

32. What is your idea of mastery?

33. What is your greatest dream?[12]

The Foundation for Your Creative Practice

Let's say you've read this far and you've decided that you want to experiment with creativity, to find a place for creative practice in your life. You understand that creativity is open to all people, but where *do* you start? Congratulations, you've already cleared the first hurdle, which is committing to creativity. Below are some general guidelines for next steps, and the Try This activities sprinkled throughout this book will provide additional opportunities.

Pursue a Passion

Creativity is closely linked to intrinsic motivation—learning, thinking, and improving for the joy of it; not for a grade, a paycheck, or because something bad will happen if you don't. If you're not used to exercising your creative muscles, it helps to apply them first to something you already really love, and then gradually let creativity spread to other areas of your life. To this end, Michele and Robert Root-Bernstein suggest taking up a hobby as an essential step to developing your own creative practice because it makes room in your life for discovery, mastery, and imaginative thinking. "If you cultivate your hobby with all the love and devotion of a true amateur, recreation becomes a form of creation that recreates you."[13] Whatever that thing was that you loved doing at some point in your life but gave up for grown-up responsibilities—you need to take it up again. And if for whatever reason that thing doesn't take hold inside you, try something else. Redevelop your intrinsic love of something. Then ideally, eventually, we want each of you to get to the point where you have a passion and an intrinsic love of your museum work, too, not just your hobby.

Build Your Creative Confidence

Perhaps you are one of the many people who got the message somewhere in your childhood that you are not creative. You need a safe space with low stakes where you can take some risks and experience creative success. One of the best ways to do this is to take a creative class. Again, creativity isn't just for artists so it does not have to be an art class—it could be building robots, making music, cooking, or any other topic that has ever interested you. The point is to wake your brain up to

observation, curiosity, and learning new things; to try out deliberate idea generation and implementation; to log some small successes in an environment that's supportive to creativity; and to take part in a cohort of learners who are in different stages of their own creative practice. Then ideally, eventually, each of our museums—as workplaces—will become a safe and supportive space for building creative confidence.

Your Creative Practice

Painterly Partners

Play, and creating for the sheer joy of it, are both essential to my creative practice. A neighbor's eight-year-old daughter, M., asked to paint with me one day. At first, I planned to paint alongside her, with each of us working on our own canvas. But then it occurred to me how fun it might be to actually create one painting together. M. lit up when I suggested this. So I set up one easel, one big canvas, and a set of brushes and paints for us to share. I asked M. to think of something she would like to include in our painting. She said she would like it to have a butterfly and a letter. She added the butterfly, and I began with the letter C. I also asked her to pick some music for us to listen to. We painted together to the music for more than an hour, adding a bird, a tree, leaves, and more letters and words. We switched sides of the canvas several times, embellishing each other's elements and creating an integrated painting with almost no discussion. It was pure creative flow and some of the most fun I have ever had creatively. Most importantly, M. had a great time and can't wait to paint together again. At its best, creativity begets more creativity—a truly renewable resource.

Cathy Maris, Education and Grants Director,
Kidzu Children's Museum, Chapel Hill, North Carolina

Cultivate Knowledge and Skills in Your Domain

We generate more and better ideas when we have deep expertise in the area where we are trying to problem solve. Therefore, another way to build your creative thinking skills is to learn everything there is to know about a particular topic, and to master all the techniques required for it. A great place to start is with a hobby you are interested in (as mentioned earlier), but you should also think about what expertise would mean at work. It's common for us museum people, when we're first starting out in the field, to put a lot of effort into acquiring knowledge—whether it's related to a specific content area (archaeology, art history, physics) or to professional training (how to teach, how to manage, how to provide amazing visitor services)—but then we slow down considerably once we are established in a museum job. That's enough to keep going day to day, but it is not enough for creative practice. For creative practice you need to activate and challenge the lifelong learner inside you around your core, day-to-day work. Think of a learning curve that never flattens out but keeps on reaching for the sky, higher and higher. And then, ideally, eventually, we can develop learning cultures at each museum that engage and support the entire staff in developing expertise and improving skills.

Develop a Creative Habit

Creativity takes practice. Like any other muscle you want to develop, you have to exercise your creative thinking regularly and vigorously in order to strengthen it. Just as we all know how important a workout routine is for keeping on track with physical exercise, the same goes for creative exercise. And just like your gym time, you need to build creativity into your regular schedule, make sure you have the tools you need (physical and mental) readily accessible, and chart your progress along the way. The goal is to set up a situation where practicing creativity becomes automatic and routine, not something you have to talk yourself into once a month. For some of you this may mean setting aside (and protecting) specific times in the day or week for deep writing, thinking, or idea generation around problems you want to solve. For others it might mean building learning habits—shifting commute, lunch, and bedtime into sources of new knowledge. And for others it may mean finding the exercise partner who will hold you accountable for your routine, cheer on your creative risks, push you to act on ideas, and celebrate your successes. Then, ideally, eventually, each museum will build its own institutional creative habits that support all workers, every day.

Reflect on Your Creativity

When you have a great idea, do you pay attention to the circumstances that brought it into being? Can you tell whether your creative practice is getting stronger? Are you experimenting with different ways of supporting your personal creativity and noting what works? Which points of the creative process are frustrating and which are exhilarating? What's getting in your way and what can you do about it? The more awareness you have about your own creative development, the more empowered you are to make positive changes. Then, ideally, eventually, we start learning together what works and doesn't work for our institutions.

Live Your Creative Practice

Ultimately, creativity should become, for each of you, not something you choose to do or not do each day—an item on your to-do list—but "a state of being," as Erin Carlson Mast and Callie Hawkins at President Lincoln's Cottage put it when Rainey interviewed them for this book.[14] To this end, in his book *Creativity: Flow and the Psychology of Discovery and Invention,* Mihaly Csikszentmihalyi outlines a comprehensive approach to enhancing personal creativity, divided into six overall strategies. Only the basic structure is excerpted on the next page, but if it piques your curiosity you should seek out his more detailed discussion in the original version. And then, ideally, eventually, we each become the change we want to see in our field.

Your Creative Practice

Hawks and Tractors

Before or after the museum is open, I drive twenty-one miles each way through the countryside. The drive gives me time to reflect on my work and refreshes me each day, while the landscape—cows, horses, the hawk on Route 15, and the tractors—reminds me what it means to be a "country" museum.

> Lee Langston Harrison, Director,
> Museum of Culpeper History, Culpeper, Virginia

Mihaly Csikszentmihalyi's Prescription for Personal Creativity

Curiosity and Interest

Try to be surprised by something every day.
Try to surprise at least one person every day.
Write down each day what surprised you and how you surprised others.
When something strikes a spark of interest, follow it.

Cultivating Flow in Everyday Life

Wake up in the morning with a specific goal to look forward to.
If you do anything well, it becomes enjoyable.
To keep enjoying something, you need to increase its complexity.

Habits of Strength

Take charge of your schedule.
Make time for reflection and relaxation.
Shape your space.
Find out what you like and what you hate about life.
Start doing more of what you love, less of what you hate.

Internal Traits

Develop what you lack.
Shift often from openness to closure.
Aim for complexity.

The Application of Creative Energy

Find a way to express what moves you.
Look at problems from as many viewpoints as possible.
Figure out the implications of the problem.
Implement the solution.

Divergent Thinking

Produce as many ideas as possible.
Have as many different ideas as possible.
Try to produce unlikely ideas.[15]

Try This:
Creativity Walk

Each of our communities is different, and each of the places our museums inhabit has people who have found different ways to express their own creativity. Take a neighborhood walk to observe the physical evidence of creative community members past and present. Seek out a neighborhood different from your own or the museum's, reflecting on how location, class, ethnicity, and other factors influence the visible creative practice. How have residents adapted their homes and businesses to solve problems, brought new ideas into being, and added their own version of beauty to the local landscape?

There Is a Lifelong Learner at the Heart of Every Creative Person

Pretty much everyone who studies creativity agrees that the more new information you expose yourself to, the easier it is for you to be creative. Those bursts of insight that we all describe as light bulbs going off in our heads? They are the result of random and disparate bits of information bumping up against each other in our brains. Indeed, some of the best insights come from combining information from different sources or different domains of thought in new ways. If there are not very many bits of information in your brain, or if the bits are too focused and similar, then there's simply not much for you to work with. This is why there is a strong link between creativity and curiosity; curious people constantly expose themselves to new information of many kinds. The quality of the information is still important, of course—we're unlikely to get very far as a society if we concentrate our efforts to obtain new information on things like cat videos and conspiracy theory websites (although in small doses these things can be perfectly useful, and in fact the Walker Art Center in Minneapolis developed a glorious film festival around the former). But the bottom line is that we need to feed our brains yummy, nutritious, and varied food every day.

What does this mean for museum workers? It means you should constantly be seeking out interesting sources of information both inside and outside of your job. It's not enough for us just to encourage lifelong learning in our visitors; we need to be developing it in ourselves as well. But that means learning in the broadest sense. If you are a registrar, you shouldn't only be reading the latest articles on collections management, a narrow body of knowledge; you should also be paying attention to developments in other segments of the field. Moreover, in your life outside of museums you should be seeking out new information, too. Art historians should occasionally pick up *Wired* or *The Economist*; anthropologists should consider learning something about string theory or wine making, and so on. You can, of course, go too far down this track—it is still important to have expertise in some area, a home base. But when you spend a little time diversifying your learning, you'll be amazed at the connections it helps you make. Throughout this book there are examples of ways to increase the quality of your information input, but here are a few in one place:

Diversify Your Content

If you are on social media, throw a few random Facebook pages or Tweeters into your feed, and do the same for your blog subscriptions. If your gym or doctor's office has magazines, pick up a wildly different one each time instead of heading straight for your favorite genre. Join a book group so you are not always the one choosing what you read. Watch a documentary you've never heard of every now and then. Whatever your preferred mode of taking in new information—digital or analog—diversify it. In *Where Good Ideas Come From*, Steven Johnson explains creativity this way: all new ideas are a combination of existing parts—either abstract (models or ways of thinking) or concrete (literally parts)—and it goes without saying that you cannot make ideas from parts you don't know about. Therefore, according to Johnson, "The trick to having good ideas is not to sit around in glorious isolation and try to think big thoughts. The trick is to get more parts on the table."[16] Diversifying your content puts more parts on the table.

Your Creative Practice

Outside the Box

I do rely heavily on thinking outside the box, and I have come to realize it's what Steven Johnson refers to as the "adjacent possible." I intentionally read just outside my area of expertise, so right now it's tourist behavior, the history of strategic planning, various educational taxonomies, narrative non-fiction, and summaries of neuroscience research—continually looking for its application to historic sites.

Max van Balgooy, President, Engaging Places, Rockville, Maryland

Network

That professional development line that is always the first to get cut from the operating budget? It's actually essential. It is hard to beat the intensity and mix of new information that happens when colleagues get together from different departments and different museums. So go to conferences, and fight for the rest of your staff to go to conferences, too. Make sure to sit in on a few sessions that are outside your comfort zone or area of responsibility, and also make time for socializing beyond the formal sessions (the informal conversations at coffee breaks and meals tend to be the most diversified and wide-ranging because they aren't confined to a specific session topic). And then don't stop there; think about other ways to grow your network (more on this in the field-wide infrastructure chapter).

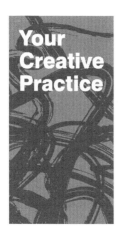

Your Creative Practice

Network outside the Lines

I work in a history museum, but I make sure I attend and participate in art education and museum conferences. I regularly meet at 3 PM every day with a colleague and we brainstorm together: "What if we did?" "What if I did?" We have a free and open conversation with no judgments. I make a point to regularly reflect on my work, try something new, and always talk to others about ideas. I have an artist background, and I bring that to my museum work every day.

Rebecca Lawrence, Museum Educator,
Schwenkfelder Library & Heritage Center, Pennsburg, Pennsylvania

Talk To New People

Networking with museum colleagues is important, but you diversify your knowledge base even further when you network outside your own field. Make friends with people who earn their living in very different professions, and talk to them about what they do at work. What are the major problems in their field that everyone's trying to solve? What does innovation look like for them? Can you find any interesting common ground? Our Australian colleague Suse Cairns articulated it this way: "Every single person you meet knows things that you don't, and the solutions to their problems might also be solutions to your problems, if only you could make the connection."[17]

Regularly Look outside the Museum Field for Inspiration

At the AAM conference in Philadelphia in 2009, before the two of us had even met, we both ended up in a session called "Eye on Design," chaired by Nina Simon of Museum 2.0 and *The Participatory Museum.* During the session, ten different exhibition developers each shared a non-museum phenomenon and discussed how it could apply to our field, from mega concerts to library book drops to victory gardens to greeting cards. During the process of writing this book we found out that we both ranked that session as one of the most memorable and useful conference experiences we had ever had. Over the years we have seen how inspiration from other places boosts our creative practice in the museum. Getting outside your own institution—and expanding your horizons in the process—is essential to your creative practice.

Share the Things You're Learning with Those around You

Talk with your colleagues and your friends about all the information you are taking in. You may find such discussions can help you further refine and clarify your new knowledge while you simultaneously spread it as far as you can. The cross-pollination helps all of us.

Try This:
Everyday Observations

Creative thinking is much easier when you have a deep understanding of the way things work and the problems you are trying to solve. The more adept you are at taking in information about the environment and people around you, the better prepared you are to see patterns and generate new ideas from them. Tim Brown in *Change by Design* says "Good design thinkers observe. Great design thinkers observe the ordinary. Make it a rule that at least once a day you will stop and think about an ordinary situation."[18] What can you observe today, either in a new environment or in one you think you already know well? Watch the people on your morning commute. Look for patterns in your neighborhood. Spend an hour with some ants. Keep a notebook (or use the note function on your Smartphone) to create those observations.

Linda's daughter shared an activity from her Observing Humans class in art school. The assignment was to go to the same place, once a week, at the same time, for an hour, and observe. Note who is there every week, how people use the space, what is different, how the weather or time of year changes the activities. Change your point of view: turn around from the position you would customarily take. Take some photographs and look at them later. Do the photos reveal something you hadn't noticed?

It's All Happening outside the Zoo

Often ideas come while cycling through the city. After a meeting with my director about a possible exhibition on the history of the Amsterdam Zoo, I watched the seagulls, who had moved to the city because of the easy access to food, and the flocks of rose-ringed parakeets, once a tropical bird held in cages and now a wild bird in the Amsterdam parks. I saw the dogs and their owners, the few remaining horse carriages, now for tourists but once the main means of transport. I realized that an exhibition about the city as a big reservation for animals would be far more interesting than one about the zoo. It would be about animals, but of course also about the interaction between people and animals, pets as well as pests. This eventually became the hugely successful family exhibition *City Animals*.

Annemarie de Wildt, Curator,
Amsterdam City Museum, Amsterdam, Netherlands

37

Try This:
Create a Mind Map

A mind map is like a drawing of what you are thinking. It's not a geographic map and it's not a flow chart. It is a map of thoughts and how they are related, usually with an informal, doodling feel. Because it's not linear, sometimes it gives you a better understanding of the exact nature of a problem or issue, and the connections between its various parts. Rainey once worked with a colleague who, when she was leaving to take a new job at another museum, drew a mind map of her responsibilities—the major areas of operation she coordinated, projects and tasks associated with each, and things that should not be forgotten. This drawing was a much clearer and more effective guide to managing the staffing transition, to understanding any changes that should be made to the position, and to finding a suitable replacement to fill her shoes than any position description or "things someone must do after I leave" document Rainey had ever seen (or written).

While everyone's mind maps are different, they generally start with a project, problem, or question at the center in a circle. Then related ideas or issues radiate out from that circle in various directions, like spokes on a wagon wheel, often prompting additional circles with their own radiating

concepts or questions. Some circles may have only a few spokes, while others have many—there is no need for symmetry. See our Acknowledgments on pp. 6 and 7 for our own mind map, or do a Google Image search for lots of additional examples. Mind maps can be of big or small concepts. Linda has done mind-mapping exercises in career planning workshops where participants map out how they got to their present position. Some of those are straight line paths, but she has also seen floral shapes, rivers, and more. You might consider drawing mind maps of:

- Each new project you embark on, to help you more fully understand the goals, resources, ideas, and steps involved
- A single teaching experience, a single exhibition component, or the meanings attached to a single artifact
- The points you need to make sure you articulate in a particular grant proposal narrative in order to make a strong case for funding
- Your filing system
- Your audience—what are your core visitor groups and what are their needs? What about stretch visitor groups you want to attract more of?
- Your museum's social media strategy
- Your collecting scope—types of objects, strengths and weaknesses
- Risk management at your institution
- A project that went really well, to help you understand why it was so successful so you can do more of the same
- Your own creative practice—and then compare with your colleagues' versions of the same

Creativity Is a Process and a Practice

While they might debate some of the details, most people who study creativity agree that it is a process that happens in stages. They also agree that creativity is hard work—you have to practice it. Yes, there are the bursts of creative insight that feel like a gift from the sky, but it's also a lot of thinking really hard, plus learning, tinkering, iterating, implementing—the other parts of the process. There are various models for describing this creative process, with different terminology and numbers of stages; one of the most well-known is the four-part process proposed by Graham Wallas in the 1920s (Preparation, Incubation, Illumination, Verification). We like the version put forward by Mihaly Csikszentmihalyi in *Creativity: Flow and the Psychology of Discovery and Invention*. It is based on Wallas's model but puts more emphasis on refining and implementing ideas by replacing Wallas's stage four (Verification) with two stages (Evaluation and Elaboration).[19]

1. Preparation

This is where you learn everything you can about a particular problem or issue in order to start thinking about it creatively. You might research what other people have already written about that topic, conduct a visitor study or some deep observation, or talk to your colleagues. Along the way, you will also probably do some focused, deep thinking about the problem at hand. Anyone who has developed a new exhibition or planned a new program knows that moment at the beginning of the project when you are immersed in the preparation stage, but it is also just as likely to come in handy when you are trying to figure out the best way to fix the front door, or solve a nagging management dilemma. The more deeply you know the problem and the more information you take in related to it, the more prepared you are to come up with your own great idea to solve it.

2. Incubation

This is the stage that people are most likely to miss, because it is such a behind-the-scenes part of the process. But it is crucial to creativity; you can make a big improvement in your practice just by knowing it exists and providing some space for it. We have discussed the importance of continuously filling your brain with different kinds of information—not just related to the problem at hand but from

many disparate fields and sources. During the incubation phase, your unconscious mind combines the new things you learned in your preparation phase with your existing body of broad knowledge. Your brain works to sift through all of that information and make larger meaning, to draw new connections. This is called associative thinking. You have to allow some room for your brain to do this work, though; it requires a quieted, unfocused mind. That means setting aside periods of time where you stop concentrating so hard and let your thoughts wander. If you are on deadline and the big idea just isn't coming—you've hit a wall—take a break to incubate. Daydream, go for a run, play around with a paintbrush, weed your garden, or take a shower so that your brain can scan the forest instead of concentrating only on the trees. Indeed, many creative people schedule regular time for incubation—daily or weekly—as a cornerstone of their creative practice.

3. Insight

This is the most visible stage of creativity, the one that gets the most attention. It's when your brain finds a new connection within all that information rattling around in your head and pops it into your conscious mind, and you realize how much potential it has, like the last piece of a puzzle falling into place. This is Newton with his apple tree, eureka in the bathtub, and the light bulb going off in your head. Many people incorrectly think that this is the only stage to creativity— that you are either born with a brain that can produce insights or you are not. But that's not true; insights are open to anyone who adequately prepares for and incubates them (and then stops for a moment to recognize them when they happen). Insights can be very pleasurable. We might even go so far as to say they are addictive. In a good way.

4. Evaluation

Once an insight has presented itself, you enter a stage where you consider its value. You go over the new idea in your mind and decide whether it merits further effort. You might think about practical considerations, or how it will be perceived by others (the public, the rest of your institution, funders). In museums, where so much work is collaborative, the evaluation process often happens as a conversation among colleagues: "Do you think it will cost a lot?" "Does it truly speak to our mission?" "Can we make space for it?" In institutions with a culture of creativity, this stage is very

Your Creative Practice

The Ways You Incubate

I like to play guitar and get together with friends to "jam." There's nothing like the focused and transcendent jamming of my beloved Allman Brothers Band. But it is also a way for me to scratch the itch of doing something a bit more free-form and loose. It gets the juices flowing nicely.

> Bob Beatty, Vice-President for Programs,
> American Association for State and Local History,
> Nashville, Tennessee

Sometimes I just get really stuck. So I turn off the computer, leave my work behind and head out in search of nature, either in my neighborhood or at the beach. I focus on the sounds of the birds, the wind, the smell of the honeysuckle, and suddenly the ideas start flowing.

> Conny Graft, Evaluator, Williamsburg, Virginia

When I have trouble thinking through an idea, I generally start doodling. The doodling is both relaxing and liberating. It can also serve as a mini Rorschach test, which opens up my mind about the problem.

> Lauren Silberman, Coordinator, Museum Assessment Program,
> American Alliance of Museums, Washington, DC

For me, nothing beats walking my incorrigible dog. Getting out, away from my desk, clearing my mind, and not thinking about the challenge at hand actually helps me see the challenge more clearly. My best insights come when I am blocks from home. (Remembering them when I get home . . . now there is the real challenge!)

> Susie Wilkening, Senior Consultant and Curator of Museum Audiences,
> Reach Advisors, Quincy, Massachusetts

 I'm a big fan of mini brainstorming dance parties (or anything else that gets you out of your head and your body moving). Whenever I have something that needs creative thought, I spend five to ten minutes thinking, turn on a song, dance around the room, and then sit down and think again. Moving my body frees my brain, and often moves my thoughts in new directions.

Kate Bowell, Museums Askew, Freiburg-im-Breisgau, Germany

important because it can strengthen the original concept and help the best ideas rise to the top—it would be impossible to find the time and resources to implement every new idea, so judicious weeding is always necessary. But in institutions that are not supportive of creativity, the casualties during Evaluation are massive: ideas are dismissed offhand without any serious consideration.

5. Elaboration

The last stage is about implementing the idea. Sometimes elaboration is very quick, and sometimes it can take years of tinkering. You might test the idea and find it needs further refinement. Or you may simply spend a lot of time compiling the database, organizing supplies and people, writing the text, moving the objects, or practicing the tour. It is important to keep an open mind as elaboration proceeds—the original idea may change a lot along the way. Because this stage takes discipline and hard work (it's not nearly as sexy as insight), the creative process also often gets derailed here. In museums we find ourselves routinely sidetracked by competing projects or fires that need putting out, and we never get around to implementing. Or we come up with a million excuses—someone may not like it, I need more information, it would look nicer if there were more money, it's not perfect yet—instead of trying something on a small scale to see what happens. But what good is an interesting new idea if it never sees the light of day? Rapid prototyping, a bias towards action, and routine sharing of ideas (so you feel positive peer pressure to move forward) can help you shepherd a great insight through the elaboration phase.

Your Creative Practice

My Creative Process, Start to Finish

It's hard to define parameters to a creative process because at times I feel like I'm in a constant state of ideation and synthesis. That said, when I'm about to begin a new project, there is a filter I turn on and I begin to view everything I am looking at as a potential connection to the project.'

Inspiration and Source Material I usually keep a document or two open for capturing general ideas, and make sketches as it becomes time for things to crystallize into a visual. I read articles and related materials ranging from deep to tangential to the subject matter. I like to find the far edges of the subject and then bring it back in. I'm trying to get a sense of the entire landscape: be it people or other projects and potential partners. I go to museums, yes, and also look at the work of artists, scientists, engineers—anyone who may be asking similar questions or working in a related vein, even if the end result is quite different. In some way, I have to reach a saturation point where I'm able to internalize the idea enough to play with it.

Transitioning to Implementation At a certain point, I'll start to keep a folder of images I'll call "design reference," which are visuals that either capture what I'm thinking or are using a technique I think might be useful in some aspect. I sketch and write some more. Maybe I craft a blog post as a way to formalize an idea or approach. I also make diagrams if I need them, and lay out all the possible components of a concept. I keep it open, and yet there is a fair bit of pragmatism in my work. I begin to shape the raw concepts I started with, and create statements,

plans, and visuals that help shape the idea. I tend to obsessively sketch or redraft things so I can squeeze in or leave out everything I possibly can. That helps me work out the details and consider all possibilities for realizing the project. Generally, I talk to others all along to test out the initial soundness of an idea. I need to keep a dialogue going on, as the work I do is intended for many, not just me. The feedback from others is very helpful in strengthening a concept.

Formal or Informal Testing? The time comes when I have to take a physical stab at the idea. I really like this part—it's probably my favorite moment, where things start to come together, and the potential for a project gets realized. It begins with paper, and then moves on as the idea calls for it to do so. There are times where I can build a prototype and do formal testing. It works really well when that can happen. While that is the preferred method, it's not always feasible. Sometimes I have to go with my best assessment, verbal input, and press play.

Working as a museum professional is about building a repertoire of experiences. My philosophy is that the work we are doing is inherently experimental because it's custom in some way: it's never been done before in that context, that idea, with those people. It takes the pressure off and allows me to be a bit freer. Things sometimes work well; other times, not as much. It's all an experiment to me.

Maria Mortati, Exhibit Developer, San Francisco, California

45

Your Creative Practice

Everyday Desk

There's no one way to think about your workspace. The neatniks among us are always groaning at those of us with workspaces where tacked-up postcards, sedimentary piles of papers, and that old Doonesbury cartoon live in lively disharmony. For some, the chaos is fruitful (Linda once had a colleague tell her that her office looked like the inside of her mind, jumbled full of ideas), and for others, a neat workspace provides room for creative thinking. The following workplace description, from Jason Illari, is one of the most unusual approaches to creative desk-organizing we'd ever heard. After you read it, you may want to imagine what metaphor you might use to describe your workspace: a lifeboat? a fruit basket? a clean slate?

When I got to a point in my career where I found myself giving a speech about Tennessee history, fixing a broken hinge on a barn door, picking up chicken from the caterer, sending the auditor PDF files for an audit, and scheduling a conference call for a grants meeting online—all in one morning—I needed a sanctuary. I craved it, and it has become my desk. Every day I spend at least an hour—yes, I said it—at least an hour of my time on this personal canvas. I call it a canvas because I imagine in my mind's eye a painting (my desk space), and my goal is to paint a beautiful painting on the canvas throughout the day and then totally erase it by the time I leave work (I admit beauty is somewhat relative and that's ok). Every morning I have a new canvas which MUST be empty by the time I leave work. The painting is not my work, per se, but it greatly enhances my work. The canvas is my desk space: my pens, pencils, folders, coffee mug, lamp, trash can, photo of Daniel, place where I put my car keys,

place where I put the museum keys, clips, grant portfolios, chair, calendar on the wall, and email; all the tools of the trade. What happens when the artist's tools are missing, broken, sloppy, not beautiful, scattered, not adequate, mis-labeled, or in someone else's art studio? His or her craft is often hindered and not as effective. I think the concept transcends just "being really, really organized." The canvas is a sanctuary, a place that is beautiful for me in my own way.

My "hour" (or sometimes more than an hour) will be in chunks of time (twenty minutes here, twenty minutes there), or spent all at once at the end of the day. I keep track of my "canvas time" and have found that anything less than an hour is ineffective. What on earth do I do!? ANYTHING to keep my canvas beautiful and then blank by the end of the day. If it's not blank, then I force myself to work overtime. I put folders away, examine my filing system to see if it's really doing its job, clean my desk, water my bamboo plant, look at Daniel and meditate for five minutes or so about his life, sharpen pencils, throw away ink-less pens, shred useless documents that are not needed, remove what I call "long range plan" sticky notes, discard clutter—whatever it takes to make my canvas beautiful and then empty by the end of the day. I strongly believe that when that balance is struck and beauty returns to the desk day after day, work is much more effective and potent—whether it be writing a strategic plan or brainstorming about an innovative public program. Everyone has their own method of organizing their space to enable creativity to flow; this is the method that works for me.

Jason Illari, Grants Administrator,
Fire Museum of Maryland, Lutherville, Maryland

Each of us cycles through these stages of creativity all the time. Sometimes you might hit all of them in the course of a day. In other cases, you may wait ten years for a major insight that will define your career. They don't have to happen in a strictly linear order—halfway through you might find you need to go back for more preparation or incubation, or you might experience a series of small insights, each with its own evaluation and elaboration, that eventually come together into one much bigger concept. Moreover, humans can process more than one creative idea at a time; the ideas don't have to wait in line for the one before them to complete all five stages.

What can be frustrating, though, is that these stages don't conform to a nice, neat time-table—they don't recognize our real-world deadlines. You can control the preparation, evaluation, and elaboration stages to some extent because they happen in your conscious mind, but incuba-tion and illumination can feel like coaxing a two-year-old to eat a new food—the more you try to force it the less likely you are to achieve the desired result. Moreover, sometimes the idea that sur-faces is not the idea you were searching for. That's why it is important to build a creative *practice*, where you figure out the best conditions for your own version of this process and you learn to cycle through all the stages regularly, routinely.

When you rush through preparation, or try to skip incubation altogether, or don't leave enough time for a healthy amount of evaluation, it is easy to end up with mediocre ideas. When you only practice creativity every once in a while instead of all the time, it is easy to end up with only a few ideas. When you avoid pulling the trigger on implementation, it is easy to end up with a flip chart full of good ideas and nothing to show for it. If, however, you understand this process and work with it—not against it—habitually, then it becomes the core of your creative practice, as an individual or as a creative team. You start to recognize and acknowledge the phases—in yourself and in others—as you cycle through them. You start to understand what your individual brain needs to do its creative thinking—what kind of physical environment, what kind of schedule, what kind of interactions with other people. Bit by bit you make changes in the everyday structure of your work to help good ideas surface regularly, and the quality, the number, and the realization of those ideas increases.

Rounding Out Your Creative Toolkit

Divergent and Convergent Thinking

Divergent thinking is an opening up of the mind to come up with as many original and varied ideas as possible. The expression "thinking outside the box"—looking for a solution that is unconventional—is about divergent thinking. Because divergent thinking has long been considered an indicator of creative potential, many commonly used creativity assessments, like the Torrance Tests of Creative Thinking or the Unusual Uses Test (how many different uses can you come up with for a given everyday object?), are actually tests of divergent thinking skills. Meanwhile *convergent* thinking is a narrowing and focusing of the mind to produce one best or right answer, and it is also important for creativity, particularly when evaluating and implementing ideas. Indeed, many creativity researchers now agree that creativity involves a combination of divergent and convergent thinking—switching back and forth throughout the creative process. Because divergent and convergent thinking play a significant role in creativity and surface regularly in the literature, you should be familiar with both of them. There are times when you need to open yourself up to the broadest range of possibilities, and there are times when you need to narrow down to define a problem, assess your options, or choose an idea to implement. Part of your practice will be finding the right balance between the two.[20]

Failure: You Can't Live with It; You Can't Live without It

It is impossible to establish a creative practice without embracing failure. By and large, creative people aren't successful because they are luckier than the rest of us or because they have some talent that comes effortlessly; they are successful because they try a bunch of stuff, think hard, persevere, and pay attention to what works and what doesn't work and why. Let's emphasize those last two bits: creative people don't fail and then give up; they keep on going, and they learn how to do it better the next time. Indeed, the design thinking firm IDEO has a mantra, "Fail early to succeed sooner."[21]

Try This:
Puzzle It Out

Riddles and puzzles make us look at the world in unexpected ways. Make it a habit to engage with the puzzles you encounter in your daily life—in the newspaper and the in-flight magazine, on the Mensa website (www.mensa.org/workout), on the restaurant placemat, or on the radio (two public radio shows here in the United States feature puzzles on a regular basis: *Car Talk* at www.cartalk.com/content/puzzlers and Will Shortz's regular appearances on *Sunday Weekend Edition* (www.npr.org/series/4473090/sunday-puzzle). This is a simple way to stretch your divergent thinking skills so you are not always looking for solutions in the same standard places.

In recent years there has been a trend of leaders in many fields "outing" the major failures of their careers in an attempt to de-stigmatize failure. In our field, for example, this has taken the form of "Mistakes Were Made" sessions at the last few AAM conferences. Even when it stings, talking out loud about failure, and the lessons you learn from it, is essential. The more we can all shift our reaction to failure from judging and assigning blame to looking for the learning moment, the more we can take a deep breath and cozy up close enough to this most terrifying of monsters to ask why it has come to visit, the greater our potential for creative workers and creative museums. Make a plan beforehand for how you will survive failure with your sense of self intact (positive reinforcement from your loved ones, a treat to get you through a bad day, a safety net should you need it), but don't shut failure out of your life.

Combinatorial Creativity

Remix. Mash-up. Fusion. Synthesis. What do these concepts have to do with creativity? Most, if not all, new ideas are built on the backs of ideas that came before them. Kirby Ferguson says "Everything is a remix."[22] Steven Johnson talks about exaptation, when an idea created for one purpose is applied to an entirely new purpose. Matt Ridley provocatively talks about ideas having sex. While great ideas can be the result of combining old ideas from the same domain, they also often come from combining ideas from different domains. The creativity literature emphasizes the importance of environments where multiple domains intermingle and expose people to new knowledge outside their area of expertise. This can happen in interdisciplinary teams, or at coffee shops, cocktail parties, and co-working spaces. The physicist Geoffrey West has done some fascinating research on the importance of cities as places where ideas from different disciplines or different parts of the world constantly bump up against each other to create new combinations.

We're living in interesting times, where we are flooded with information from the moment we wake up to the moment we put our heads on the pillow. That's probably one of the reasons why we are paying so much attention to creativity right now—the Information Revolution is enabling an exponential exposure to such a wide range of ideas, and we are combining them at a breakneck pace. You have

also probably noticed that the walls between disciplines are starting to break down; this too allows for freer flow of information, which leads to more ideas, and more idea combinations. So continue to cite your sources, of course, but celebrate the abundance of ideas at your disposal and seek to combine them as much as possible.

Constraints

It may seem counterintuitive to insert limitations into the creative process, but in actuality constraints serve a very important purpose. The blank page, the inexhaustible budget, the nonexistent deadline—all can get in the way of creativity. The artist Austin Kleon writes, "Nothing is more paralyzing than the idea of limitless possibilities. . . . When it comes to creative work, limitations mean freedom."[23] Coming up with a great idea is like charting a path through an immense forest. When every direction is open to you indiscriminately, it's easy to go around and around in circles. In describing constraints, psychologist Patricia Stokes writes: "Free to do anything, most of us do what's worked best, what has succeeded most often in the past."[24] In other words, when faced with the immense forest, it's easy to fall back on a marked path. But as Stokes goes on to explain, constraints provide limits and directions that structure our search for ideas; they are "barriers that lead to breakthroughs."[25] Therefore, think of strategic constraints as a compass, loosely guiding you through the forest but not confining you to a set path.

Many creative people talk about posing challenges as a way of opening creative doors; in her book *The Creative Habit,* the choreographer Twyla Tharp provides the following examples: "paint only in shades of green, write a story without using the verb 'to be'; film a ten-minute scene non-stop with one camera."[26] Tina Seelig emphasizes the importance of introducing a series of changing constraints into the brainstorming process. Indeed, the poet's meter, the challenge to "do it in under $100," and the A to Z exhibition are all techniques for providing creative constraints.

Rainey has seen the positive power of constraints first-hand in the material culture course she teaches in the Tufts Museum Studies program. Halfway through the semester she guides her students through a writing activity. They each bring an object and a blank sheet of paper to class, and sit in a circle. Students start with their own object, writing everything they know about it for five minutes. They then pass their object and sheet of paper to the student sitting next to them, and

Try This:
SCAMPER

Michael Michalko developed the SCAMPER method to guide people through the process of generating ideas.[27] Think of SCAMPER as a set of useful constraints for reframing a problem or issue:

S substitute something
C combine with something else
A adapt something to it
M modify or magnify
P put it to some other use
E eliminate something
R reverse or rearrange

Here are some ways you might use SCAMPER in a museum context:

Substitute

Substitute one thing for another. Instead of an exhibition label? Instead of a period room? What else can be substituted? Who else? When else? Substitute emotions: What's the funniest way to look at this? What about substituting different rules: touch the art, be noisy?

Combine

Combine your purpose with something else. A museum and . . . a grocery store? Coffee shop? Factory? Consider combining an assortment of services; think about the way things are packaged (for example, the Whitney Museum's membership package). How could combining work in an exhibition? Combine your subject's appeal with something else. Or imagine merging with your subject: Einstein imagined he was a beam of light.

Adapt

Adapt from other worlds or fields. Science, religion, politics, prison, comics, oceans, space, food (see the Conner Prairie games example on p. 82). Adapt from nature: "This project is like an ocean because . . ."

Modify

Turn an old idea into a new concept by changing something. Change meaning, purposes, uses, dimensions, limits, process, character, color, motion, sound, shape, or function. Make three small changes—to job tasks, to newsletters or marketing pieces, or workspaces. Can you restate the problem in five to ten different ways, using a thesaurus? What problems could museums restate: how to attract more visitation? What are different words for "attract": bait, beckon, enthrall, entice, fascinate, lure, tempt, wow?

Put to Other Uses

Can you make something do more things? For instance: Can your museum event do more? Other functions, relationships, spinoffs? What would a twelve-year-old imagine it could be used for? Think about contexts: How would different countries, regions, or cultures make use of it? What's the

most unconventional new use you can imagine? Silliest? Most practical? How will it be used ten years from now?

Eliminate

What if it were smaller? What parts aren't necessary: cataloging fields, even collections themselves? Think of the "History of the World in 100 Objects" project from the British Museum. How can you dissect to see what's useful? Miniaturize and condense? How can you improve one part at a time (think about improving lobby spaces and first impressions). Can you downsize? Can negatives be eliminated? What isn't the problem? (Like all those security barriers in museums with few visitors to transgress them.) Can you state the narrowest definition of the problem? What if nothing is done, what happens?

Rearrange

Interchange components, change the order. Where should this be in relation to that? Another layout? Another pattern? Consider guided tours this way. Another sequence? Change the pace and schedule? Transpose cause and effect? Switch the verb and object? Sell more bottles/bottle more sales; attract more visitors/visitors more attracted? Rearrange how you work on the problem: consider changing people, environment, habits, and priorities.

Reverse

What are opposites? Look up; look down. Be a devil's advocate. Reverse: relationships, uses, functions, goals, ideas, and roles. List three assumptions you're making; reverse them and make them work. What are negatives—can you reframe them into positives? "We're off the beaten path," for instance, becomes, "We provide a quiet retreat." Visualize the desired result and work backwards from there.

are given a new writing instruction: craft an exhibition label for the object in front of you. Again, they rotate objects and receive a new instruction: write a haiku about your object. This cycle continues—Tweet in 140 characters, write in first person from the object's perspective, and so on—until both sides of the paper are filled. Her students love this exercise and ask for more. In fact, they consistently rank it as their favorite activity in course evaluations. It unleashes student creativity by setting productive constraints.

What You Need to Be Your Creative Best at Work

There is a lot of new research on what makes a work environment that is conducive to creativity. In this literature, a handful of companies are invariably held up as the pinnacle of creative culture: 3M, Apple, Pixar, Google, IDEO. They produce great projects and products that have had a sweeping impact on our society, and one gets the feeling that if you work for one of these companies, you cannot help but be creative. But what happens if you don't work for Google or Pixar? The next chapter will address at length how you can build a culture of creativity at your museum, but first you need to understand some of the factors that contribute to individual workplace creativity. Then, wherever possible in your own daily work life, you can encourage and protect your creative practice—and start to do the same for your co-workers—regardless of whether your institution supports you in that effort.

Intrinsic Motivation, Expertise, and Creative Thinking Skills

Teresa Amabile's extensive research on workplace creativity shows that our best creative efforts as employees happen at the intersection of intrinsic motivation, expertise, and creative thinking skills. We have discussed each of these concepts already in this chapter, but as a refresher, intrinsic motivation is your passion for the work—your desire to do it because you love it and not because someone is making you. Expertise is your knowledge and skill base related to your core work, whether that's archaeology, museum security, or paper conservation. And creative thinking skills

are your brain's ability to do things like carry out the creative process, employ both divergent and convergent thinking where needed, and reframe problems. If you are looking to make more room for creativity in your job, assessing your own level of these three factors is a great place to start:

- ■ **_Intrinsic Motivation_** Do you love your work, or have you forgotten why you joined the museum field in the first place? If you are struggling to love your work, what is the problem? Is it your specific job responsibilities or something about your environment? What are the bright spots in your day where you really are enjoying yourself, and what makes them so good? What changes could you make to do more of what you love and less of what you hate?

- ■ **_Expertise_** Do you know everything you need to know to be really great at your job? Are you keeping up with the literature? Are you challenging yourself to add to your skillset? Do you have a mentor who could suggest a course of learning for you?

- ■ **_Creative Thinking Skills_** Are you incorporating the creative process into your daily work? Are you looking for opportunities to improve your divergent thinking skills? Are you making time to think deeply about problems and ideas?

Some of you are probably thinking this stuff isn't within your control—that other people dictate the work you do and the way you do it. To some extent this is certainly true—it is a lot easier when your co-workers, your director, and your board are also nurturing your motivation, your expertise, and your creative thinking. But each of us bears a responsibility for keeping our side of the street clean. The change starts with you.

Try This:
Use Your Body

In *Steal Like an Artist*, Austin Kleon discusses the importance of stepping away from the computer to engage one's body in the process of creating:

> Our nerves aren't a one-way street—our bodies can tell our brains as much as our brains tell our bodies. You know that phrase, 'going through the motions'? That's what's so great about creative work: If we just start going through the motions, if we strum a guitar, or shuffle sticky notes around a conference table, or start kneading clay, the motion kick starts our brain into thinking.[28]

Meanwhile, Michele and Robert Root-Bernstein borrow the term "thinkering" from novelist Michael Ondaatje to emphasize the importance of using one's hands to think: "The physical manipulation of things, like direct personal experience of any kind, generates sensory images of all sorts and thus enables thought. Hands-on tinkering leads to minds-on thinkering."[29]

Another technique is bodystorming, a similar concept to brainstorming, except you act out your ideas with your body instead of saying them out loud. How might you use your body to think about the objects in your collection, to better understand the museum's physical space—back and front of house—or to prototype (instead of merely talk about) visitor-staff interactions?

Supporting Each Stage of the Creative Process

If you understand the creative process as a series of stages, each with its own requirements, you can start to see that many work environments derail this process instead of helping it flourish. For example, teams routinely hold brainstorming sessions that are supposed to produce a long list of great ideas, pinning all their hopes on that one session to solve a problem without realizing that scheduled meetings in a conference room can sometimes be the worst time and place to generate insight. If the other stages of the creative process are humming along like a well-oiled machine—workers have adequate opportunities for preparation, incubation, evaluation and elaboration, sometimes individually and sometimes together—then the insight flows much more naturally, whether you are in a brainstorming session or not. Meanwhile, management and facilities practices can also work against the stages of creativity. When you are incubating, you may need to leave your desk and go for a walk—is that acceptable at your museum? Or sometimes you need to shut yourself off in a quiet room for deep, concentrated thinking, and sometimes you need to talk to hash out stuff with your colleagues—do you have the space and flexibility to support both?

Wherever you have control in your work life, look for ways to nurture all five creative stages. Are you struggling with a project that's just not coming together? Maybe you need more preparation—can you go back and do more research or talk to additional knowledgeable people? Or maybe in our over-stimulated twenty-first-century world you are not giving yourself any regular time for incubation—can you schedule a half-hour walk during your lunch break, turn off the news or music and zone out during your commute, or make time for stream-of-consciousness journal writing every morning? Or maybe for you it's more of a struggle to implement your ideas; you drag your feet for any number of reasons—can you break your ideas down into smaller steps and initiate some test cases early-on to keep yourself moving forward?

Meanwhile, when you are scheduling, planning, and budgeting for your department, how might you better support the creative process? Are you holding meetings for the right reason and at the right stage? (This might mean coming together to share research and get to the bottom of a particular problem during the preparation phase, or to evaluate and prototype ideas later on in the project, as much as it means brainstorming for insight.) Are your deadlines realistic, or have you forgotten to

leave adequate room for the two stages that often get short shrift, preparation and evaluation? Are you budgeting for multiple versions of your idea or expecting to get it right the first time? When you project-manage, are you doing everything you can to provide an environment that enhances the creative potential of your team members?

Making Room for Failure

It is clear that failure is an essential part of the creative process, but how do you make room for it at work, particularly in our risk-averse field? One strategy is to think about scale: a series of small risks, each with its own learning moment, can set you up for a larger success down the line. You can also follow Twyla Tharp's advice: "The more you fail in private the less you will fail in public."[30] Think about ways to build prototyping, testing, and practice into the process behind the scenes, either for yourself alone or the teams you work with, so that the debut in front of people who matter a lot is not the first run-through. The peer review process for this book, which involved a team of more than a dozen museum colleagues looking for problems and holes in the manuscript, was a version of failing in private.

Another strategy is to manage expectations—with yourself, your co-workers, and members of the public. When scientists are working in a lab, we assume that sometimes their experiments will fail; it's the cost of doing business if you want scientific discovery. Similarly, when you tell museum visitors you're trying out some new exhibition components, they don't expect them to be perfect out of the gate. So instead of expecting your projects to always be right the first time, approach them as a series of experiments to figure out how to make the best possible improvements to the museum: some will succeed, some will fail, and that's the cost of doing business if you want breakthroughs in museum practice that make your institution a beloved part of its community.

Lastly, Tharp also reminds us that there are many ways to fail, including failure of nerve and failure from repetition. In other words, sometimes playing it safe, particularly when you play it safe for years, becomes a form of failing yourself. Indeed, museums that play it safe for years can fail their communities. So if failure is in so many ways inevitable, which kind of failure will you choose? The kind that eventually leads to growth and creative success, or the kind that comes from not trying at all?

Try This:
Document—and Share— Your Creative Process

In the old days, a logbook was a place for sailors to keep track of how far they'd traveled, and that's exactly what you're doing—keeping track of how far your ship has sailed.

—Austin Kleon[31]

Documenting your creative process at every step is important for funders, employee reviews, measurement of project success, and to help your colleagues—at your museums and at other institutions—learn from your exploration. But most importantly, it helps you chart your own progress and figure out what is working and not working in your own creative practice. And it's so easy. Put a system in place for note-taking—as simple as stashing a small notebook in your pocket—in case something interesting occurs to you when you're not at work. Keep a camera around or use your Smartphone to take pictures of prototypes and visitor reactions. Share your process through your own or your organization's website, your Facebook page, your Twitter feed, and even the bulletin board in the staff break room. Invite staff members to comment on the process—and perhaps take inspiration from your work.

Ideas Need to Bump Up against Each Other All the Time

You generate more and better ideas when you regularly expose yourself to new information, and that new information often comes from your colleagues. Steven Johnson describes it this way: "You have half of an idea, somebody else has the other half, and if you're in the right environment, they turn into something larger than the sum of their parts."[32] Sometimes you share raw and seemingly irrelevant material in the form of what you have recently read or seen. Sometimes you have a discussion about a problem you have in common with someone else. But it is actually much more helpful when these bump-ups are random and informal than when they are governed by an agenda and a deadline. In other words, it is the brief side conversation at the beginning or end of the meeting that is more likely to lead to creative breakthroughs than the meeting itself. (This isn't to suggest that you should never schedule formal meetings; just meet for the right reasons and set the right agenda.)

Pixar supports this concept by locating all the workplace amenities—the bathrooms, the copy machine, the café—in one central place in the building so that everyone has to go there multiple times a day and they never know whom they'll run into. Museums are at a particular disadvantage here, because we end up working in such complicated buildings. We squirrel away individual departments in the basement and the attic, or even in separate sites altogether, such that we only see each other when we have an established agenda in mind. But once you know how important these informal exchanges are, you can actively work to increase your own interactions, regardless of your institution's limitations. We should be clear we're not interested in adding to the amount of complaint sessions, where co-workers get together to grumble about their jobs, their families, their lives. Instead, we are talking about information and idea exchange, where you regularly seek out your co-workers to talk about the new things you are learning, the approaches you are trying, or the challenges you are grappling with. Do you make time in your day to talk to your colleagues about what they're reading or working on? Do you ever go out for a drink or a bite to eat with your co-workers? What are you learning from them, and what are you sharing in return?

Sow Many Seeds of Good Ideas, or the Importance of Tinkering

Because the creative process doesn't adhere to a predictable timetable, you can't click your heels together three times while wishing for an idea and have the right one come to you. But if you put many ideas into development simultaneously, instead of just one or two, then you greatly increase the odds that something useful will regularly materialize that will solve real problems and help your institution grow. The worst that can happen is that you spend a little time prioritizing which ones to implement first. This is one of the reasons creativity is best approached as a practice, not a one-off.

Those awesome creative companies we mentioned earlier, IDEO and the like? They know that if you hire great workers and support and trust their individual creative practices, then your investment is sure to pay off, you just may not be able to predict exactly when and how. This is where the famous "15 percent rule," established by 3M and adapted by other companies like Google, comes into play. 3M employees are allowed to devote 15 percent of their staff time to tinkering with problems and ideas that interest them, regardless of whether they are part of the employee's work plan or the company's goals for that quarter. We have the 15 percent rule to thank for Post-it notes, for example.[33] In museum work you will probably find it hard to tinker a set number of hours every week, but can you make a little room for it here and there, in the dead of winter when visitation is low, during any other down time, or every now and then on a Friday afternoon? Can you start keeping a list of interesting avenues for exploration? Can you outsource your tinkering to interns, who are often less bound by time pressures? And can you start to recognize it as a valuable resource in your co-workers?

Try This:
Read about Creativity

We digested a lot of material on creativity in order to write this book. You don't need to do this reading yourself in order to work creatively at your museum. However, if creativity really gets you excited and you want to explore more deeply, here are five books and one blog that we feel would provide the most bang for your reading buck.

■ Twyla Tharp, *The Creative Habit.* This is the best book we have encountered for understanding how to develop your own individual creative practice. Tharp isn't interested in creative cultures; instead she addresses the lifelong, solitary pursuit of creativity by describing her own philosophy and experience as a choreographer and providing activities and instructions for developing yours. We recommend this book if you want to get your own house in order before you start working to build creative teams.

■ Scott Doorley and Scott Witthoft, *Make Space: How To Set the Stage for Creative Collaboration.* The premise of *Make Space* is that you need physical spaces designed and programmed for creativity—flexible, full of tools, conducive to collaboration—in order to maximize your creative output. Museums often operate in complicated buildings with lots of workspace baggage other fields don't have to deal with. Doorley and Witthoft made us realize we should all demand better of our physical environments instead of just making do.

- Steven Johnson, *Where Good Ideas Come From.* This is a great book for understanding where museums can fit into the broader picture of creativity in society at large.

- Tina Seelig, *inGenius: A Crash Course on Creativity.* Drawing from years of experience teaching creativity at Stanford University, Seelig outlines her method of creative practice, applicable to both individuals and teams. If you gravitate toward the Try This activities in this book, *inGenius* will further enhance your toolkit.

- Scott Belsky, *Making Ideas Happen.* If your challenge isn't coming up with ideas but with implementing them, then Belsky can help. He provides concrete suggestions to move from merely thinking about ideas to acting on them.

- *The Creativity Post* (www.creativitypost.com). This blog provides short but meaty bursts of theory and advice on creativity. The content is interdisciplinary—you will read about creativity as it relates to everything from cognitive psychology to educational policy to philosophy to business.

Happiness
lies in the joy of
achievement,
in the thrill of
creative
effort.

Franklin Delano
Roosevelt

Chapter

2 Building Creative Cultures

Our museums are exponentially stronger when there is a creative culture in place that supports each individual worker's creative practice and unites everyone toward a common purpose. Any museum is a complex organization with more moving parts—people, facilities, collections, audiences—than can be counted. Rarely is it a sleek racing machine, built all at once, but more likely a Rube Goldberg-ish contraption that has been assembled, in fits and starts, over the course of many years. A truly creative museum requires that all these moving parts work together, with each person aware of not only his or her own role but also of the entire machine.

In this chapter, we look at the creative functioning of three distinct parts of the machine: the board of directors, the executive director, and the staff (paid and volunteer). There are some specific suggestions tailored to each of these roles, but regardless of where you fit in the organizational structure, this is the one place in the book where it is important to digest the entire chapter instead of browsing selectively. In building a creative culture, everyone in the mix is a potential leader and change agent, no matter what your job title; it's just that your approach and techniques may vary a little depending on your role. You will contribute more effectively to institutional change if you understand how these roles work together, and the ways in which all of us, no matter where we work or volunteer in the museum (from the boardroom to the front desk) can move as one machine to carve out more room for creativity and to kick start the forward momentum. At chapter's end, you will find ideas for recruiting staff and volunteers to ensure that your creative culture continues to grow.

We define a creative museum culture as an approach to museum practice based on constant learning and collaboration, where information sharing, experimentation, trust, and creativity are expressed values. It is an environment with a bias towards action, where the staff not only generates new ideas but also follows through with implementing them, making the museum stronger. When thinking about institutional cultures, consider the direction of the culture (is it moving forward towards a creative mission?), the pervasiveness of the culture (is creativity embedded in only one department, or is it institution-wide?), and the strength of the culture (is it making a creative difference?).

A creative institutional culture makes a museum a great place to work—a place you are excited to go off to every day because you are learning new things, producing interesting and meaningful

results, and feeding off your colleagues' energy. A creative culture means that idea generation is democratized—it doesn't reside just with museum leaders or the designers or the education department. In such a culture nagging problems get solved through creative thinking, establishing a positive progress loop for everyone. A creative culture also means risk and uncertainty, but within a supportive environment and in the service of greater success. Developing a creative culture is not a one-size-fits-all process. Constant experimentation means different things for every organization. Each museum needs to find its own balance between risk and reward, between flexibility and structure, between idea generation and idea implementation. But the important thing is to start that experimentation today, to take a step forward, no matter how small.

Leading from the Boardroom

In the United States, a large majority of museums are independent, non-profit organizations governed by a volunteer board of directors. When we informally surveyed our colleagues at the beginning of this project, a significant number reported that the governing board of their museum was a barrier to creativity. We heard statements like "there's an old guard of trustees," "there's too little input and support from the board," and "the board is very risk-averse." Because non-profit boards have a very real, legal responsibility to protect the interests and assets of the museum, the system is constructed to make them cautious and conservative. But these complex times—when society is changing all around us and museums are forced to do more and more with less and less—call for a shift in approach, for courageous board leadership that embraces the value of experimenting with new strategies as a vital part of museum work. Creative board members of organizations large and small can encourage their peers, their fellow board members, in this regard.

Some calculated risks—and not even necessarily financial ones but more likely risks in approach or risks in process—are necessary to move museums to a more central position in their communities. Taking those risks will not only yield tremendous benefit to your institution over the long run, it will also lead to exponentially more meaningful board service and a more committed, engaged board. In researching this book we heard from colleagues who were concerned that, particularly at

large museums with elite boards, expecting trustees to participate in the museum's creative process was disrespectful of their standing, that powerful people don't have time for creativity. But such a mindset is based on the myth that the world breaks down into creatives and non-creatives. In fact, some of the most powerful people in the world—CEOs, government leaders—will now tell you that creativity is essential to effective leadership. Board members deserve the self-actualization that comes from creative growth just as much as anyone else, and opportunities for it just may be one of the most valuable things a board member receives in exchange for his or her volunteer service.

The most important role of board members is to ensure the institutional health of a museum—ensuring that it prospers, not stagnates. A creative museum culture is an insurance policy against stagnation. The board can—and should—set a tone that encourages creativity and risk-taking.

Your Creative Practice

Look Outside

At our volunteer-led museum, I personally see our more creative ideas coming from outside the board. Recently, two young talented people from outside our area gathered history and community stories about our small town, wrote a play, and got residents from the town to participate. The cast of "Granite Falls, a Meandering River Walk" included everyone who wanted to participate. It took a new organization, PlaceBase Productions, with staff Ashley Hanson and Andrew Gaylord, to help show a new way to appreciate our amazing history. The play turned out wonderfully and led to a Paddling Theater that unfolded in different locations along the Minnesota River, with the audience in canoes. This project set our standards higher for the historical society's walking tours and programming and showed us what is possible in portraying history.

Mary Gillespie, Board Member, Granite Falls Historical Society and
Andrew J. Volstead House Museum, Granite Falls, Minnesota

And because there is such a strong perception—real or imagined—that the board's job is to protect the institution from new ideas, this tone must become a part of the board's regular practice, not just be cursorily mentioned at a retreat. How can the board set this tone?

Recruit Creative Board Members

All kinds of people can share their strategies and expertise in encouraging a creative culture. Musicians, small business owners, storytellers, engineers, designers—people who have developed strong creative practices of their own—can model creative leadership to other board members. Make sure such people are represented on your board; you might consider developing a rubric to help you gauge and diversify the skillsets your board members bring to the table—not just accounting, law, or fundraising, but also curiosity and creative practice.

Incorporate Creative Practice and Conversation into Board Activities

This is about walking the walk, not just talking the talk. If your board is primarily a rubber-stamping and reporting venue, then experiment with creating an environment that is more than business as usual, with the ultimate goal of developing more meaningful and engaged board participation. Reframe the roles and responsibilities of board members. Introduce prototyping into board committee work. Consider Howard Gardner's research on multiple intelligences in developing the financial report. Put art supplies out on the table and see what happens. Organize your meeting agenda by goals in your strategic plan rather than committee reports. Or try meeting in a different space—in a gallery, an education room, or even in a different museum or out in the community. Encourage divergent thinking instead of one conventional answer by asking why: Why do we do things this way? Why does our mission privilege preservation over access? Why do we continue to do this program that consumes time and resources for the same small group of participants over and over? Why doesn't our board represent the diversity of our community? At the Santa Cruz Museum of Art and History board meetings, committee reports are brief. Instead, board members are each invited to share a MOM (My Own Museum) moment to spark discussion, and a significant chunk of each meeting is focused on a single key issue, in workshop format rather than report format.

Your Creative Practice

Start with the Art

Both the staffs and boards of art museums face a challenge: Regardless of our daily administrative burdens and concerns, we must always remember to start with the art. We must never forget to ask ourselves: Why do we work for the art? How does the art inform both our professional rigor and passions? How does the art inspire our voice, and how can we deliver this voice intact, in spite of the obstacles that often arise in a museum setting?

My solution is simple. For nearly thirty years I have convened all my board and staff meetings by gathering in front of a work of art. I have found that these encounters are critical for framing productive meetings with excellent attendance, deeper bonds, and active participation.

The best practices manual for such meetings might read like this:

- List the work of art as the first item on the agenda, and convene the meeting in the gallery. To build bonds of playful and authentic inquiry, allow fifteen to twenty minutes for participants to share perceptions, experiences, and research.

- Audience comfort is essential. Lead the conversation, yet make it obvious that this is not a lecture, not a forum where the expert is in control. It should feel more like experimentation, almost even like play.

- To encourage broad participation, invite staff from across all museum domains. Make sure they feel on equal footing.

- Be an active listener. Reward participation—support those who take artistic or personal risks in the discussion. Also respect stretches of silence.

■ Know when to stop. When a busy agenda awaits, make sure to keep competing commitments in perspective.

To present and preserve art, we must connect ourselves, our colleagues, and our audiences to the objects we steward. When we are in charge of devising transformative experiences for others, we cannot ever risk setting aside our own agency and curiosity.

Why start with art? Because experience sticks, and experience engages. If you always begin with the art, then you will begin to build an ongoing communal investigation, a shared inquiry that will enrich all other museum efforts—research, analysis, design, and curation, as well as public education and outreach.

For the dedicated, knowledgeable, and overworked staff member, this gallery exchange allows a step back from deadlines and pressure. Then the staff, too, can take a moment to inhale the atmosphere our visitors so enjoy—the pervasive air of creative expression. Likewise, board members often tell me that these shared gallery moments create an ongoing appetite for art in their lives, as well as increased loyalty to the museum. For a museum director, these engagements help develop long-term relationships whose currency is conversation about art and ideas.

No one, not even the staff or the board, comes to a museum primarily for small talk or administrative details. Starting with art ultimately helps develop our capacity to experience—and share—an imaginative and reflective self, and it acknowledges that we all come to art in search of meaning, understanding, revelation, wonder, and delight.

Saralyn Reece Hardy, Director,
Spencer Museum of Art, University of Kansas, Lawrence, Kansas

Encourage Efforts to Create a Learning Culture

Protect the museum's professional development budget. Suggest a staff sabbatical policy. Have some frank but friendly conversations about failures and what the museum is learning from them—not to scrutinize performance but to encourage growth. Extend this learning culture to the board itself. In a *NonProfit Quarterly* article titled "Problem Boards or Board Problem?" William Ryan, Richard Chait, and Barbara Taylor liken the work of boards to the work of firefighters—occasionally they are called upon to fight fires (that is, hire directors or vote on a merger), but they actually spend most of their time preparing and training so they are ready when those fires happen:

> In lieu of formal board training events at long intervals, boards could construe learning about their communities or constituencies as vital, continuous preparation for governing. Instead of merely recruiting members who appear to be well informed, organizations could use their meetings to promote learning by all board members. Board members could construct and pursue a learning agenda through fieldwork, meetings with other boards, or extended interaction with constituents.[1]

What should your board be learning, and how can it help the museum staff learn, too?

Recognize the Creative Efforts of Staff Members

Ask individual staff members to report periodically to the board on their creative work. Set a small prize for the most creative idea of the year and recognize the winner at a board meeting. Notice and celebrate creative changes throughout the institution. Make it clear that the board appreciates the shift to a more creative culture.

Incorporate Creativity into the Strategic Planning Process

This may be the board's most important creative contribution. Indeed, a thoughtful strategic planning effort mirrors the creative process: intense information-gathering to fully understand both internal and external issues and define the museum's challenges, incubation in various forms, generation of solutions and strategies to propel the museum forward, followed by continuous

evaluation and implementation of those strategies. It's a changing world of strategic plans, with some planning experts suggesting that today's pace of change means those five-year plans are an outdated concept. A creative planning process can help ensure that the plan doesn't just reside in a drawer but is a living, flexible framework for experimentation and growth.

The strategic planning team itself should be composed of people from within and outside the museum, with varied expertise and skillsets. You may find that considering a strategic plan for a creative museum involves concepts not usually associated with the board room, like deep observation (Where can we go to understand more fully what our community looks like and what it needs?), narrative and metaphor (What is the story of our museum? If it were an animal what animal would it be?), or reframing (How can we transform our barriers into creative constraints?). Whatever form the strategic planning process takes, it should shape a creative vision and provide a creative staff with the tools to make it happen.

Hire an Executive Director Who Values Creativity

A key task of a board of directors is to hire the executive director. When a search committee undertakes this process, creativity should be a critical part of the conversation. To find a candidate ready to nurture and lead a creative culture, credentials and connections are only the starting point. See the Recruiting for Creativity section at the end of this chapter for more on this issue.

Leading as a Director

The executive director may be the most important element in a creative culture. It is clear that it is infinitely easier to develop a creative museum when the executive director is instigating and encouraging the effort. From our discussions with museum workers across the field we found that they look to the director of their institution to model creative practice, to encourage ideas from every part of the museum, and to build an environment that supports creativity on a daily basis. Moreover, when we ran our Try This activities by a group of twenty colleagues for their feedback, many said they were excited about the individual ones but worried that they did not have the buy-in

for the institutional activities; on the most basic level museum workers simply need their executive director to give them permission—to say out loud that it is okay to bring creativity over the threshold and into the workplace. When directors address the creative needs of their institution it can open up room for greater individual satisfaction and breed tremendous loyalty. When directors routinely dismiss creativity out of hand, set up roadblocks, are reluctant to experiment, or are only interested in the ideas of a few people, workers get frustrated and motivation suffers.

We will not pretend that leading is an easy job. Go into any bookstore and there are rows and rows of books about leadership. There are laws of leadership, levels of leadership, coaches and politicians who tell you how to lead, books that teach you how to become a better leader in thirty days, or even leadership lessons to be learned from the Bible. These rows and rows are a testament to how challenging leadership is on any level, in any organization, creative or no. Meanwhile, museums are increasingly complex entities, pulled between the needs for community engagement, income generation, collections preservation, facilities maintenance, and more. To many directors, it will probably feel like the pursuit of a more creative museum introduces one more complex pressure into the equation, one more expectation to pile on an already stressed and overworked team leader. But take it from one creative director, Stuart Chase at HistoryMiami, who told us, "It is work. But the energy I invest in creativity results in a much higher return on investment than anything else I do."[2] Nina Simon, director of the Santa Cruz Museum of Art and History, put it a slightly different way: "Leaders absolutely need a vision and creative spark, and they need to bring energy every day." To her creativity is a constantly renewable resource, like solar or wind power, that generates the energy to lead. And the one way that resource can be restocked on a regular basis is "to create the conditions that allow you to be creative."[3]

As a director, the staff and board need you to invest in creativity. You are the lynchpin; they cannot maximize the creative potential of the museum without you. But it doesn't stop there—your community needs you to as well. The benefit to the public is exponentially greater if your museum is thriving creatively instead of inching along the way it has always done things. Above and beyond these reasons, there are plenty that are less about service or doing the right thing and more about direct benefit to leaders. Creativity helps find solutions to problems more effectively. Creativity can

Try This:
Energy Meter

Look at your current projects, as an organization, department, or individual, and place them on this energy meter, adapted from Scott Belsky's book, *Making Ideas Happen*. Place projects that take the most energy (mental, physical, time) in the Extreme category, and then move across the meter, placing projects appropriately, all the way to Idle, where work is on the backburner (this might be because a grant has just been written and submitted or it might be because it's an idea that simply has gone no further).

Projects	Extreme	High	Low	Idle
Project 1				
Project 2				
Project 3				

Now look at the chart. Are you spending your energy in creative ways that build forward momentum, or are you spending large amounts of energy on repetitive tasks that at the end of the day leave your institution in

the same shape it was in the day before? (In other words, to use a house-keeping analogy, are you spending your time doing the dishes over and over instead of rearranging the kitchen drawers to make doing the dishes quicker and easier?)

Is your meter filled with what Belsky calls "insecurity work" (like looking repeatedly at website analytics, or creating spreadsheet after spreadsheet, the work that makes us feel like we're working but that is actually just security blankets when we are afraid to move forward)? All those reports have a place (like, for instance, on the Indianapolis Museum of Art's online Dashboard), but the production of them is not our main work.

Try the chart again, this time placing projects where you think they should be in order to truly reflect your museum's priorities and create forward momentum. How can you shift your day-to-day work to reflect the new version of the chart? Try this with colleagues to see where differences in opinion surface, and then have a thoughtful conversation about those differences and the reasons for them. Ask others for suggestions on how to shift the balance.

also transform a museum and make it a magnet for visitors, volunteers, members, job candidates, and funders so it is easier to bring in the resources needed. And a creative culture doesn't just make rank and file workers feel good; it can make a chief executive feel good, too. You probably entered this field because you believed in curiosity and lifelong learning—most of us did. It can be difficult to hold onto that glow after years in the trenches. A creative culture can help all of us get back to a place where museum work means learning, growth, and looking forward to something new every day.

How exactly do you pull off this incredibly difficult but extremely important and rewarding challenge? John Maeda, the president of Rhode Island School of Design, has outlined one short-and-sweet model for comparing the qualities of a creative leader and those of a traditional leader:

Creative Leader	Traditional Leader
Interactive	One way
Concern with being real	Concern with being right
Improvises when appropriate	Follows the manual
Loves to learn from mistakes	Loves to avoid mistakes
Validity	Reliability
Jazz ensemble	Orchestra model
Community in conversation	Community in harmony
Hopes to be right	Wants to be right
Open to unlimited critiques	Open to limited feedback
Taking risks	Sustaining order
Open system	Closed system[4]

Your Creative Practice

Inspiration from Details

Very often I find inspiration in tiny details, which could hardly be noticed from the first impression. This could be compared with academic drawings of the late nineteenth century, when artists were trained to make drawings beginning from the tiny secondary detail. In 2010 I curated an exhibition on fairy tales at the Kyiv National Museum of Russian Art. The exhibition, with more than 200 objects, the catalog, and all the programming were made possible by a poetic impression of a subtle detail—I was struck by a small saucer from the Dmitrovsky porcelain factory depicting a scene from "A Tale of Tsar Saltan" by A. Pushkin. I'd been observing this piece in my museum collection every day, but when I stopped seeing the collection out of habit and looked again at details, it gave me a new inspiration, quite different from previous experiences. Thus, a small saucer became a source of inspiration for two years of research and an impulse for a big exhibition that integrated the collections from a number of museums and drew new audiences to our museum. Creative practices appear when you give yourself the opportunity to close your eyes, and afterwards open them as for the first time, observing the world anew.

Tatiana Kochubinska, curator and educator, Kyiv, Ukraine

If you are a director, take a moment and consider Maeda's chart. Where do you fall? Where would your staff and your board place you? And how can you think about making changes? Here are strategies for making that change, and it is important to point out that most of them don't just apply to executive directors. Many museum workers manage other people—other staff members, volunteers, interns—and therefore are also in a position to make decisions and give permission for creative change.

Model Your Own Creative Practice but Also Value Ideas from Everywhere, Not Just the Top

If you are experimenting, taking risks, and setting aside time for learning and inspiration, it is much more likely that the rest of your staff will, too. On the other hand, we heard from more than one person about the potential for creative leaders to overshadow and stifle the creative potential of their staff. Your role as a leader is not to generate all the ideas, but to, as Tim Brown puts it, pick up your gardening tools and "tend, prune, and harvest" the ideas that surface all over your institution.[5] So model your own individual practice—but leave plenty of room for everyone else on your staff when it comes to creating together.

Facilitate Open Communication and Broad Sharing of Information

Creativity needs a steady stream of information to thrive, and all of us can contribute to it. Not trickles of information and not backwater, but babbling brooks with shallow, sandy banks for easy wading. As a creative leader, one of your key roles is to break down silos, put lots and lots of documents and data in shared places, increase transparency, and make sure that your colleagues talk with each other often and deeply.

Invest in Your Staff by Growing Their Creative Potential

Try adding a professional development component to the employee review process to help plan opportunities for each staff member to increase his or her knowledge, learn new skills, and grow his or her network. Pay attention to challenge when assigning projects and responsibilities—creative

Understanding the Financial Puzzle

Like every other museum, ours has experienced tight budgets these last years. We discovered it was a challenge for staff members to understand the why of budget decisions the leadership team made. Working together, we tried several different ways to increase transparency and financial understanding amongst the museum's entire staff, not just top management or the accounting department. Our experiments included:

- The Price is Right: To understand the cost of doing business, we created a game show for a staff meeting loosely based on "The Price is Right," where contestants have to guess the price of items such as radio spots, newspaper ads, or electricity for one week, in direct response to concerns about programs not being promoted enough.

- Reality Teams: To bolster staff buy-in for a program winnowing process, we formed two inter-divisional teams. Both were given "balanced scorecard worksheets" and three years of budget numbers for ten programs. Team members awarded points for criteria such as: institutional mission, sponsorship dollars, earned revenue (tickets, food), and attendance. They noted trends over time, ranked each program by score, and recommended "expand," "continue," or "discontinue." The teams met to reach consensus about recommendations to the executive leadership team. Some heated discussions transpired—particularly around favorite programs—but conversations opened eyes about institutional investment of time and

support. Finally, the team spokespersons presented their methods and findings at a staff meeting.

■ Influencers: Museum finances are not intuitive, and we needed to explain the framework and rules before explaining the budget crisis. We hoped this would create better understanding of financial terms and approaches. Small meetings were arranged with key "influencers" (no more than four or five at a time) in each department where basic financial concepts—capital and operating funds, sources of revenue, and the like—were explained. These influencers were asked to share these conversations with other staff members. The process also included staff-wide meetings where all could ask questions.

No one method worked perfectly, but we continue to refine and experiment with ways of sharing information with our staff.

Ellen Rosenthal, President and CEO,
Conner Prairie Interactive History Park, Fishers, Indiana

workers need the right amount of challenge (not too little and not too much) and also the right kind (matched to employee abilities). Encourage colleagues to experiment with the Try This activities in this book, either in small groups or as an entire staff. Cross-pollinate staff by putting teams together in different configurations. Approve regular tinkering time or sabbaticals (your first instinct might be to say that the under-resourced nature of our field leaves no wiggle room for such self-directed exploration for the sake of exploration, but the under-resourced nature of our field is exactly the reason we need to invest in better ideas).

Help Your Staff Make Steady Progress

In *The Progress Principle*, Teresa Amabile and Steven Kramer outline the results of a multi-year study that analyzed 12,000 daily journal entries logged by workers in twenty-six project teams in seven different companies. This study found that the most important thing a leader must do in order to motivate employees, not only for creativity but also productivity, commitment, and collegiality, is to facilitate their day-to-day progress in meaningful work—not only ensuring that they have the resources, assistance, and encouragement they need to move forward, but also reducing obstacles and distractions that stand in their way, like hierarchy, bureaucracy, territoriality, and toxic situations with co-workers. If workers experience small wins in their projects on a regular basis, it creates a positive progress loop that builds momentum for themselves and for the organization.[6] Therefore, one of the most important questions a director can ask in leading for creativity is: How can I facilitate progress for my staff today? (Let's be clear: not How can I monitor or micromanage their progress, but How can I provide the tools and environment for them to succeed and then get out of the way?) If you are a staff member managing volunteers, or a volunteer managing volunteers (such as a committee), the same charge holds true.

Provide a Mix of Constraints and Freedom

In order to be creative we all need both constraints and freedom. Working with the board, set a clear vision for the institution, and then develop clear goals for each employee. Give them a lot of day-to-day autonomy over how those goals will be achieved. Indeed, vision is the grandmother of all creative constraints. It frames and focuses workers' search for ideas so they don't cast about

Try This:
Appreciation-based Exchange

How often have you brought an idea to a meeting and had people say, "yes, but . . ." and proceed to overlook the good parts of the idea and focus on the areas that still need work? In *Making Ideas Happen* Scott Belsky recounts his "Adventure in Appreciations" in Jay O'Callahan's storytelling workshop. Adopting O'Callahan's appreciation process can make everyone's creative ideas better, without that sinking feeling that comes from having ideas picked apart by museum leaders or colleagues. Here's how it works: an idea (or a story, or an exhibition concept, for instance) is shared, and each participant is asked to comment on the parts of the idea that they most appreciated. Then the idea generator goes back and rethinks the project based on the appreciations, rather than negative feedback. According to Belsky, the underlying assumption is that "a creative craft is made extraordinary through developing your strengths rather than obsessing over your weaknesses."[7] As a result of the appreciation and resulting revisions, weaknesses begin to lessen and strengths become more prominent. Evaluation, feedback, and failure are a necessary part of every effort, but it's worth trying this approach to make it all more constructive.

relentlessly in all directions in their quest to benefit the institution, and also gives them a rubric for evaluating whether an idea is truly useful to the museum. An annual work plan or a departmental goal functions in the same way but on a smaller scale. (See p. 52 for more on constraints.) Meanwhile, everyday freedom makes room for experimentation and improvisation, and gives employees flexibility to practice the creative process however it is most productive for them: the destination is clear, and there may be a few basic directions, but they chart their own creative path and have autonomy over the daily details. This mix of constraints and freedom applies equally to project planning, team collaboration, or improving physical spaces in the museum. Interestingly enough, it also applies to time and resources. If workers have all the time in the world to finish a project, they lose focus, but if they work overtime for months to meet an immovable deadline, they burn out. If they have all the money in the world for a project, they don't spend it creatively, but if there is absolutely no flexibility in the budget, then great projects cannot move forward. As a leader, make sure the goals and basic operating instructions are clearly defined, but then get out of the way for day-to-day work.

"Reward Success and Failure, Punish Inaction."

This quote comes from Robert Sutton, an organizational psychologist who teaches management at Stanford University. He stresses that it is impossible to come up with any great ideas unless you try a bunch of bad ones along the way.[8] Leading for creativity means making sufficient space for museum staff to freely and widely explore, test, and refine ideas, and to try again if an idea doesn't work the first time, all with a bias toward action. As Sarah Schultz from the Walker Art Center emphasized to us, a good manager knows when to step back and let someone safely make a mistake or even fail so he or she can learn from experience.[9] This does not mean that it's okay for your museum's registrar to gamble away the collection, mind you, but it does mean creating an environment where small or even medium-sized losses are expected and encouraged—and budgeted for—not only by you but also by everyone else. You could try instituting a badge of honor for people who fail and learn from it, praising employees who quickly bring bad news to your attention, talking openly about your own failures, and emphasizing actions taken and lessons learned in staff meetings and performance reviews.

Set a Different Expectation with the Outside World

Building a creative culture is not something a museum director should do in secret, behind closed doors. Transparency helps everyone understand the process and get on board. As the most prominent public face of the institution, part of a director's job is to share the museum's creative practice with partners, funders, and the community. With partners this might mean setting an expectation of experimentation when you embark on a new collaboration. With funders it might mean adopting a questioning approach: "We're exploring whether our family programs might be more effective if we incorporate immersive theater, and we need funds to test our ideas." With your community it may mean inviting them to help you generate and try out new methods.

Leading from Anywhere and Everywhere in the Museum

Developing a creative culture is not only the responsibility of leadership at the very top. All of us—staff and volunteers—have important roles to play in nurturing creativity at our museums. A number of colleagues expressed concern to us that they didn't have enough power to bring about creative change at their institution. But every person with a creative practice leaves a mark on his or her museum culture. It is rarely the case that your colleagues are actually anti-creativity; they just may not understand how creative practice works or how it can benefit them. So quietly and humbly make your own practice transparent. Show—don't tell—your coworkers how to find inspiration and how to generate and implement ideas, and then share the credit whenever those ideas help the institution move forward. Whatever you do, don't succumb to what museum consultant Kathleen McLean told us she observes getting in the way of creative practice at museums large and small: self-censorship.[10] Don't assume your colleagues aren't interested or will disapprove and then use that as an excuse to give up without even trying. Start a few creative experiments in the spaces and processes within your control, no matter how small, and then start a few more.

Indeed, building a creative culture is most likely to involve a series of small changes—some of them perhaps even barely perceptible—until you eventually reach a tipping point where creative

thinking becomes the new normal for everyone at your institution. Even if it is a long road we believe creative practice is a better road, and that each passing step will get easier and easier as you build positive momentum. This process is continual; you don't wake up one morning and find that you are finished. But along the way, you and your colleagues may find a more fulfilling work life, and for each of your museums you'll strengthen the opportunity to unleash the creative power of your community using your own unique collections and capacities.

Practice, Practice, Practice

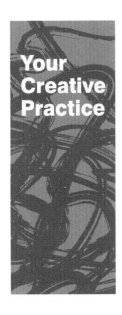

Your
Creative
Practice

In the Mood

At the start of a new exhibition project, we create a "mood board." When we all shared a workspace this was a physical bulletin board, but now that we work independently we use a virtual version like Pinterest. Anyone on the team is free to post inspiration—words, images, color and/or texture samples, sample artifacts, sound bites, anything at all. Almost always the most useful ideas come from places/things that have nothing to do with museum exhibitions: a restaurant interior, a package design, an experimental opera, and so forth. Over time, we edit the board. Ideas are thrown out and new ones are added. Themes and an overall tone emerge. We try to keep things ambiguous, and not to push for a solution for as long as possible.

Jane Severs, Interpretive Planner, St. John's, Newfoundland, Canada

It will be easier for you to advocate for a creative culture if you understand creativity on a personal level. Read the first chapter of this book to develop your own creative practice, and use it as a well to draw from in leading and working with your colleagues. We are confident that every day, no matter where you work in the museum, you will encounter at least five issues that could benefit from your creative problem solving skills. When you yourself are working creatively, you increase your job satisfaction and your level of personal growth, regardless of how creative your museum's culture is. Moreover, a creative practice can help you become better at your job, which over time might give you more clout to improve the overall creative climate.

Expand Information Intake for Everyone

Spreading interesting information is such an easy way to boost the creative capacity at your museum, and if your co-workers are tentative about creativity they don't even have to know that's why you're doing it. Circulate interesting articles from a variety of fields. Offer to give mini-workshops. Invite people to join you for after-work lectures. Watch TED Talks together at lunch. Make a habit of changing the topic of conversation at the water cooler from gossip to what you just finished reading.

Find the Bright Spots and Replicate Them

In their book *Switch*, Chip and Dan Heath acknowledge how hard it is to make major changes like overhauling an entire institutional culture. Instead of getting deflated by all the enormous problems and how much effort it will take to solve them, the Heaths encourage change-makers to search out the "bright spots"—small moments that *are* working the way you want them to—and then find ways to scale or replicate them.[11] Look for a particular department or project within your museum that, despite the lack of a creative institutional culture, is managing to solve problems and produce creative work. Take time to puzzle out what is making them succeed—is it their space, their meeting system, the management style?—and how you can spread those practices to other parts of the museum.

Your Creative Practice

From Idea to Buy-in

As part of a three-year, grant-funded project team whose purpose was to create a more immersive experience for visitors at the Atlanta History Center, I had a great deal of freedom in my work. Our team created specific goals for ourselves, but we were given significant independence within the institution. Although freedom can be exhilarating, it can also be daunting. I needed to trust in my own creative process, which sometimes takes me down unorthodox paths, to keep me focused and moving forward.

I was responsible for creating new school programs, and I looked for inspiration everywhere, trying to find kernels of human connection and universality that would draw students into the material and help them build empathy for people from other time periods and situations. Sometimes inspiration came from the historical material itself, sometimes it came from my coworkers, and sometimes it came from the world outside the museum. For example, watching a counselor engage our museum summer campers in a communal version of the classic role-playing video game The Oregon Trail gave me an idea for a Civil War simulation of the experience of common soldiers, with different outcomes for each participant. And observing my partner's reaction while watching the Civil Rights Movement documentary *Eyes on the Prize* for the first time led to a program with the theme "Do you have what it takes to be a Freedom Fighter?"

Whatever the inspiration, my ideas weren't sustainable until they were embraced by the entire institution—the museum leadership, the school group tour guides, everyone. At the beginning of each project, it was sometimes hard for my coworkers to envision where I was going with these ideas when I described them on paper or in meetings. But once they had an opportunity to see them in action and to watch

how engaged the students were, they almost always responded with enthusiasm. I learned that prototyping with a few sample school groups helped build institutional buy-in.

Andrea Childress, Education Specialist,
Atlanta History Center, Atlanta, Georgia

Make an Idea File

Abraham Lincoln's idea file was his top hat, where he kept some of his papers and important notes. Here at President Lincoln's Cottage, we have our own version of an idea file: a project planning idea spreadsheet, adapted from one first developed by our colleague Sandra Smith when she worked at sister National Trust site Villa Finale. The spreadsheet questions (How does this idea relate to our mission? How will we evaluate its success? What will it cost? What kind of staffing would we need?) prompt us to document useful information about each new idea. Then all the spreadsheets are saved in one place, regardless of whether an idea is actually implemented, so they can be mined later as needed. The system that works for the Cottage may not work for every institution, but the good news is that idea files are incredibly scalable: a small museum may only need a simple Word document saved on a networked drive, while a large museum could develop an online wiki for use by all staff.

Erin Carlson Mast, Executive Director, and
Callie Hawkins, Associate Director for Programs,
 President Lincoln's Cottage, National Trust for Historic Preservation,
 Washington, DC

Your Creative Practice

Look Widely and Share

Since the work of the Lemelson Center is all about invention and innovation, I think about this topic a lot. To me, it's not just about creative output (or work product), but being creative and innovative in the way I approach my work ("living the mission," as we like to say). Lately, I find myself looking for inspiration and new ideas most frequently outside of the museum field. I regularly read *Inc. Magazine*, follow innovation-related Twitter accounts, and search for articles, reports, and other materials that show how businesses and non-profits (other than museums) are employing innovative strategies and methods to fulfill their missions. I'm interested not just in innovation and creativity related to educational program and product development (my key work area), but also in hiring and managing staff, resource allocation, strategic planning, brand development, and smart and strategic program development.

When thinking about exhibitions, I look to non-museum entities who know how to get people into, through, and out of a space, and that do a great job sending important cues/messages to their customers graphically and visually instead of using the written word. (Think places like retailers, restaurants, and theme parks.) For hands-on education programs (my niche), I look a lot to groups who are doing great work digitally—on websites, through apps, or using other new technologies—and think about how to take what's good and cool and educationally effective about them and translate them into in-person, hands-on experiences.

I try to share what I learn from these non-museum sources with my colleagues so that we can collectively think about how to apply these

lessons and ideas to our various projects and programs. Sometimes I simply forward a link to an article or tweet, and when appropriate, bring these ideas up in meetings and discussions. I'm lucky to be involved in a group called the Smithsonian Institution Learning Advocates Group (SILAG), which is made up of educators and others around the Institution who are interested in discussing ways to convey messages to our visitors through programs, exhibitions, websites, and other means. This group has been a great venue for sharing—and learning about—innovative and "non-industry" ways to educate and inform our audiences.

Tricia Edwards, Education Specialist,
Lemelson Center for the Study of Innovation and Invention,
National Museum of American History, Smithsonian Institution,
Washington, DC

Your Creative Practice

Get Out!

There are times in a creative team when thoughts and ideas don't flow anymore. You can discuss for hours and nothing new comes up. You can stay up for long hours in the evening, it just doesn't get any better. You begin to criticize one another instead of letting ideas flow. That's the time to call it a day.

Even if it's in the middle of the day: call your team together and let everyone drop the mouse, hammer, pencil, whatever. Important: Nobody leaves the team. Rally your team and go to the closest restaurant or cafe, given the time of day. There's only one rule: don't talk about the project or work in general. This might lead in the beginning to silence, because no one is accustomed to it. But then, slowly, people will start to talk. About their children, pets, school days, sports, all things "allowed." They will tell stories. They will laugh. The benefit: people will know and understand each other better. They will find similarities they haven't realized before. Shared interests. Other ways of thinking. Other lifestyles. Stay as long as it takes (especially as the project leader, others may leave early because of family duties and so on) and listen, listen well. It's important not to go back to work on that day (no, not even the project leader!). But on the next day you'll realize that all are empowered by a new spirit. You will find new ideas, ways you haven't thought of before. But it needed this harsh break for a new beginning.

Angela Kipp, Collections Manager,
TECHNOSEUM, Mannheim, Germany

Identify Like-minded Co-workers and Band Together

If you can't build a creative institutional culture at your museum, build a creative subculture instead. Find a space to talk about creativity where you don't feel judged by other co-workers, and then build toward some joint experimental projects. Support each other's efforts to strengthen expertise and develop new skills. Remain understated but open about your efforts—you're not trying to create a secret, exclusive club of people who are better than everyone else; you are simply seeking a safe environment for exploration that may be considered outside the norm at your institution. Recruit others to your group, one by one.

Your Creative Practice

Ignore the Hierarchy

Everybody has creativity, but for it to come out the right circumstances are needed. Our exhibition team consists of people from different departments of the museum. I think our biggest source of creativity is non-hierarchical teamwork and an atmosphere that encourages participants to tell their opinions. We are all equal and everyone's opinion is important. Anybody can propose new ideas. We have decided that there are no stupid ideas, only ideas that guide us and help us find a direction. Directors' opinions are not honored more than trainees' opinions. Of course we have to make decisions, and it is the project manager's duty to decide which is the final solution.

Tomi Heikkilä, Exhibition Manager,
Espoo City Museum, Espoo, Finland

Question Rules and Reframe Problems (Some of the Time)

If your team is stuck in a rut or dealing with a particularly vexing issue, look at your work from a different perspective by challenging conventional wisdom and encouraging divergent thinking. Recast problems or barriers as creative constraints. Ask what if—What if we changed our opening hours? What if the annual appeal doesn't have to take the form of a letter mailed to every household on our list? Be careful to target these conversations and have them only where they make sense—during project planning or perhaps as food for thought at the start of staff meetings; if every time you talk with anyone you question another routine practice, you run the risk of being pegged as just a trouble-maker rather than a creative generator.

Help Your Institution Experience the Transformative Power of Small Creative Successes

Major institutional change can be very hard and scary. It rarely happens overnight, and in fact when it does, it can be traumatizing. But don't underestimate the capacity of small successes to gain powerful momentum—they can eliminate long-standing obstacles, gently remind people how good it feels to move forward, and prompt people to look for more opportunities for progress. Apply creative problem-solving to the tiny rocks in everyone's shoes, and then stand back and see what happens.

Cheerlead

It's important that everyone at your museum recognize that the creative process can be a struggle—it doesn't feel good at every step of the way. There will be points when a team is full of hope and optimism (usually at the beginning, and during prototyping when it feels like tangible progress is being made) but also points of frustration or even panic (when it is still unclear what the best idea is, or during implementation when there are setbacks but the deadline is mounting). Prepare for these moments, treat them as a healthy part of the creative process, and provide reassurance to help a team get through them. Indeed, cheer and support everyone through the lows and the highs, and reward creative efforts big and small. Encourage colleagues when they take a different approach,

Try This:
Strategically Throw Out the Rules

The museum field is intensely rule-driven. On one hand, some rules are necessary and, as we have discussed elsewhere, constraints can be extremely helpful. On the other hand, blindly following rules without regularly re-evaluating their usefulness can stifle creative growth. At the 2012 AAM conference, in a session titled "Beyond Brainstorming: Leadership Approaches for Innovation and Creativity," presenters Beth Tuttle, Paula Gangopadhyay, Olga Viso, and Martha Tilyard led the audience in a rule-breaking exercise. Small groups started by listing as many museum rules as possible, both written and unwritten (don't touch anything, no photography, no disruptive behavior, no food and drink, opening hours are 9:00 to 5:00, we can only present objects on-site in our own building, and so forth). Then each group chose one rule from the list and brainstormed how it could be broken strategically. One group explored the possibility of installing museum objects in grocery stores; another group considered adopting a "your hours, your space" policy to better accommodate both staff and visitor schedules. What rules are you and your museum colleagues holding tight to, and do you really need all of them? And if you're not in charge of the rules, take a step anyway. Lobby for change, one rule at a time.

Your Creative Practice

Welcoming Play into Our Process and Practice

To further explore experience-based learning, our education team turned to a neighboring organization, The Second City, to learn Improvisation for Creative Pedagogy. Second City instructors trained educators in the "theater game" technique created by Chicagoan Viola Spolin. In two workshops, the Second City staff introduced our museum team to this powerful approach. The improvisation games are designed to develop both individual and group skills in communication, "physicalization," narrative, empathy, and team building.

Letting down their guards and cheering one another on, team members participated in games that allowed us to explore new approaches to interpreting Chicago history. Team members assumed poses of a wheel, door, window, and passengers to physically construct together the museum's "L" Car No. 1. They debated contemporary issues such as housing and gentrification from the perspectives of a Gold Coast resident, realtor, and neighborhood activist. The team experienced a new approach that would later become an interpretive tool at one of our exhibition activity stations.

Lynn McRainey, Elizabeth F. Cheney Director of Education, Chicago History Museum, Chicago, Illinois

reframe a problem, or persist through many iterations; pitch in to help them prototype. A creative leader helps everyone understand that they're all in this together. A little humor never hurts—we have all had experiences that have been mitigated by someone else's ability to laugh with us at a frustrating situation.

Recruiting for Creativity

While it is true that anyone can be creative if he or she has the tools, environment, and motivation, finding excellent workers and volunteers who are already predisposed for creativity can be a tremendous boost to your institutional culture. Anyone responsible for recruitment and selection should strive to build a team of creative people with diverse backgrounds and expertise and make sure that they are all enthusiastic about the same goals, are willing to support each other, and respect what each team member brings to table. This is partly a chicken and egg issue: the more you walk the walk of creative practice, the more your museum becomes a magnet for the field's brightest creative lights—and vice versa.

Where to start? As with everything else that museums do, begin by looking for opportunities for creative reinvention of your recruitment process. Do the position descriptions need reworking—both in the words used and in the way core strengths and responsibilities are envisioned—to reflect your museum's commitment to creativity? We surveyed online position descriptions for a number of museums and found that even at institutions that have a reputation for creativity, the descriptions mostly stick to conventional language (although we did find a few bright spots—the San Francisco Children's Creativity Museum's recent job opening for a director of development included thoughtful descriptions of the museum's creative mission and the work culture, for example). How and where are openings—for staff and volunteers—advertised, and is the advertising yielding the quality of candidates you're looking for? Which staff members are you involving in your searches, and are you doing so because of their title and seniority or because they are the most appropriate individuals to help you spot great people? Are you thinking broadly about the fresh perspectives volunteers could bring to the table?

Try This:
Create a Success Wall or a Lessons Learned Wall (or Both)

In a virtual or real space, make a wall to celebrate the process of bringing creative ideas to completion. Make the idea process visible, posting drawings, notes, important themes, and more. Keep Post-it notes nearby so team members can share their insights on the entire work process. Update your wall regularly so everyone can revel in the glory of moving forward. And since creativity involves risk and failure, embrace the scarier side of the process with a lessons learned wall where everyone can share their fails and the takeaways from them, laugh together, and move on.

Your Creative Practice

Write the Opposition's Position Paper

There was a beautiful article, published in *Aeon Magazine* recently, on Sherlock Holmes and empathy. In it, author Maria Konnikova proposes that Holmes's success as a detective comes not from his cold rationality, but from his high empathy, from his ability to think himself into another's position and out of his own. She writes, "Empathy and creativity share an important, even essential feature: to be creative, just as to be empathetic, we must depart from our own point of view" (www.aeonmagazine.com/being-human/maria-konnikova-empathy-sherlock-holmes/).

Creative responses to problems often come from reframing the problem, from seeing it through new eyes. So next time you are stuck on a problem or cannot get a great idea passed by the people who need to approve it, try making their argument for them. Write their position paper, fight against the thing you believe in the most, and you will better understand why your proposal has been rejected.

I spend significant time in my personal and academic life trying to make the argument against my own, to try to learn the flaws and weaknesses in my own position. I also get valuable insight into how my opposition might think and feel about the actions I am proposing. This gives me greater depth and insight, helps me think with nuance, and gives me better understanding about what the people whose perspective is not aligned with mine might be concerned about. Ideally, I can then find new ways to alleviate that concern.

Suse Cairns, museumgeek blog, Australia

Once your museum has a strong recruitment system in place, here are some specific traits to screen for in getting to know prospective members of your museum's creative culture:

Expertise

Over and over again the creativity literature emphasizes that you cannot maximize your creative potential until you fully understand your domain (the body of knowledge you operate within, whether it's quantum physics, jazz, or museums). You must know the theories, methods, and ideas that are currently in place in your domain—what's been tried already—not only to generate new ideas but also to grasp which new ideas are most useful. On some level you might think our hiring methods already value expertise: it is common practice, all things being equal, to choose candidates with more years of museum experience, or a higher level of related professional training. But years of experience and museum degrees don't necessarily translate into expertise—a lot of workers spend a little effort at the beginning becoming adequate in their domain and then stop trying to improve. Moreover, expertise in museums might not always be the expertise you actually need. Creative workers go the extra mile to continuously and actively learn about their domain, to supplement the bare minimum knowledge they would pick up passively from five years on the job or a master's degree. They recognize that the nature of work is constantly changing and that the knowledge they acquired when they first started their career may now be woefully outdated. In hiring and volunteer recruitment, look for people who are working hard to fully develop their expertise—people who are keeping up with journals, blogs, and books; who regularly go to conferences; who network widely; who have seen behind the scenes at not just one but several different institutions. These are the people who bring a rich body of knowledge to the table. When you are filling entry-level positions, expertise may be harder to spot, but you can still look for signs of a self-learner—someone who understands how lessons learned in an entirely different type of position might apply to museum work, someone who sought out internships or part-time jobs or spent many hours on a special hobby, someone who is still tracking the new literature even though she earned her degree six months ago and no longer has to for class. When you are adding to your volunteer ranks, consider how expertise from other fields might be a boon to your creative culture.

Passion

Intrinsic motivation is an extremely important factor in workplace creativity. No amount of financial compensation, employee of the month programs, or other external rewards can match a strong inner drive fueled by four personal motivators: interest, enjoyment, satisfaction, and challenge. Intrinsically motivated employees keep working on and thinking about problems that need solving, not because they *get paid* to do so but because they want to do so. During the interview process, this intrinsic motivation manifests itself as passion for the work.[12] Look for people who demonstrate passion—quietly or effusively, who are deeply engaged in thinking about museums, who can articulate why the work is personally interesting and challenging to them.

For volunteers, because there's no paycheck involved, intrinsic motivation should be particularly easy to spot; if it's missing, there may be something wrong with the fit. Perhaps the motivation is for something that is not so easily discerned. Is the person volunteering to be a docent but the real passion shows when talking about order and organization? Perhaps he or she is better suited to be a collections volunteer. Some passions may even prompt you to think more broadly about what volunteers can do for you, filling needs you didn't even realize you had. A volunteer who is also a musician could provide concerts enhancing objects on exhibit, or a serious gamer could take a fresh look at your educational programming.

Curiosity

Creative people are inherently curious. They constantly seek out new inputs of information to serve as raw material for the idea collisions and combinations going on in their brains. You might try asking people what they are reading and learning about—both inside and outside the museum field—as a demonstration of curiosity. Or look for people who ask questions during the interview—who are deeply engaged in learning about your museum and how it works, regardless of whether or not you choose them.

T-Shaped People

The concept of "T-shaped" people is much discussed in business, technology, and design sectors. It refers to people who possess a depth of expertise (the vertical part of the T) combined with a breadth of knowledge, experience, or interests (the horizontal part of the T). The depth of expertise is a well that T-shaped people can continually draw from for ideas. The horizontal breadth serves different purposes, depending on whom you ask. Some models explain the horizontal as an ability to work across departments (not just collections management but fundraising, education, visitor services) and therefore generate ideas that are in sync with the big picture. Others emphasize that having broad interests and talents (hobbies, research areas, skill sets) means T-shaped people are well-positioned for the cross-pollination of information that yields creative insight.[13] Meanwhile, Tim Brown, CEO of IDEO and author of *Change by Design,* links breadth to empathy: an ability to understand other people's perspectives so much that you want to learn about their own domain makes you a great collaborator on interdisciplinary teams—you are just as interested in other people's ideas as your own.[14] What all these concepts of horizontal breadth have in common is sharing, seeking, and learning beyond narrowly defined roles—attributes which often show up in resumes but can also be probed for through questions about interests both in and outside of work. Don't underestimate the power of T-shaped people to reinvigorate your volunteer pool.

Previous Evidence of Creative Practice

The above attributes are indicators of people who are predisposed to creativity—who possess the raw materials even if they need a little development. But it is also helpful to identify people who already have a creative practice in place, whether they know to call it that or not—people who are used to idea generation, idea implementation, and creative problem solving from past experience. Some candidates' experience with creativity is evident—it is such a part of their identity that it surfaces in all the ways they present themselves. In other cases you may have to probe for it.

Try asking behavioral interview questions about past experience with creativity—questions like "Describe a time you had to think fast to come up with new ideas," "Describe an experience where you had to use new thinking to solve a long-standing problem," or "Tell me about the riskiest project

you've ever worked on." Recently, Linda put out an offer on her blog to mentor one museum professional over the course of a year. In order to help her choose one, she asked prospective mentees to answer a few of the creative habit questions developed by Twyla Tharp. She got fascinating and enlightening responses, even from people who wouldn't necessarily describe themselves as creative. (Specifically, Linda asked: Describe your first creative act. Do you favor process or result? When does your reach exceed your grasp? What's your ideal creative activity? You can find all thirty-three of Tharp's questions on pp. 23–25.) Tharp's questions aren't necessarily appropriate for every interview situation, but sometimes they are just what you need.

Every organization needs great people, but you can't expect a board, staff, or volunteers to solve all the museum's problems unless they have clear goals, effective leadership, a foundation of trust, and a creativity friendly environment to support them. Step by step, by attending to each of the elements addressed in this chapter, together you and your co-workers can build a strong foundation for a creative culture that empowers everyone to shine. Imagine how great that will feel.

> What's important is that you have a faith in people, that they're basically good and smart, and if you give them tools, they'll do wonderful things with them.
>
> Steve Jobs

3 Tools for Creative Cultures

In this chapter you'll learn how to fill your work environment with the tools you and your colleagues need for creative thinking. These include creative spaces to work in, simple hands-on tools like Post-its notes and markers, and the ever-changing world of virtual tools that make it easier for us to collaborate. We round out this chapter with three processes—observation, prototyping, and brainstorming—that will help you optimize your creative output.

Spaces for Creative Museum Workers

Look around your workspace. Although the public spaces in our museums may be grand and glorious, our workspaces are often considerably less so. Many of you are squeezed into former closets, working on desks donated by board members, in the basement behind the furnace, or in the attic with the collections. You might be located floors away from other colleagues—or even in another building. You might be crammed into a very small room while a space called "the board room" languishes unused twenty-nine days a month. Some of the reasons for these conditions are outside of your control, but others, like the ones below, often can be improved to make more room for creativity. First, let's identify some common and often overlapping problems, and then we'll outline a process for finding solutions.

Hoarding

That non-working computer monitor, those text panels from an exhibition five years ago, the boxes of outdated membership brochures—all those hoarded leftover materials take up not just physical space but also mental space. While some people do need clutter to feed their creativity, it's one thing to actively choose to fill your environment with inspirational objects and helpful tools and another thing to passively resign yourself to drowning in useless odds and ends because you aren't mindful about your workspace, or worse, because you inherited a leftover hoard from a former staff member. Those piles and stuffed closets of abandoned materials are the opposite of inspiring. They

Creativity in Museum Practice by Linda Norris and Rainey Tisdale, 107–138. © 2014 Left Coast Press, Inc. All rights reserved.

keep us from opening up our thinking and instead leave us sidestepping around the remnants of past ideas, some good and some not. Are you actively using the hoard you have accumulated or just letting it paralyze new thinking?

Territoriality

Many years ago Linda worked in a museum where there were not enough desks for staff plus interns. She would go out onto the museum floor and come back to find an intern perched at her desk, hard at work. At the time it seemed annoying, but now it seems right. In many museums, there are an increasing number of part-time workers—and many of them have full-time desks. Plus, networked computers mean everyone's projects can now be more portable. Territoriality can also apply to closets, classrooms, and other potentially multi-purpose spaces that are controlled by one department.

Silos

Workers are grouped together by department/division for reasons. They might have some functional commonality, with issues to discuss and projects to collaborate on, so it makes sense for them to sit in close proximity. Curatorial staff need to be near the collections and education staff near the classroom. But this type of siloed building also means that you only interact on a regular basis with people who think and approach their work the same way that you do.

Hierarchy

Creativity can—and should—come from anywhere in the organization. When a top-level manager occupies the same amount of floor space as ten lower level staff, there's a message conveyed about the relative importance of ideas as well. Decreasing hierarchies of rank and space and opening up access can have a profound effect on workplace culture.

Your Creative Practice

Opening Up the Space

In late 2009, the Newfoundland and Labrador Provincial Historic Sites Division central office moved to a temporary location while its permanent office was undergoing multi-year renovations. With a shortage of office space in the St. John's area, staff were unexpectedly re-located to a much smaller, open concept space. Having worked in personal offices (on two different floors!), our instinct was to re-create the look and feel of the personal office model by carefully allocating space for each staff member using government style cubicle dividers. When we moved into the space and it started functioning as an office, it was very unnerving at first. It was a small space with twenty foot ceilings and no white noise, so despite the cubicle dividers you could literally hear everyone's conversations. This was especially awkward for me as a manager because I did not have any privacy.

The more comfortable we became with the openness of the environment, the more we started talking to each other, literally without leaving our chairs. If you needed to discuss something privately, you met somewhere else. For example, all HR discussions took place in a separate HR office. Otherwise, it was wide open, and over time everyone felt more and more comfortable providing their opinions. Our office has essentially become an incubator for creativity and effective work performance. The open concept enables us to be perpetually collaborative in everything we do, and as a result it creates an incredibly organic, creative, and healthy work environment. The proof, as they say, is in the pudding—in the past two years our office team has won the

 Tourism, Culture and Recreation Innovation Award and in June 2012 was awarded the Public Service Award of Excellence, the highest honor in the Newfoundland and Labrador Public Service.

Gerry Osmond, Manager of Provincial Historic Sites,
St. John's, Newfoundland, Canada

Lack of Attention

All of us get used to the places we see every day. What this means is that we don't look closely at what could be different and what could make our workplaces into spaces where we actually want to create, to work collaboratively, and to generate and implement new ideas. David Kelley of IDEO describes space as an instrument, not a given condition; it is malleable and exists to serve our needs.[1] Even very small alterations in environment can lead to big improvements in outlook and approach to creative work.

If you do take a closer look at the spaces you inhabit for hours every day, you can intentionally change them to reflect a bias *toward* creativity and *away from* hoarding, territoriality, silos, and hierarchy. You can let the users of the space begin to take control, and encourage them to take on the weeding out and re-thinking of different areas of the museum, if possible with a small budget for new items. Encourage people to think about creating space for their best, most productive, most creative selves, not for selves that are stuck with what they've got. As with every other element of this book, prototyping, risk, and even failure are key. Don't worry about the perfect change; a change that has a patina of imperfection and impermanence encourages more thinking about what comes next. Try one change, and try again, and again. Indeed, a series of small changes can often be much more effective than a top-to-bottom renovation because each step lets you understand something about your users, their needs, and what actually works for them.

Where do you start? First, spend some time observing what happens in all of the workspaces at the museum. Consider putting up a piece of paper in every room where each person who comes into the space makes a quick note about what they do and for how long: do they come in to eat lunch, to talk to a colleague, to make copies, for privacy? Are there some spaces that are underused and some that are used constantly? Why are the latter spaces used so much more? Is it the activity that takes place there (that is, everyone goes for coffee), or is it that the space, for some reason, just feels more attractive?

Next, find some inspiration by taking a look at how people have adapted spaces to make them workable for their own purposes. These days there are books, blogs, and Pinterest boards filled with photos of interesting workspaces. You might talk to friends and family members about what they like and don't like about their own offices. Or visit other places in your area—museums and non-museums alike—to get ideas. At the Exploratorium in San Francisco, for example, anyone can look into the exhibition fabrication lab and see the many ways in which different staff members have adapted the space to suit their own needs while at the same time conforming to an overall work-in-progress aesthetic.

Try This:
Emerging Designers

Invite your colleagues from other museums over for a workspace walk-through. New sets of eyes generate new ideas. Ask them to point out those hoards you have been ignoring and think of creative ways to get more from your workspaces. Do they have successful spaces at their museums that could inspire change at yours? And if everyone feels energized by the possibilities, use those extra pairs of hands to take the first steps in the rearranging process. It will be easier to take more steps in the weeks to come if some initial progress has already been made.

Next, think about what you ideally want from your space. How can it reflect the values you hold as an organization? For instance, the d.school at Stanford University developed these six values and creates spaces to encourage them:

- Collaborate across Boundaries
- Show Don't Tell
- Bias towards Action
- Focus on Human Values
- Be Mindful of Process
- Prototype towards a Solution[2]

What are your museum's implicit and explicit values? Does your space reflect them?

In addition, think about the "zoning" for your spaces, so that different activities can happen in different types of places. *I Wish I Worked There!* by Kursty Groves and Will Knight, which features twenty workplaces specifically designed for creativity, breaks down creative workplaces into four types:

- Stimulating: these spaces are filled with information and inspiration—our museum galleries are excellent spaces for stimulation.

- Reflective: where people can incubate ideas, work on projects that require focused attention, or hold private meetings with minimal interruptions. Such areas are particularly important if your museum has an open plan or multiple staff members share the same office.

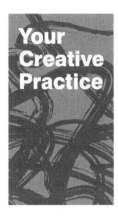

Your Creative Practice

Have Fun

Wharton Esherick's motto was "If it's not fun, it's not worth doing," which has become our staff motto, too. We always try to have fun and be creative, so if that means walking away from tasks and walking through the creative and fun space of Wharton Esherick, then that's what we do. We pull his fun and creativity and put it towards our daily tasks and big projects.

Lauren Heemer, Assistant Curator and Program Director,
Wharton Esherick Museum, Malvern, Pennsylvania

- Collaborative: where people exchange information, often unplanned and informally. Groves notes that food is a reliable lure to populate collaborative spaces.

- Playful: where people can experiment, make a mess, or literally play without worrying about damaging anything important or getting in trouble.[3]

A walk through your space will help you identify where these four kinds of spaces exist (or could exist) in your museum, and how you might tweak them to support a range of activities and workers. Beginning with small amounts of effort and funds, you can develop spaces that enhance and encourage the creative process.

Here are some simple fixes to make your spaces more creative, adapted from one of our favorite books, *Make Space* by Scott Doorley and Scott Witthoft:

- Find a place to install a big whiteboard so a group can gather around it to work. The whiteboard can be used for brainstorming or for collecting bits of inspiration (too expensive? Use shower board from a home improvement store). If you can, designate an actual project room where teams can meet for the life of a project, like an apartment rental, so ideas are shared and maintained in one place. Several teams can occupy the same space if they are each given a wall, or

make a series of whiteboards on rolling frames that can be pulled out and put away as needed (see *Make Space* for instructions).

- Create a hiding place that can be used by anyone when there is concentrated solitary work to be done, with a no interruptions rule. As Sartre says, sometimes "hell is other people."

- The Stanford d.school has experimented with different room configurations for creative teams— comfy sofas; bar stools; low and close seating reminiscent of a padded sandbox; conference tables; and open spaces with no seating—and found that for their projects standing up yields more energy and more ideas. Make your meeting spaces flexible enough to allow for both sitting and standing, and try both to figure out what works best for your team.

- Create a space—and encourage the use of it—for relaxation. This might be solitary relaxation—a comfortable chair with no technology and a great view—or group relaxation, a space for coffee breaks.

- Always, no matter the space, keep supplies close at hand in a mobile storage system—consider a wheeled cart or cabinet.

- Supply more chairs than workers, and make chairs and tables easily moveable. That way different conversation configurations can happen easily, not only at people's desks but wherever else in the building two or more people find they have something to discuss.

If people are forced into space changes that don't suit their needs, they often resist, and then figure out how to make the space their own anyway. (Think of the paths in public parks that, no matter how well paved, are intersected by well-worn, unpaved footpaths created by those who use the space to meet their own needs.) Observe the way your co-workers use your current spaces, and also ask them to consider what spaces they would really like, given a shift towards a more creative culture. What spaces do they enjoy working in outside the museum: a coffee shop with a mild hum of energy and ambient noise? Out in the backyard? How is their home office organized? Where do they have their best conversations? In addition, think about how your museum workspaces are privileged. Your director might occupy a large office in which, in fact, he or she spends little time. The

Your Creative Practice

The Sandbox

One thing that we've used on a project at the Canadian War Museum is a "sandbox." The idea was to create a space where anyone could come in and play around with ideas and questions that we were grappling with. It was a humble cubicle wall in a high-traffic space, with push pins, Post-it notes, and colored markers. We used it to post questions, ask people to vote for preferred solutions to problems, and even help choose exhibition content. We put up sample text and invited people to edit and comment. We made an effort to provide results and updates so that people would know that their contributions were valued. We used the label "sandbox" because we wanted it to be playful and open to all.

The most important part to how the sandbox came about was having a really great working relationship among the core project team. We share values and visions not only for the project, but for the way we want to work. We all wanted to work as collaboratively as possible, and agreed that our creativity and overall output would be enhanced by having more, and on-going, feedback from all sorts of sources, not just those in the formal approval process. We even wrote a team philosophy. We did not seek to mandate or direct anyone's work—participation was deliberately kept optional and low commitment, and allowed for anonymity. I am fortunate that this type of collaboration is welcomed, if not explicitly encouraged, in my workplace. Permission to create the sandbox was not needed, though for other things, such as traditional brainstorming or workshops, it is.

Kathryn Lyons, Senior Interpretive Planner,
Canadian War Museum, Ottawa, Canada

board of directors might appreciate seeing that lonely boardroom become a creative place, where they get to see thinking in action. Your volunteers may or may not feel welcomed into your space at all. Consider ways that everyone can get more of what they need and less of what they don't.

Worried you can't get permission to change common areas of the museum? Work on your own desk area instead. Clean out the flotsam and jetsam your predecessor had been saving since 1986 just in case. Make your own inspiration board. Attend to your own needs for both quiet focus (noise-cancelling headphones?) and collaborative discussion. Figure out where in the museum you can go to incubate ideas. What are the weaknesses in your own creative practice and how could minor space changes help you address them?

Worried because you work in an historic building? Sure, you probably can't remove walls and maybe you have to be careful what you paint, but there are still plenty of changes you can make in how the furniture is configured and how the space is used without affecting the historic fabric of the building. Who is sitting where and is it working? Can you make some panels to lean against a wall if you're not supposed to drill into it? Can you give people regular reasons to emerge from those tiny offices tucked away on various floors so they start sharing more information and ideas?

Hands-on Tools for Creative Work

While you are attending to your workspace, you can also think about filling it with useful tools. All those art supplies really do make a difference. Keep a set of plastic transparent boxes, dispersed throughout the museum's workspaces, that are filled with materials that can be used for quick thinking: Post-it notes, markers, colored pencils, glue, tape, pipe cleaners, and nearby, a flip chart or roll of newsprint. Make sure that everyone knows that these supplies are for everyone's use, regardless of job responsibility; they are not just for the education department (where such supplies usually live). Task someone with making sure the bins are kept well supplied. Every once in a while, try getting supplies out of the box and leaving them around—on a conference table, in the lunchroom—to make them even more accessible. Encourage staff members to consider what else they'd like to think creatively with: wind-up toys, images from magazines, or? Another

Your Creative Practice

Tools and Space

We recently moved into a new space, and I really wanted to set up a work environment where we could collaborate and make our thought processes transparent. There's an armchair in the corner if people want to read. Next to it is a bookcase stocked with books on design, creative coding, data visualization, as well as exhibition catalogues, newspaper clippings, and articles on science, technology, and culture—basically anything that inspires us to think differently about our work and museum practice. There's a big conference table in the middle, and people from other departments are welcome to camp out there if they want a change of scenery. There is a small room off to the side that is available to all staff for ad-hoc meetings, phone calls, and so forth. The design department has covered the walls of that room with imagery to inspire their thinking about the museum's brand and identity; this shared space helps break down boundaries between departments. We have all of our current, future, and completed projects listed on a whiteboard that any staff can see and ask about. We have a big pin board that's covered in screenshots and notes from our latest projects. We want people to know what we're working on and thinking about. I want the museum's processes to be transparent so I've created an environment where we can be as transparent, open, collaborative, and creative as possible.

Jeff Steward, Director of Digital Infrastructure and Emerging Technology, Harvard Art Museums, Cambridge, Massachusetts

set of hands-on tools comes with what you probably have in your pocket: a smartphone or digital camera. Take photographs of what you create with your supplies to document ideas; use the voice memo function on a phone to record thoughts on the fly; and use the video to remember what you see in your museum and in the world around you.

Virtual Tools

One of the reasons there is so much focus on creativity right now in society at large is because the Information Revolution has given us copious new digital tools to enhance our creative efforts—tools for information sharing at an unprecedented level, tools for collaborating across time and space, tools for more effectively organizing our creative work. With each passing year, these tools become cheaper and more widespread: software that two years ago was very costly or had to be custom built is now readily available to anyone, cheaply or even for free in many cases.

By the time this book is printed, there will be a host of new virtual tools to experiment with. Therefore, rather than make a great number of specific recommendations, below are suggestions for the types of virtual tools that are useful in creative work and what a great tool might encompass. Our best advice is to keep investigating what other people are using. When someone mentions an app you have never heard of, ask about it.

Discovering, Sharing, and Organizing Information and Inspiration

Often the web seems like a giant fire hose spewing information our way. The challenge is to find the best methods for you to manage that stream on a regular basis. You need to discover ideas and inspiration, organize those discoveries, and explore ways to share them with your colleagues near and far. Throughout this book, we express a bias toward open access to information. Therefore, as you use all these virtual tools, we encourage you to embrace the idea of sharing your work with not just the colleagues in your museum, but throughout the field.

If you are someone who needs your information in short bursts, Twitter has become the most effective way to keep your finger on the pulse of both the museum field and anything else you are

curious about. Follow museums or individuals that interest you and then follow their links out to all kinds of information. Many museums and museum thinkers also maintain a Facebook presence that can help you quickly see what other institutions are trying and exploring.

For more visually oriented learners, there are tools to help you to find and organize images. Museums are using Pinterest and Tumblr to share collections (often grouped by themes). Through these apps and others, teachers are sharing great classroom ideas that can be adapted to the museum, and exhibitions and design images abound. Even a simple Google Image search can rapidly turn up some inspiration. Don't forget the way fans are inspired by our museum work: My Daguerreotype Boyfriend's Tumblr feed is an appreciation of great-looking historic images, many from museum collections. In adopting tools like these, look for ease of use and the ability to both share widely and have a private section (say, for internal project planning).

RSS readers like feedly are tools to organize materials from sites that are regularly updated—like blogs or other online publications. They act as a subscription service, feeding all the new posts from your favorite sites whenever they are generated. All reader apps keep content ready and waiting in an easy-to-access format, and a great reader app allows you to organize, tag, and track items of interest to you.

The web increasingly offers a wide range of ways to learn, individually and collaboratively. *TED Talks,* online video lectures by experts from every field imaginable (and some you can't imagine) provide quick, high-quality bursts of interesting and insightful information to diversify your knowledge base and aid your associative thinking. The growth of MOOCs (Massive Open Online Courses) makes it possible for all of us to learn new skills—nearby and very far away from our own knowledge base. We collaborated with museum colleagues from across the globe as a working group in creativity expert Tina Seelig's MOOC through Stanford University and found it intriguing enough to consider trying others. Coursera, which partners with thirty-three different universities for online courses, is a great place to begin finding out what's on offer. Just a sample at this writing: General Game Playing; Unpredictable? Randomness, Chance and Free Will; Inquiry Science Learning: Perspectives and Practices; and Archaeology's Dirty Little Secrets.

But the hardest part of all this access to information is figuring out how you will find it again and employing effective ways to organize it. Organizational tools, like all online offerings, continue to evolve, and one tool may personally work better for you than another. Many websites provide reviews of emerging apps; and since so many apps for organizing are free, try them out and see what works best for your own style. For example, Pocket clips and saves internet content so you can read it later on any device. Evernote lets you capture not only web sites but also notes, emails, and other digital information and then organize and tag everything so it's easy to pull up items related to the same project or idea. Meanwhile, Zotero, from the good folks at the Roy Rosenzweig Center for History and New Media, is our favorite tool for organizing bibliographic sources for easy citation. You can create different folders of sources, some private and some shared for team projects.

Collaborating

The development of cloud computing and varied new ways to have online, real-time conversations has changed the possibilities for how we work together, dramatically reducing the logistical complications so everyone can spend more of their energy on creating. You can now collaborate virtually, for free, with almost anyone, anywhere, anytime. There continue to be substantial benefits to sitting down, face to face, with colleagues, but given the pressures of both time and money, it is clear that online work will become a significant part of all of our institutional cultures if it's not already.

Each institution needs to experiment to find the tools that are most useful to it; you may find that working with partners outside your museum introduces you to tools you haven't worked with before. For example, many organizations are already using Google's suite of free tools to collaborate. *Google Hangout* enables video chatting with up to nine people online. You can share documents, watch videos, discuss, and imagine together. *Google Drive* provides a single online location for all sorts of files, including documents, slide shows, and spreadsheets. You can edit (and track edits) online, share, comment, and, most importantly, access the same file at the same time from different locations. And *Google Calendar* allows you to set meetings, find out when people are free, and track your time on projects.

Some additional collaborative options include Skype, which is a great way to talk, for free, with people around the world. (Our weekly Skype chats while writing this book served as the foundation for our collaborative process.) For electronic brainstorming, Padlet helps you collect and share ideas via a wall of virtual Post-it notes. Your team can post anonymously or by name, and you can designate someone to serve as a facilitator who organizes and edits the posts as you go along. And sites like SlideShare, Instagram, Vine, YouTube, and Vimeo provide different ways to share visual information. Want team members to see what is actually happening in an exhibition space or to hear from a member of the team? Snap a quick picture, do a quick video or slide show, and post.

Consider the situations in which you want to make your collaborative work public. Could you open up a Padlet wall for your community to share ideas? Invite visitors to post their own Instagram photos of your community's special places for an exhibition? Our collaborators need not be just our colleagues, but can, and should, in some situations, include a broad audience.

One final piece of advice on using virtual tools: Keep your eyes open, don't reject something out of hand ("Oh, I would never use Twitter"), and if you try it and it doesn't work, try something else.

Observe Your Target Audience

Observing target audiences is a fundamental part of museum evaluation, and it's a fundamental part of creativity theory, too: you have to observe deeply to understand the complexities of the problem you're trying to solve. In a creative culture it's useful to expand the notion and value of museum observation to include not just the front of house but also the back of house. There is room for everyone on the museum staff—not just evaluators, educators, or front-line visitor services staff—to pay more attention to and design for users. With a nod to IDEO's design thinking observation process as described by Tim Brown in *Change by Design*, we have developed some basic strategies below that can be used anywhere in the museum by staff with any type of responsibility.

Using a concrete example, let's imagine you're trying to get everyone at your museum to follow security procedures more effectively—they're not signing in regularly, they're not thorough in walkthroughs, they're not keeping close track of keys, or they're skipping close-out steps.

Some of you may question why one needs to approach security creatively—isn't it just a nuts-and-bolts, routine part of museum operations? Creativity belongs in any area of your institution where there's room for improvement, and we chose this example in the interest of encouraging observation in every part of the museum. The observational strategies below may only lead to small tweaks in your system, but they could also lead to a major breakthrough in approach that would not only help you lower your own risk but could also help your colleagues in other museums adopt more effective security practices.

Determine Your Target Audience

In this example it's anyone who has access to a controlled area, or anyone responsible for keeping museum assets secure.

Observe People at the Center and the Edges of Your Target Audience

New staff members dealing with a learning curve might teach you what's easy and what's hard about your policies. So might the UPS delivery person or the colleague from another institution who is just visiting for the day. And so might the staffer who has been there ten years, for whom the policies have become rote.

Look at the Environment You Are Interested in Improving but Also Analogous Environments

You need to observe your museum, of course, but you might also learn something from observing security procedures at other museums, retail stores, libraries, or government office buildings. Is there a process you can borrow from these environments? Can they teach you something about the nature of security and how users approach it that will help you more fully understand problems at your museum so you can improve your system?

Observe How People Think, How They Behave, What They Feel

What's the actual root of the under-compliance? Are your fellow staff members frustrated or rushed? Maybe there's a way to automate or streamline the system to make it easier for them, or maybe they need a small incentive (anyone with perfect security record wins a reward at the end of the month?) to turn a burden into a game. Are they carrying things while trying to sign in and out? Maybe you can place a table next to the sign-in book to make it easier to follow procedure. Do they not understand the importance of security (believing that nothing will ever happen here)? Maybe they need more information about past incidents and the risk of various security breaches in your area. Is a particular time of day harder than others? If so, why?

How Do People Interact, Not Just as Individuals, but within a Group or between Groups?

Are senior staff members modeling good security habits to junior staff or instead sending the signal that they're not that important? Is a particular department sharing keys freely, and if so, why?

Look for adaptations. How have people taken the system that's in place and altered it or made quick fixes to better suit their own needs? These are often the points that warrant further exploration. Are staff members creating cheat sheets to tackle complicated close-out procedures? Are they adapting security forms as a workaround? Are they modifying the walk-through route? If so, these might be areas that require rethinking.

Enlist Others in Observation

Ask other people on the museum staff to make their own observations and give suggestions. Maybe you can learn something through their eyes.

Prototype Something, Anything

Not only does prototyping help you improve ideas, quickly see what's not going to work, or even find completely new and better ideas, it also lets you test many ideas in parallel instead of serially. A lot of teams hesitate at the prototyping stage—it can be hard to dive in when the ideas still aren't fully formed. So you might find it helpful to set an early deadline for initiating some sort of prototype (maybe the end of first day or first week of a project) to make it a team habit. You shouldn't feel a need to produce high-quality prototypes that themselves feel like finished products. It can be useful if prototypes look really rough. If they appear close to finished, like they might actually belong in the real world, then people outside of your development team might treat them rigidly and be less open to the potential for improvements. Each prototyping process is a little bit different, but a similar framework can be followed:

Establish the Question Your Team Would Like to Explore

For instance:

- How will this exhibition interactive work? What will visitors take away from the experience?
- What happens if you make your front desk more welcoming by changing what the signs say?
- What would a more effective weekly staff meeting look like?
- How could you share more information about your collections?

Plan and Do It

Plan how you're going to gain feedback on the question, and then make it happen. For the exhibition interactive, you could develop a simple simulation (having a kit of prototyping supplies on hand is really helpful), take it onto the gallery floor, and observe visitors using it. For the signage, involve the front line staff in creating simple temporary signage, and ask them to engage with visitors about the information. For staff meetings, try a different format each week and ask participants for very quick feedback at the meeting's conclusion. For sharing collections, try posting an image on Facebook each week and see what your audience is interested in.

Pay Close Attention to Reactions

Ask questions, probe deeply, and keep great notes about your process.

Fail—Yes, Fail

Part of the prototyping process is learning from the failed parts. Your job as a prototyper is both to expect failure and to make sure that others in the organization understand that failure is an integral part of the process. In fact, that's where real learning emerges. Make sure you find time to debrief about what's been learned.

Try Again

Sometimes a prototype works terrifically the first time. But more often than not, you learn that some parts work and some don't. Take that knowledge, make changes, and go back out to your audience (internal or external) with a new, improved version so you can learn more, verify your hunches from the first round, and arrive at the best product possible. Trying again rapidly has substantial benefits. Linda has developed a great many exhibition prototypes and has learned that a speedy process of iteration—where you make a series of changes to the prototype along the way, refining it based on what you learn—often produces the best results. If you think in terms of evaluation, this is definitely qualitative not quantitative. You can see how visitors react to label copy, how they understand (or fail to comprehend) instructions for interactives, and even how visitors can take you further in an idea than you ever intended. It helps to keep a kit of supplies to make it easy to dive in and revise: odd bits of foam core, mat board or cardboard, a roll of newsprint, markers and colored pencils, clipboards, magnets and magnet boards, Post-it notes, Ethafoam, and fabric.

Extend the Learning Outward

Every prototyping process can provide you with knowledge that can be used in other ways. As you wrap up the process, consider how knowledge gained in one area can enhance your work in another. Did you learn that visitors hate complicated instructions? Then you don't need to prototype any more complicated instructions, but you can explore other questions. Can the ways in which

visitors react to one interactive influence the overall development of the exhibition? In planning an exhibition about pre-1750 western New York at the Ontario County Historical Society, Linda prototyped several different interactives: one used charades to explore the challenge of communicating without a common language, and another was a simple trading game. During the prototyping one young participant took the learning from the first interactive (the lack of a common language) and applied it to the second (the trading game), saying: "Oh, remember! We can't understand each other. We have to do all this by acting it out and no words." That insight not only helped the team understand how to make these particular interactives work effectively but also reinforced the significance of that cultural gulf in other parts of the exhibition. Consequently, the final exhibition iteration was strengthened on several different levels.

Public prototyping is one way of letting your community know that your museum is a creative museum—and that you need public participation in that creative process. In our experience, visitors are thrilled to be included in the process of thinking through museum projects (and not just exhibitions—programming, web content, marketing strategies). Prototyping not only refines ideas, it creates fans and advocates for our work.

Your Creative Practice

Physical Prototypes

While interning at Boston's Museum of Science, I did a lot of prototyping for a new Pixar exhibition. Working with Pixar material obviously inspires creativity, but it was at times intimidating to wrestle with rough exhibition prototypes while surrounded by examples of human ingenuity. It was almost comical; I was hand-writing labels on craft paper and attaching them with packing tape right next to beautiful images of polished Pixar characters. Yet I knew that Mike Wazowski and Buzz Lightyear were once rough prototypes themselves, which let me have faith in the process.

The physicality of prototyping also inspired my creativity. If one label didn't seem to work, I'd rip it off and tape up another. I scratched out words with a black sharpie, cut craft paper to fit, and rearranged the position of labels. We moved whole interactives from one side of the room to another. Knowing that it was just paper and tape and plywood allowed me the freedom to play with words, ideas, and layouts. It was okay if I messed it up; I was supposed to mess it up. Otherwise, how would I know if something really worked?

Krista Schmidt, Emerging Museum Professional, Minneapolis, Minnesota

To Brainstorm or Not to Brainstorm?

For better or for worse, brainstorming is the central way most people currently experience creative practice in the workplace. We all have been taught more or less the same basic method for this process. First developed by advertising executive Alex Osborn in the 1950s, today it is widely used in laboratories, offices, and classrooms alike. You get some people together in a room, you throw out as many ideas as possible and try to build on them to generate even more ideas, recording on a write-board or flipchart as you go. And you defer judgment during the process—every idea is valuable.

There is a growing body of research, however, that suggests this method was never as tried and true as we believe. The critics assert that one person thinking alone consistently comes up with more and better ideas than a group working together. According to the organizational psychology research, there are a number of problems that get in the way of effective group brainstorming.[4] Here are some you should know about:

- Production blocking: In a group, only one person can speak at a time. This constraint leads brainstorming participants to forget or censor their ideas while waiting for their turn to speak. The larger the group, the more of a problem production blocking becomes.

- Evaluation apprehension: Even if the brainstorming facilitator emphasizes that all ideas should be considered, without judgment, participants still sometimes self-censor, thinking an idea will be perceived by the group as silly or stupid. Evaluation apprehension is a bigger problem in groups with a low level of social cohesion and trust.

- Social loafing: Because there is usually little individual accountability in brainstorming groups, it's possible for some participants to sit back on the sidelines and let others do most or all of the idea generation, particularly if those folks aren't motivated to take an active role.

- Matching: Individual participants tend to match their performance level to that of others in the group. Sometimes this phenomenon pushes low-performing participants to match the higher level of idea generation displayed by others in the group, but it can also work the other way around, where high-performing members stop trying so hard.

- Motivation: There are many factors that affect the degree to which individuals are motivated to perform in group brainstorming, including the social dynamics in the group, the presence of competition and reward systems, and the level of individual intrinsic motivation. If you don't have the right motivational factors, you get mediocre results.

- Idea incubation: Group brainstorming doesn't allow much space for the kind of deep, solo thinking that can be a crucial stage in generating good ideas. Sometimes participants need time to fully process what happens in a group brainstorming session in order to effectively build on each other's ideas.

Given all of these potential problems, do we persist in relying on this method out of habit, or because we think it will increase buy-in on later decisions, or because it addresses some other social need within our workplace culture? Do we brainstorm together because it is *good enough,* even though other strategies would yield better results? Is it time to throw out our conventional brainstorming model and try something new?

Brainstorming involves such a complex mix of cognitive function, group dynamics, and motivational factors that it is difficult to form hard and fast rules (perhaps that's why we keep falling back on Alex Osborn's method: we all like hard and fast rules). The two of us have participated in plenty of brainstorming sessions that generated tons of interesting ideas. But then again we have also been in plenty that fell flat or even completely derailed. And like many of you, we have had valuable ideas come to us through other means—while listening to a conference session, talking one-on-one with a colleague, sitting at desks organizing our own thoughts, or working with others online. In other words, sometimes it works and sometimes it doesn't.

Group brainstorming can be useful, but it should not be the only tool in your creative toolbox. In too many workplaces, group brainstorming is the only creative tool in use. But you are unlikely to get great results from brainstorming without an overall creative culture to support it. Moreover, because there are so many variables that affect the outcome of a brainstorming session—the people involved and their level of trust and motivation, the environment, the information the team has to work with, the process—you need to experiment until you find the method that works for your situation, and keep practicing until everyone participating is good at it. If brainstorming is not

No Sepia Tones

One of the best ways for me to get creative is to work with a team of people who don't think the same way I do. This is hardly profound—working with a team is a basic way to refill your creative well. Unfortunately, when I get overworked and stressed, my natural inclination is to hunker down and stop talking to people instead of reaching out and sharing. But drawing only from my own creativity without finding ways to explore, discuss, and argue over ideas is a sure recipe for burnout and poor results. I have lots of ideas every day, but just because they're ideas does not make them good ones. I'm a firm believer that no idea is good until it's tested.

Recently, we developed a Civil War exhibition targeted for a school age audience. I wanted to do something active and vibrant. I envisioned a colorful and action packed portrayal of the war, not a stiff sepia-toned version. My idea was to present the war as a comic book and highlight the stories of individual Kentuckians during the conflict. I assembled a team of curators and historians, and we began researching various characters, the main themes of the exhibition, and ways to tell it using hands on activities. This was all very exciting and creative, but it was still a fairly standard process for us—that is, until we brought an artist into the mix.

We hired Ray Reick, a professional comic artist/graphic novelist to complete the art for the project. I knew that the quality of the art would make or break the project, but I did not anticipate the pure joy of this creative process. Our team knew almost nothing about creating a comic book, and Ray knew little about exhibition development and how historians think. Our back and forth about how the characters should

look and what they should be wearing was invigorating. We argued, we discussed, and we laughed a lot. Ray wanted the art to be dynamic and fun, and the historians wanted it to be historically accurate. We didn't always get it right at first. One character, Henry Lane Stone, started out too rigid and formal; we wanted him to have swagger, but then he looked too much like James Dean and we had to rein it in a bit. We had constant back and forth conversation that was sometimes frustrating, but it was also incredibly energizing. Ray pushed us to look at each scene—we wanted to create events that actually happened, ones we did not have historical photographs for. However, we still thought of everything as a carefully staged static photograph. We were so constrained by what the historical evidence suggested that making it dynamic and dramatic seemed impossible. Ray blew apart our thinking by bringing motion and action to each drawing. He placed characters in the foreground of each scene rushing out at the viewer, and made them closer to us—both literally and figuratively. Without his willingness to push us, we would have remained constrained by our world view.

Trevor Jones, Director, Museum Collections and Exhibitions,
Kentucky Historical Society, Frankfort, Kentucky

yielding wonderful, transformative ideas at your museum, talk about where the process might be improved, and start trying these strategies:

Make Sure You Have the Right People in the Room

Ideally you should recruit a team of talented, smart, interesting people who have a strong grasp of the problem at hand and are motivated and open to addressing it. The more diverse your team the

better the outcome; they will all bring different perspectives to bear on the problem. That means a range of knowledge bases, types of expertise, skill sets, and roles at the museum. Sometimes it is useful to seek the participation of outsiders, people with knowledge of the issue but who might approach it from a different angle or discipline than your museum staff. And lastly, it helps if the group has social cohesion—they trust each other and are open to working together. If they don't, make sure you build in time at the beginning of the process for participants to get acquainted.

Change the Room

IDEO's Tim Brown says, "As Dilbert has shown, regulation-size spaces tend to produce regulation-size ideas."[5] That conference room—where so many boring meetings have taken place—may be shooting you in the foot. Try relocating somewhere else. Or fill the room with images and objects for inspiration. Provide art supplies for people to draw and mini-prototype.

Treat the Brainstorming Session as a Middle Step— Not the End Step—in Idea Generation

We often expect that by the end of a brainstorming session the group will have picked the best idea and even have roughed out a plan of execution. That may be true with easy problems, but it's asking too much with hard problems. It can be useful to give the ideas you generate a little room to breathe and be evaluated. Sometimes an even better idea will surface in the hours or days after the brainstorming session, once all the participants have done some additional associative thinking (see stages of creativity on p. 40). In fact, you may even want to assign each participant the task of following up with individual brainstorming that will be reported back to the group later. Moreover, sometimes the people who will yield the best ideas for you are not the same people who should be choosing between them, and vice versa. So try making room in the schedule for further steps to unfold.

Structure the Brainstorming

We all have brainstormed so many times that it's easy to get lazy. We often throw some people in a room and simply say Go, expecting that everything will sort itself out. But brainstorming requires

care and feeding to optimize results. Give instructions at the beginning to make sure everyone is clear about the process and their individual role. Divide complex problems into sub-problems that are tackled separately by the group. Remember to emphasize to all participants that they should be building on each other's ideas. Schedule short breaks for individual reflection and incubation, and make sure to capture thoughts from those breaks as the group reconvenes.

Take Your Brainstorming Online

Electronic brainstorming allows a group of people to generate ideas via computer while each participant is sitting at his or her own desk (or theoretically outside under a tree, in a coffee shop, or in another country). The electronic brainstorming session can take place over a series of days instead of an hour so that there is more time for individual reflection, and it can involve a much larger group of people (in fact, it works most effectively with a large group). Documentation of ideas is instantaneous; there is no risk of losing meaning when they are transcribed to a flipchart by the recording secretary. Online services like Monsoon manage electronic brainstorming for a fee; we have also used a free app called Padlet. A group leader schedules the session, invites participants, proposes the topic(s), and facilitates the unfolding process. The group members submit ideas individually at their own pace and then have a chance to evaluate and help organize the ideas at the end of the session. For electronic brainstorming to be most effective, participants should be reminded to pay attention to the ideas of other members of the group so that they can build on them—it's particularly easy to forget this crucial point when you're not all in the same room.

Adjust Your Group Size

Some of the organizational psychology research has found that four or fewer people can be quite productive for in-person brainstorming (in fact, just two people can work well, too), but once the group gets larger than four, the drawbacks start to outweigh the benefits of group brainstorming. Meanwhile, electronic brainstorming has some disadvantages until you get past eight people, but then its benefits are stronger than other methods.[6]

Brainwrite instead of Brainstorm

This technique still happens with a group of people sharing the same time and space, but it involves writing down ideas instead of speaking them aloud in order to minimize issues like production blocking. Generally participants sit in a circle, with pieces of paper or index cards in the middle. The facilitator poses a problem or topic, and each person individually writes down his or her ideas, periodically circulating them for others to build upon. In one version of brainwriting, called 6-3-5, six participants generate three ideas each in five-minute rounds, generally for a half-hour, for a total of 108 ideas. At the end of each round, the participants pass their papers to the person next to them, who then tries to build on his or her neighbor's ideas or writes his or her own new ideas. Or alternatively, participants can go at their own pace, seeking new inspiration from a pool of ideas in the center of the table, either every time they generate three ideas of their own or whenever they run out of their own ideas. Regardless of which version you choose, you will want to spend time sorting and categorizing the ideas at the end.

Push Past the First Two Waves

Twyla Tharp uses the analogy of waves when discussing ideas; they come in clumps of increasing usefulness. She writes, "It's the same arc every time: the first third of the ideas are obvious; the second third are more interesting; the final third show flair, insight, curiosity, even complexity, as later thinking builds on earlier thinking."[7] Some brainstorming groups make the mistake of spending all their energy on the first and second waves, quitting before they get to the good stuff. If your team recognizes the need to move quickly through the first two waves—and not give up until the third wave crashes onto shore—you increase your chances of generating transformative ideas.

Reframe the Problem

Sometimes changing the perspective from which you see a problem can dredge up great ideas lurking below the surface. Pay attention to how problems are framed, and experiment with reframing them to get different results. Tina Seelig, in her brainstorming guidelines in *inGenius*, recommends pushing past the conventional ideas by removing the team as much as possible from the practical,

real world and challenging their deeply-held assumptions. You can do this by phrasing the problem in a provocative way (not just "What should we do for our members' event?" but "How can we create the most memorable members' event ever, that will have people talking about it for weeks?"); by devising controls that rule out the easy and obvious ideas ("Your ideas cannot involve the use of docents"); or by introducing a series of prompts that alter the constraints ("What if we had to solve this problem with less than $50? What if we could solve it with $1 million? What if we are trying to solve this problem in a library/shopping mall/school instead of a museum? What if we are trying to solve this problem in a museum on the moon?").[8]

Try Plussing to Get to Better Ideas

"Plussing" is a concept initially developed by Walt Disney, then adapted and used extensively by Pixar, with some influence from improvisational comedy. It's a specific method of idea building that helps channel into productive outcomes our tendency to criticize each other's ideas. With plussing, every time you find yourself wanting to say, "That idea won't work because of x and y," you instead look for something about the idea that is interesting and potentially useful that you can build on, saying, "Yes, we could do that and we could also push it even further by doing z." By replacing *no* and *but* with *yes* and *and*, plussing shifts the focus from judging ideas to elaborating on ideas, helping the group push themselves toward more creative solutions. Less judgment, more trust.

Take a Group Pulse

After you've generated a long list of ideas and it's time to start evaluating, give everyone three to five votes that are registered with either Post-it notes or checkmarks. By giving people more than one vote, you allow for a rough consensus to emerge. The folks at IDEO call this technique "the butterfly test" because all the Post-it notes flutter around and land on the most compelling ideas.[9] It probably won't tell you the number one best idea you should choose from all the others, but it can be remarkably effective at winnowing down a long list into a handful of concepts that are worth exploring further.

Teach Your Team How to Brainstorm

(You might start by having them all read this section beginning on p. 130.) It's not enough for one person on your staff to understand the difference between effective and ineffective brainstorming; *everyone* needs to understand why some techniques work better than others, so that your entire team is actively working to produce the best results. We participated in two different electronic brainstorming sessions while we were writing this book. The first was one we initiated ourselves; it looked at improving professional training for museum workers. The second was part of Crash Course in Creativity, an online course taught by Tina Seelig through Stanford University's Venture Lab; it was part of an assignment to solve common sleep problems. Both brainstorming sessions used the same online application (Padlet), and both came up with roughly the same number of ideas. But the second session, for the Seelig course, generated a much higher proportion of inter-esting, compelling ideas. Why? We think one of the main reasons was because everyone partici-pating in the second session was better prepared to brainstorm. They had just read (and watched) Seelig's materials about the best way to generate ideas, unlike our group for the professional training session, which only received minimal instruction from us. If everyone is clear about your methods and desired outcomes, your chances for success increase significantly.

Cultivate Creativity in Other Ways Besides Brainstorming

If new ideas are not valued at your museum, if not all stages of the creative process are supported, if you are not hiring for creativity, then your brainstorming is unlikely to be productive. If brainstorming is the only way your institution tries to be creative, it may be nominally useful to you, but it probably won't be transformative.

**If you want to build a ship, don't drum up
people to collect wood and don't assign them
tasks and work, but rather teach them to
long for the endless immensity of the sea.**

Antoine de Saint-Exupéry

Chapter

4 A Field-wide Creative Infrastructure

When we began this project we ran across the quote on the previous page, and then came back to it in the writing of this chapter, the place where all of us are connected. It's the place where we're not wood gatherers and sail makers, but rather, where we long for the endless immensity of a creative museum field. Because this isn't just about individual museum workers or individual museums; we'll get so much farther if we work together to strengthen the field-wide support systems that help us share information, learn more effectively from each other, and build a professional culture of experimentation.

The entire infrastructure of the museum field deserves creative attention. We operate in a profession that is chronically under-resourced, where silos abound. Many of us have job duties that make it difficult to leave the museum building during the course of the work day to gain outside perspective and interact with people from other walks of life. And because so many museums are in the business of preserving cultural heritage for the long haul, creative change—change of any kind—does not come naturally. These are problems that are hard to fix because of the fundamental nature of museum work, and they leave us operating at a disadvantage when it comes to creativity. But there is another problem that we can perhaps fix to boost the creative power of all museums: some of the support systems that would help us do our work more creatively are weak in the museum field as compared to other fields.

What would it mean to band together and build stronger resources that help every museum, so we're not stuck pulling ourselves up by our own creative bootstraps? Because, of course, when we say "the field," we really mean all of us. The field doesn't change on its own; it only changes when a critical mass of colleagues bring creative change to the table. So in this chapter we will address those field-wide support systems by posing questions and ideas for further discussion and action, and by sharing some of the bright spots we have encountered in our research. We do so in the spirit of three qualities thought leader Seth Godin, in a Valentine's Day 2013 blog post, says he looks for in his own network of colleagues:

- Open to new ideas, leaning forward, exploring the edges, impatient with the status quo . . . In a hurry to make something worth making.
- Generous when given the opportunity (or restless to find the opportunity when not). Focused on giving people dignity, respect and the chance to speak up. Aware that the single most effective way to move forward is to help others move forward as well.
- And Connected. Part of the community, not apart from it. Hooked into the realities and dreams of the tribe. Able and interested in not only cheering people on, but shining a light on how they can accomplish their goals.[1]

Hopefully, you will approach this chapter in the same spirit, and think about your own contribution to a creative museum field.

Try This:
Start a Curiosity Club

A curiosity club is like a book group on steroids, formed with the express goal of seeking new information to apply to your work. Any member can suggest a subject they are curious about; no topic is too far afield. The group might investigate this topic through books and articles, special guests, field trips, public events, or other exploratory experiences. When the group meets, focus the discussion on making connections between the topic and some aspect of museum work, looking for theories, models, or metaphors that can cross disciplinary boundaries.

Platforms for Creative Museum Practice

What do a coral reef and Wikipedia have in common? They are large open systems—platforms—that encourage the free flow of ideas, information, or resources (or in the case of the coral reefs, nutrients) with little or no cost to individual users. In *Where Good Ideas Come From* Steven Johnson talks about the importance of such platforms for stimulating entire ecosystems of creativity.[2] They grow organically over time as users discover or develop new functionality that suits their own needs. They become places (sometimes literally, sometimes figuratively) people know they can go back to again and again for a certain kind of useful interaction. In this way, these platforms have a transformative power to foster and expand creativity by connecting a broad group of users to information, resources, and people to make good ideas happen.

Platforms have existed in various shapes and sizes for a very long time, but the Information Revolution has dramatically enhanced the role they play in our lives. In fact, the internet itself is a platform (in fact at this point it's evolved into a platform made up of many subplatforms: Wikipedia, Facebook, eBay, Pinterest, Kickstarter, and so on). The effectiveness of these digital platforms in connecting people with useful information has increased as the sophistication of search functions has increased. It is getting easier and easier for individuals to organize and sift huge amounts of information to find specific nuggets pertinent to the current problem they are researching (particularly helpful during the preparation phase of the creative process), and also to browse for serendipitously useful information to feed associative thinking.

Over the past few years a number of digital platforms have emerged that help museums share their content more effectively—through their own websites, through widely-used social media applications like Twitter, Facebook, and YouTube, and even through specialized collections-based sites like Historypin and Europeana. On her blog, *Museum 2.0,* Nina Simon has argued that museums themselves should be platforms for visitors to create, remix, and interpret content—she calls for them "to harness, prioritize, and present the diversity of voices around a given object, exhibition, or idea."[3]

If we are working to build a creative museum field, we have to be conscious of when these platforms are open and when they are closed. To be our best creative selves, we need platforms that are open, creating what Johnson would call a "liquid network," where knowledge and ideas flow freely without boundary, reaching as many minds as possible.[4] And not just museum minds, minds outside our field as well, to foster cross-pollination. Although most museums now operate from an abundant point of view in making their collections accessible to the public, in terms of sharing professional practice resources with each other we still regularly operate from a culture of scarcity. In so doing, we all have contributed to a less liquid network. Our journals and publications, for example, in the model of our academic colleagues, often remain behind paywalls, while vast amounts of our collections are freely shared with the world through online catalogs and databases. Professional organizations create closed platforms in order to offer access to specialized information as a benefit of membership. And individual museums regularly overlook the importance of sharing the information and ideas they develop: a 2012 blog post by the Center for the Future of Museums calls attention to just how much useful information generated by individual institutions is "proprietary, locked up in a file cabinet somewhere, probably forgotten even by the people who commissioned it," including the following:

- Analyses of attendance and revenue after admission fee changes (free to paid, paid to free, raising or lowering)
- Attendance projections (with details on methodology)
- Branding studies
- Community studies that pave the way for tax or bond proposals
- Crossover studies looking at cultural and/or leisure activity audiences that overlap with museum audiences
- Exhibitions: cost, size, ROI; traveling exhibitions' impact on attendance and revenue
- Large format film research: cost of building and operating theaters, income, ROI
- Measuring community impact, including non-economic metrics

- Niche marketing analyses
- Visitor demographics/psychographics, with a particular need for info on bilingual audiences[5]

Museum workers are not the only ones dealing with a liquid network that trickles instead of gushes. Other fields face this same challenge as everyone debates open access and searches for sustainable financial models in the digital world; to some extent it is an issue with the particular stage we are at in the Information Revolution. Nonetheless, more active engagement throughout the field in encouraging the free flow of unrestricted information on open platforms would help us all. Imagine if:

- You could do a keyword search across all the siloed museum discussion groups at once.
- You could see not only the articles published in all the museum journals and museum blogs at once, but also archives of recorded conference sessions, and all sorts of documents created by individual museums.
- There were a place where museums routinely posted their new ideas and projects, and the resulting outcomes, so you could understand everything that has been tried before and how it worked.

ExhibitFiles is one example of an open access museum platform. The development team articulates its raison d'être this way:

> We developed ExhibitFiles to preserve and share experiences and materials that are often unrecorded, temporary, and hard to locate. Museum exhibitions change, so does staff, and knowledge is often lost. We think it's important to build on what others have done and learned and to open our work to comment and review.[6]

Case studies and exhibition reviews are fully accessible to anyone who visits the ExhibitFiles site, and although this platform is mainly used by exhibition developers and designers, it is free and open to all (with more than 2,500 members and counting from around the world). The project was developed by the Association of Science-Technology Centers and initially supported by a

Your Creative Practice

A More Liquid Membership

Like many organizations, the New England Museum Association (NEMA) lost members pretty dramatically during the recession, so we needed to envision a way to recruit and retain them more effectively. I began speculating why some museums treat their NEMA membership like a magazine subscription—nice to have, but not essential when times are tough. I realized that, in most cases, only the museum CEO had direct contact with NEMA and experienced the benefit of the membership; most of the museums' employees and trustees had little or no involvement with our organization, which purportedly serves the entire museum field in our region. So we came up with the idea of an "Institutional Affiliate Membership" program and launched it in 2011. It allows all employees and trustees to opt into a free NEMA membership as long as their museum remains an institutional member. Since we started the program, we've more than doubled our membership base with the addition of 1,300 of these affiliates, and we also gave our member museums a stronger reason to retain their relationship with NEMA. While at first glance it may seem like we gave away something for free, lowering the bar for participation has only increased the power of our network. Other organizations are watching our progress closely and, I understand, adapting the idea for their own purposes, which is gratifying.

Dan Yaeger, Executive Director,
New England Museum Association, Arlington, Massachusetts

National Science Foundation grant. Although science was its original focus, museum workers from all manner of disciplines have found it useful, and now featured projects range from "Teen Miami" to the "Secret Life of Objects," focusing on Finnish design.

But we dream of something bigger, something that cuts across all types of museum work and all types of museum workers: a giant open platform that integrates the creative work of the *global* museum field under one huge umbrella and eliminates the need to look in twenty different places, half of them password-protected, in order to see what has been done, written, and learned already about a particular museum topic. Because of the organic nature of the digital world we realize such a truly liquid network is unlikely to happen, at least not anytime soon. The closest we have seen so far is Europeana, a platform for sharing all the collections of European cultural institutions in one place. Europeana is about collections, not museum practice, but it has managed to bring together a vastly diverse group of stakeholders—2,200 institutions in thirty-four countries—to participate. In so doing it has opened up knowledge and ideas about these collections on a completely new scale, providing exploration of major themes like immigration, scientific discovery, and Art Nouveau from a multinational (and multilingual) perspective. Europeana views its tasks, as noted in its strategic plan, to aggregate content and distribute it widely, facilitate knowledge transfer, and engage the public in cultural heritage participation.[7]

What would an organization or a platform that undertook those same tasks—aggregate, distribute, facilitate, and engage—for our creative professional knowledge look like? While we wait to find out, each of you can work to improve the liquidity of our shared network by advocating for open platforms and ensuring that the information you create is easily accessible to colleagues everywhere. In addition, because one important aspect of creative work is drawing inspiration from a wide variety of sources, each of you can continue to expand your own creativity by dipping a toe in someone else's pond. That might mean checking out Registrar Trek, for example, or lurking on the Association of Children's Museums LinkedIn discussion group. And those groups should welcome all of us. Our professional organizations need to move from gatekeeping knowledge to facilitating information flow. The AAM has taken an important first step by opening up participation in its topic-specific professional networks to all. Let's take more steps together.

Your Creative Practice

The Birth of Registrar Trek

I was emailing with a South American colleague, Fernando Almarza Rísquez, about the fact that most professional resources for registrars are written in English, which becomes a huge barrier for people in the professional field outside of the UK/US. We said: okay, we are only two museologists coming from two different cultures and paths. Fernando is a former registrar in contemporary art and now Professor for Registration Methods and Documentation at the Instituto Latinoamericano de Museos in Costa Rica. I am a collection manager in a science and technology museum in Europe. We had both written articles about registration topics. We said: let's start with that. Let's translate them and put them on a website in the three languages we can provide, and maybe others will join. After we translated our articles we looked for platforms to share them. But we realized there weren't any appropriate platforms out there for registrar topics, even though responses to a LinkedIn post showed there was interest.

I had a web address I wasn't using, so I suggested putting our two articles there in three languages to start. Then I came up with a short story about object research; Fernando had stories to tell, too. Other sections of the site followed: Registrar's Humor, "Think Again" for philosophical pieces, FAQ. The site went live in January 2013 and within twenty-four hours, Liliana Rego posted that she was willing to begin translating it into Portuguese. Other writers have joined us, too. We are still developing, but already we can see so much potential for expanding knowledge and expertise.

Angela Kipp, Registrar Trek, Mannheim, Germany

Networking

Platforms connect us to information, but they also connect us to people. And these networks of people—colleagues—are essential to creativity, not just because they support the free flow of information but also because they provide opportunities for deeper, sustained interactions and thoughtful, professional dialogue. Most of us consult a small group of colleagues regularly, subscribe to an online museum discussion group or two (which we may or may not read regularly), and perhaps get to some sort of museum conference once a year. What would it look like to step up our game in order to boost creativity across the field?

In the United States and elsewhere, large professional gatherings at the regional and national level are still one of the most important ways that most of us learn and connect with our peers. In recent years, many organizations have experimented with changing approaches at these conferences. Some of those experiments include:

- The unconference, where the agenda and sessions are created by participants at the beginning of the meeting, not months in advance, based on what's most pressing and interesting to the group. A concept that originated in the technology field, the unconference allows anyone who wants to initiate a discussion to claim a space and time to do so.

- An online system developed in 2012 by the AAM so that the session proposal process for its annual conference would be more transparent and encourage new voices. Anyone can submit a proposal, and the entire museum field is invited to evaluate proposals and make suggestions before they are reviewed by the program committee. The number of proposals doubled in the first year, and potential presenters were able to develop stronger sessions and connect with potential collaborators. AAM made significant revisions to the online system again in 2013, reminding us that just because a new process isn't perfect the first time around doesn't mean it's not worth trying.[8]

- Dinner discussions now cropping up at several conferences, where small groups meet at a local restaurant at the end of the day's sessions, sometimes to address a specific museum

topic and sometimes for free-form conversations, allowing for a more introvert-friendly networking environment.

■ The Museums in Conversation conference sponsored by the Museum Association of New York, where organizers, with some success, specifically ask for session proposals that are designed as conversations, rather than presentations.

■ Alternative session formats now offered at many conferences—not just three-speaker panels but town hall-style forums, workshops, flash presentations, facilitated small-group discussions, speed networking, and simulations.

These experiments are a step in the right direction, but as conferences become more and more expensive to mount and to attend, many of us face uphill battles in order to justify the value of networking to our museum leadership. Perhaps as a field it is time to re-think and re-articulate the benefits of conferences, above and beyond tweaking the format here and there. How can conference connections be made deeper and more meaningful? Are skill-building opportunities one thing and networking/dialogue opportunities another? What can we do to sustain and strengthen networks after the conference is over?

Conferences are not the only way we can network. Randy Roberts and Rachel Tooker from the Crocker Art Museum, along with project consultant Daryl Fischer, shared with us their three-year, Institute of Museum and Library Services sponsored initiative to engage family audiences. The project included site visits by Crocker board and staff to three other art museums, and these face-to-face visits became the catalyst in establishing a longer-term, multi-institution cohort for creative practice. Daryl Fischer described the impact:

> The professional development outcomes kept expanding, like the ripples in a pool. From Crocker staff to the colleagues that hosted them at site visits to colleagues from museums across California who came to a two-day Pushing Our Practice Exchange. And now, with the publication of two booklets inspired by POP-Ex, the collective learnings about creative practice will be shared with the profession at large.[9]

Because this particular networking opportunity has involved sustained connections among a relatively small number of colleagues, from institutions that are facing similar challenges, they have developed trust and mutual understanding that has allowed them to push past a superficial communication level and on to deep, thoughtful dialogue around shared issues. How might you build a similar cohort to support your own creative museum practice?

We are also encouraged by informal professional groups that have been organized in some towns, where local museum people get together once a month over coffee or lunch to trade news and talk shop. One of the points made in the creativity literature is that often it's not the meeting agendas, the focused discussion group questions, or the planned and vetted conference sessions that lay the groundwork for fabulous new ideas; instead, informal, wide-ranging conversations about subjects people happen to be interested in that day are just as important as structured meetings and exchanges with pre-set topics or agendas.[10] If your town has such a group, please start viewing it as essential, not optional. If your town doesn't have one yet, please start one.

Your Creative Practice

Building a Network
One Costume at a Time

For more than a decade the Small Museum Association has hosted a costume banquet as part of its annual conference. When "Survivor" first appeared on our TV screens, a costume (and conference) theme was "surviving." We've done pirates, Roaring 20s (that was for the twentieth anniversary conference), Mardi Gras, 1960s, Disco, and superheroes. We've eaten bugs, held dance contests, made toilet paper gowns . . . you name it. This custom has encouraged fellowship, creativity, and camaraderie.

Pam Williams, Manager,
Bowie Historic Properties and Museums, Bowie, Maryland

Grants Girl

In terms of my own Small Museum Association banquet costume this year, I knew I wanted to do something related to my job, since at this point I'm a step removed from museums. But I just wasn't feeling inspired until the Saturday before the conference. My husband and I were lying in bed, and I was muttering about how I still didn't have a costume, and I needed a superhero persona, and what would my attributes be if I were Grants Girl. My husband immediately started coming up with ideas—obviously a bag of money was a requisite. But what else is associated with grants? Fine print! So I needed a magnifying glass to read it. Red tape! So I needed a pair of scissors to cut through it. He suggested a red pen for grants reviews. So that was Grants Girl. Then we decided that my nemesis was really Red Tape, and wouldn't that be a great costume, too? The Crimson Band, wrapped in red ribbon, throwing red streamers. So we suggested that costume to a colleague, and she ran with it. It was actually lots of fun to distill down the issues and complaints associated with grant writing and turn them into a hero and villain. And I have to admit, it's even gotten me thinking more deeply about improvements we could make to the funding system.

> Jennifer Ruffner, Assistant Administrator,
> Heritage Areas Program, Maryland Historic Trust,
> Crownsville, Maryland

Networking gatherings don't have to be serious in order to be productive—they can be as simple as people from different museums (not just one institution) talking in small groups about their current projects. For example, the new "Drinking About Museums" movement has been popping up in places like Denver, Washington, DC, Boston, and Sydney, where colleagues across the city get together at a café or pub for socializing and museum talk after work. Or, for a little more flare, consider Museums Showoff in London, an informal bi-monthly museum open mike night. Using a sign-up sheet, each presenter gets nine minutes to show and tell, pitch, or generally show off. The creatively inspired presentations have ranged from Aidan Goatley "talking about my childhood desire to be an astronaut, the science museum, my dad the engineer, and why I never made it into space" to Rebecca Mileham and Dea Birkett sharing "examples from their collection of terrible museum text, and [inviting] entries into the all-new Bad Text Awards," and to Becky Clark exploring "how poets have found inspiration from the 'bric-a-brac' by reading, as energetically and engagingly as she can, some of the many poems inspired by museums."[11] Meanwhile, at the Maryland Association of History Museums Brew and Review event, colleagues join together, after work, to share thoughtful criticism of exhibitions, signage, school kits, and other museum projects. With any of the events mentioned here, the networking across institutions can easily be continued and extended into virtual space long after the face-to-face meetings.

Increasingly, emerging museum professionals are taking the lead in coordinating networking events—and hopefully their efforts will continue to expand in the coming years. Dozens of Emerging Museum Professionals groups, all run by volunteers, now exist around the United States, from Boston to Seattle. They maintain an active presence on social media, and host a wide variety of informal, in-person meetings, from book discussions to happy hours. What is most exciting about these events is that they are laying the groundwork for an entire generation of museum workers to develop a higher expectation about their level of connection across the field.

Your Creative Practice

Organize Early and Often

The Emerging Museum Professionals groups have created an early national network of the next generation of museum leaders. We all know each other, yet we are all over the country. There's always someone to email or text or tweet if you are traveling, or if you know someone who is relocating, you can find them a local network to tap into. This is so crucial, as the field is more and more who you know and who they know—and less and less what you've done, your degrees, your personal accomplishments. It is network-driven, for sure.

Kate Burgess-Mac Intosh, Co-Founder,
New England Museum Association Young and Emerging
Museum Professionals, Boston, Massachusetts

Try This:
Start the Conversation

It's hard to approach someone you've never met before to start a conversation; it doesn't necessarily happen spontaneously. If you ever find yourself in charge of a room full of museum professionals, make it easy for them to network by orchestrating those approaches. Divide the room into random small groups and offer them a topic or question to get started. In a crowded conference session, give everyone a reason to interact with the people on their right and left. As participants arrived at the 2012 Smith Leadership Symposium organized by San Diego's Balboa Park Cultural Partnership, they each received a Bingo card in their packet. The card featured photos of each of the speakers, jumbled around in random order. If you participated in a session with a speaker or interacted with them directly, you could check off that square on your card. At the closing session, those who reached Bingo submitted their cards for a drawing. Linda was a speaker from out of town who was not personally known to many in the crowd, and the Bingo game meant that participants who might have been reluctant to approach her directly sailed right up and into conversation.

How else might we extend the networking power of the field and provide each of us with more opportunities to interact with museum professionals we don't know yet? This year the Art Museum Teaching forum started a summer Google Hangout Book Club: everyone reads a specified museum book and then comes together online, regardless of real-world location, to discuss how the theories in the book apply to day-to-day museum work. Or, could we make it a widely known and accepted practice that museum professionals traveling from out of town will not only receive reciprocal free admission but will always be welcomed at the museums they visit for coffee and informal shop talk with the staff (as long as they call/email/tweet ahead to give a little advance notice)? Such a welcome mat policy might also help with geographic cross-pollination, particularly if we establish a "leave an idea, take an idea" tradition, where the visiting museum worker is expected to identify one interesting idea he or she wants to tinker with back home, and share one interesting idea from his or her own experience that the hosting museum might want to implement. Another possibility: could we start holding quarterly regional un-conferences—with very little planning or infrastructure required—where museum workers can spend a day talking over their current projects and challenges in a flexible, "free-range" setting? Could we encourage "spot mentoring" sessions, a chance to quickly connect with a colleague around a specific issue?

And one more: academic sabbaticals provide a chance for tenured professors to recharge, to pursue research interests, and to connect with colleagues. Museums could find ways for their staff members to do the same thing. Maria Mingalone of the Berkshire Museum was burned out, and in ordinary circumstances the answer might be just to do less at work, become more crabby, or look for another position. But the museum's director, Van Shields, suggested another alternative—creative disruption. Maria's two months in California, volunteering and networking at several museums and continuing to work on a specific Berkshire Museum project, brought her back rejuvenated.

Research and Development

Opening the flow of information is one issue; increasing the amount and quality of information is another. Heritage Preservation's 2005 *A Public Trust at Risk: The Heritage Health Index Report on the State of America's Collections* is a sterling example of the reasons for and potential impact of field-wide shared data and research. The report (fully available online with multiple ways to dive into the data) gained significant public media coverage and led, in part, to the national Connecting to Collections project. It is a model for the kind of meaty information that strengthens the preparation phase of the creative process for all of us—in this case by bringing clarity to a field-wide problem in need of solutions. It is also more of an exception than the rule.

Many businesses in the for-profit sector long ago established research and development departments to experiment with new products and strategies, analyze trends, and think about the big picture. How and where is research and new thinking on museum practice generated in our field? First, there are the individual museum workers, who coax journal articles, conference presentations, and blogs into being, usually on top of their regular job responsibilities or in their spare time after hours. They work really hard on these labors of love, almost always for free. You know these people; in fact, some of you are these people. Then there are the individual museums. They carry out focused R&D projects based on their own needs—visitor studies, feasibility studies, market research—generating customized insights that may or may not be useful to, or disseminated to, other institutions in the field. Occasionally, grant programs specifically encourage research and development that benefits the entire field—the USS Constitution Museum's Family Learning Forum, funded through an Institute of Museum and Library Services National Leadership Grant, is one example.

Then there are non-museum entities who study the field. Consultants are contracted to provide R&D services to individual museums, but they also sometimes take the lead in drawing attention to issues and highlighting solutions that affect all museums, not just their clients—witness the recent impact of John Falk's *Identity and the Museum Visitor Experience* or Susie Wilkening and James Chung's *Life Stages of the Museum Visitor.* University professors also produce books and articles

based on their specific research interests, and many professional associations commission occasional reports on specific topics deemed of use to their members. The Museum Association of New York, for example, has produced white papers and field reports on issues such as succession planning, the museum value proposition, and the effect of the economy on New York State's museums. Newer efforts, including the American Association for State and Local History's Visitors Count program, the AAM's Benchmarking Online, and the Cultural Data Project, are all accumulating significant amounts of data, available to project participants but not yet freely available in the aggregate. We even have a few think tanks: here in the United States the Center for the Future of Museums is the most robust and wide-ranging, generating and highlighting a wide variety of creative, future-oriented research for the field. The Institute for Museum Ethics, the Art Consortium, and the Getty Leadership Institute also come to mind. Through our work in Europe we have come across others: the Institute for Museum Research in Germany, MELA (European Museums in an Age of Migrations), and LEM (the Learning Museum project).

Does this strike you as dribs and drabs, as if big-picture, field-wide research is something you do with spare change and is not essential, core work? Creativity needs information and research to thrive. Imagine if we had the brain power of a massive think tank like the Pew Research Center or the Aspen Institute trained on the work of museums: commissioning studies, experimenting with new practices, and disseminating their research throughout the field. Imagine if it was someone's job to make sure all the areas of inquiry the field needs are covered, instead of us all relying on the museum worker writing on a Saturday, the specific interests of the paying consulting client, or the highly skilled but selective academic? Imagine if our field regularly convened groups of experienced professionals from different institutions to tackle museums' most pressing problems. Imagine if big data—numbers crunched from thousands of institutions all at once—played a role in museum practice. We need many more people whose job it is to think hard about museums and how we can make them better. Can university museum studies programs step in and fill some of this role? (We are thinking here of some of the interesting research generated in the UK by the University of Leicester's School of Museum Studies.) Can professional associations support more research and development, and if so, how would they fund it? And of course, in a notoriously

conservative field, how can we encourage, disseminate, and foster the adoption of new practices based on research and development?

A few bright spots are emerging that might point the way to future potential. After years of discussions across the field about whether "starchitect" building projects are a good thing or a bad thing for museums and their communities, discussions that rely mainly on anecdotal evidence and individual case studies, the University of Chicago Cultural Policy Center put out a 2012 report analyzing the cultural facilities building boom in the United States between 1994 and 2008. The research team studied more than 700 construction projects, along with copious economic and demographic data, and found that there was a significant overinvestment in these capital expansions, with supply exceeding demand. Specifically for the museum projects included, the study determined that the desire for the prestige of a signature building and the vision of the architect (as opposed to the needs of the institution or the community) often drove project decisions, resulting in construction exceeding budget an average of 46 percent, frequently accompanied by eventual staff layoffs and cuts to vital programming as the institution struggled to reach financial equilibrium post-expansion.[12] The detailed analysis from this broad research project will hopefully help museums across the field see the big picture more clearly and make thoughtful, inspired decisions that are right for their institution, based on lots of good information, creative thinking, and experimentation.

Another bright spot: as this book goes to press, the California Association of Museums (CAM) is working on a crowd-sourced initiative to address a significant critical issue facing California museums. Museum workers from across the state were invited to submit brief descriptions of problems of common concern, and through an online voting process, CAM will choose one to work on "together through statewide knowledge sharing and collaborative applied research."[13] More of this kind of broad-based, multi-institutional approach to the same rocks that keep appearing in all of our shoes could truly spell creative change for the field.

Try This:
Hackathon

"Hackathons" come from the world of software developers, but they can be used in a museum context as well. The concept is not unrelated to the small museum staple, the volunteer work day, where volunteers come out to paint shutters, mow the lawn, and clean out spaces to ready them for the season; the difference is that hackathon participants don't just provide free labor, they also generate ideas. Consider turning that volunteer day into a city-wide or conference-wide hackathon where volunteers and staff band together (in newly formed groups) to address an issue that affects multiple museums (perhaps one of the issues raised in this chapter). Start the day by introducing the hack challenge and give participants time to brainstorm ideas in small groups. Then each small group pitches their best ideas to the entire room, and participants vote with their feet as to which ones they want to work on for the rest of the day. Expand your network and invite new individuals in—and stop worrying about control. Make it a high-energy event with plenty of food and ask the hack teams to report back at the end of the day to the full group. And then be sure to think about ways to keep in touch with participants moving forward, both to share results and to continue the conversation. A quick Google search will yield additional resources online for planning your hackathon.

Funding for Creative Practice

The more we learn about the creative process in workplaces, the more we are concerned that, at least here in the United States, museums innovate *despite* the funding system instead of *because of* it. Here, we are talking in particular about grant funding, although these issues often apply to corporate or individual major gifts as well. During our research for this book, we heard from colleagues about several key problems with current funding practices in terms of support for creativity. First, funders require too many details to be pinned down before a museum submits a proposal or makes an ask—this expectation may encourage incremental improvements based on prior successes, but it doesn't allow for the kind of open-ended experimentation that leads to transformative ideas. Second, funding sources that require a panel of experts or a committee of stakeholders can stifle creativity—in order to submit the most competitive proposal possible, such groups are stacked with very established, senior people, safe bets, who tend to coalesce around established, tried and true methods instead of risky new ideas. And third, an emphasis on project-based funding, instead of long-term (more than three years) or operating support, doesn't allow enough time—for innovative practices to become rooted in an organization, for successive iterations of an experiment to take place, or for full understanding of the impact of a project—before the funding cycle ends.

It is perfectly logical that funders would want to control for success by requiring a carefully thought-out plan that consults multiple stakeholders, quickly generates results, and focuses on measurable outcomes. They want to ensure that their investment in an organization is as effective as possible. But has this system made us too risk-averse, in a field that already skews that way to begin with? Have we gone so far down this path that there's no room for experimentation, failure, or letting the creative process drive the outcome? We seem to be operating from a position that 100 percent of funded projects should be successful, which simply is not realistic if you also want to produce a lot of projects that are groundbreaking, innovative, and transformative. Paying careful attention to this funding model is crucial because one of the perceptions—real or imagined—that many of our colleagues hold deeply is that risky, creative projects will alienate their funders—whether foundations, wealthy board members, local businesses, or museum members.

Your Creative Practice

The Anarchist Guide to Historic House Museums

The other night I was reading some poems by e.e. cummings. At first I was unable to decipher the text, the syntax, and the narrative—it seemed almost wholly incomprehensible. It wasn't until I took out my red pen and started a process of trial and error with the narrative that I began to see language out of mere letters. The page ended up being this messy, scribbled out, mass of failed attempts of understanding. Finally, I saw this amazingly beautiful and subtle song of poetry grow out from what looked like chaos. In the same way I struggled with the e.e. cummings poem, I think too often funders see grant applications that are made up of letters; rarely do they see language. By language I mean a point of view—a real, innovative idea—potentially greater than itself.

In successfully applying for funding from the New York Community Trust (NYCT) for a pilot program to test out concepts derived from "The Anarchist Guide to Historic House Museums," a community-based approach to historic sites that I have been developing since 2012, I worked closely with the NYCT program officer to understand their perspectives and goals. Once I understood those issues I could frame the application in a way that benefited both the funder and my organization. Our test project is the Lewis Latimer House, the home of African American inventor Lewis Latimer located in a diverse residential neighborhood in Flushing, Queens. The house currently lacks collections, programming, or staff, but does have a compelling narrative and the opportunity to be a vital community resource.

I embedded into the grant application a section called "Fail?—Try again." I openly acknowledged that we would fail and that we were not going to give up. We would keep trying to test innovative ideas. I was told that it was the first time they had such an open, honest acknowledgment of failure as part of the process. I made it clear that anything was better than nothing—and that the only way to get to true innovation is to "let the chickens out of the pen."

Franklin Vagnone, Executive Director,
Historic House Trust of New York City

163

Seb Chan, Director of Digital Emerging Media for the Cooper-Hewitt National Design Museum, highlights two additional funding problems in a January 2012 blog post. Chan, who recently moved to the United States from Australia, was reflecting on the differences between the two museum systems. First, he writes that in the United States, "the primary funding model (private philanthropists, foundations and big endowments) isn't conducive to broad collaboration or 'national-scale' efforts. Instead it entrenches institutional competition and counterproductive secrecy. A lot of wheels get reinvented unnecessarily." He then goes on to point out that the American reliance on project-based funding means much of a museum's most creative work is contracted to outside vendors, which limits the museum's ability to develop a learning culture where each new project teaches the staff more and more about their creative capabilities. These contract projects "rarely have the chance to have significant institutional impact on the core. The 'creative agency' gets all the learnings from the project—and the museum acts in a 'commissioning' role."[14] In other words, not only does the funding system encourage museums to play it safe, it also encourages them to silo and outsource creative practice.

Although the funding deck seems stacked against creativity, a few relatively new museum grant programs are experimenting with a different model, one that takes steps towards collaboration and creative learning:

■ ***Sparks! Ignition*** Started in 2011, this Institute of Museum and Library Services program awards $10,000 to $25,000 to museums to "support the rapid prototyping and evaluation of promising and groundbreaking new tools, products, services, or organizational practices." The guidelines go on to say, "You may propose activities or approaches that involve risk, as long as the risk is balanced by significant potential for improvement in the ways libraries and museums serve their communities," a promising if still cautious step toward recognizing that transformative ideas require some failure along the way.[15] In the first two rounds of funding, projects included a partnership between the Philadelphia Please Touch Museum and the Philadelphia Zoo to pilot a training and retention program to hire and retain employees who come from surrounding neighborhoods; experimental strategies for deepening visitor loyalty at the Santa Cruz Museum of Art

and History; and a new legal framework being developed by the Southern Ute Cultural Center and Museum for institutions that store artifacts without formal transfer of ownership.

- *No Idea Is Too Ridiculous* An initiative of the Pew Center for Arts and Heritage, No Idea Is Too Ridiculous works with one small group of public history organizations at a time in the Philadelphia area to develop risky projects. Staff teams from the participating organizations start with a two-day workshop to develop their ideas; then they have eight weeks and $1,000 for hard costs to execute them, thinking along the way about creative practice issues like "indicators of successful failure." Ideas that have been funded include the Bucks County Historical Society's series of "adult" programs about Victorian sexuality and a musical finding aid, commissioned from five local composers, for the Mary Elizabeth Hallock Greenewalt Papers at the Historical Society of Pennsylvania.

- *Innovation Lab for Museums* A partnership between AAM and EmcArts that is funded by MetLife, this program awards three museums $40,000 each to try out a "half-baked idea" with potential for innovation, and then holds their hands for up to two years to help make it happen. Funded projects have included re-imagining historic house museums at the National Trust for Historic Preservation, a learning network to engage Latino communities based at the Levine Museum of the New South, and the development of a model for involving kids as experts in conducting research and creating exhibitions at Madison Children's Museum. Ideally, each of these projects and lessons learned will live on the web, where we all can gain insights from them.

A review of these grant programs yields a few commonalities. First, the proposals involve a lot of questions—the projects are set up as an exploratory process instead of one where all the answers have already been determined. Grantees present more like startups looking to test the market than established, grande dame institutions that figured everything out long ago. Second, the funders make some room for risk and failure. And third, two of the three programs create learning cohorts and support systems where staff members from funded museums meet to workshop their ideas and reflect on their creative practice as they cycle through the grant program.

These themes are reflective of a potential trend in nonprofit funding as a whole that is sometimes referred to as "creative philanthropy." In a book about this trend Helmut Anheier and Diana

Leat call for, among other things, a shift "from evaluation and performance measurement to risky learning," to find more flexible and long-term methods of evaluating fundees that make room for learning from failure.[16] Creative philanthropy also involves active, strategic engagement on the part of the funder with system-wide problems and solutions, above and beyond individual funded projects, and more of a partnership between funder and recipient, where the funder might provide a number of forms of assistance besides just money—coaching, staff training, field-specific research or networking, and collaboration matchmaking.

Other philanthropy trends are trickling down into the museum field. Kickstarter, with the motto "fund and follow creativity," presents an entirely different model, where funding requirements and measurable outcomes play very little role—it's all about whether the project is unique and compelling, and how effectively the individual or organization can promote it. A number of museums are experimenting with Kickstarter—to fund oral history projects, artifact conservation, exhibition components, art installations, and even the creation of new museums. The now-global project Sunday Soup provides an even smaller scaled model. Soup is made and sold, projects are pitched, and the guests decide whose creative project gets the evening's proceeds. Although it is clear Kickstarter, Sunday Soup, and other crowd-sourced funding efforts are not the magic bullet that will solve our field's funding challenges, in some situations they do present a useful method of supporting experimentation and creative practice and may be of particular importance to small museums' creative experiments.

What other changes could be made to the museum funding model—on both the funder side and the recipient side—to support creativity? Here are some suggestions:

Develop Risk-taking Capacity

Kristin Herron, Program Director, Architecture + Design | Facilities | Museum at the New York State Council on the Arts, told us it is easier for funders to support an experimental project when the museum has built a track record of taking risks: "If they start with small projects and gradually increase capacity, being honest about their challenges and also what they have learned along the way, the review panel tends to respond positively. In fact, we welcome such proposals; they're

refreshing."[17] Consider how you can work your institution's previous experimentation or prototyping into proposal narratives such that risky projects don't feel like they are coming out of left field.

Build Learning Cohorts

It is so important that No Idea Is Too Ridiculous and Innovation Lab for Museums bring grantees together for workshops and discussion while they are embarking on experimental projects. Many museums need networking and coaching while they are learning how to build a creative culture. Can we develop this kind of funding infrastructure on a larger scale, initiated either by individual funders or by recipient museums?

Encourage Learning from Failure

Would the field benefit from small prizes to organizations that can articulate what they learned from a recent failure, and how this learning will change their work moving forward? (On the flip side, a June 2013 *Chronicle of Philanthropy* article reported that some leaders in the philanthropic community are calling on their peers for more transparency in sharing the details of funding efforts that fail so that funders can learn more, too.[18])

Advocate for Prototyping Spaces

Some museums are now creating lab spaces where public audiences can expect to experience works in progress or experimental ways of thinking about what a museum can be. Arizona State University Art Museum's InterLab, the Powerhouse Museum's beta space, the BMW Guggenheim Lab, and the Walker Art Center's Open Field are all explorations in ongoing public prototyping. While we could make a case that experimentation should happen throughout the entire museum building instead of only in certain designated places, we see these labs as a step in the right direction, one that can model creative practice to the entire museum staff, to colleagues at other institutions, and to the public. Therefore, they warrant support on a broader scale.

Try This:
Invest in Idea Incubation Teams

In "Entrepreneurship in Historical Organizations" John Durel describes the process of creating an innovation cycle to prototype new initiatives. A museum sets up a small pool of funding to support experimentation, a time frame—Durel suggests $1,000 and three months per initiative—and a cross-institution team of workers to manage it. During each short-term innovation cycle ideas are generated (anyone at the museum can propose one), tested through prototyping, and evaluated to generate lessons learned. At the end of the three months the museum decides whether to keep the project going or to scrap it, and another three-month cycle starts all over again.[19] This new initiative funding could be scaled to any size organization with any size budget. Try approaching a funder to sponsor such ongoing experimentation at your museum.

Professional Training

Not all museum workers have formal university training in museum studies at the undergraduate or graduate level, but such a degree is a well-traveled route to a museum career. Many of us remember our museum studies courses as our first opportunity to catalog an artifact, write a grant proposal, or design a school field trip. The skills taught in these programs are part of learning how to be a contributing member of our profession, of developing domain-specific expertise. But is that enough?

There has never been a clear consensus on the best way to train museum professionals. Some people believe a subject specialty—archaeology, biology, art history—is more important than a museum studies degree. Others insist that on-the-job training is the only instruction that matters. Still others think that non-profit management—budgeting, strategic planning, donor cultivation, board development—is as crucial as the nuts-and-bolts museum skills. We got a taste of the diversity of viewpoints on this subject when we held an electronic brainstorming session about reinventing professional training as part of our experimentation for this book—one of the reasons we didn't get very far with the idea generation is because there was little agreement regarding what exactly it is about museum studies programs that needs to be improved.

Your Creative Practice

Extending the Learning

I am the senior site manager at a house museum in Portland, Maine. Like many museum professionals, I ended up in this position because of an internship from my master's program. I enjoy my job, the staff I work with, and the docents I oversee, but there are times when I feel stagnant as a historian. That's when I call on my friends from grad school and we start sharing our energy. I draw so much inspiration just from their Facebook comments about everything from the latest in museum practices, to thoughts on a local exhibition, or an interesting blog post about a little-known historical fact.

Lucinda Hannington, Senior Site Manager,
Victoria Mansion, Portland, Maine

Meanwhile, we have talked with a number of colleagues who teach in professional training programs and who are acutely aware of the complexities of educating the next generation of museum workers. They are watching as new museum studies programs appear every year, despite the fact that there are not more jobs. They are concerned about diversifying the field, not just in terms of race, class, and gender, but also in terms of skill set and approach. They have difficulty measuring their impact beyond anecdotal evidence about the success of individual students (something surely worthy of field-wide research). And, of course, they are negotiating the demands of the universities that host them, each with its own ecosystem, policies, and agenda.

Given the complex landscape of museum training, a stronger creative presence in museum studies classrooms could have a profound impact on the field. Imagine if these programs sent students out into the working world with an individual creative habit already in place, understanding how to contribute to the creative culture of their museums, and assuming that creative practice is standard best practice, not an exception. Teaching students to think creatively will help them tackle a host of challenges when working in museums, and help them adapt to a continuously changing cultural landscape. In ten years we want this book to go out of print—not because no one read it, but because it is no longer needed—and training an entire generation of museum studies students in creative practice would go a long way toward achieving that goal. Museum studies programs could expand their creative focus into the existing curriculum in the following ways:

- Talk to students about the creative process, intrinsic motivation, cultivating both deep domain expertise and also broad curiosity, and other key creativity topics
- Adopt a more imaginative approach to course design and assignments to model creativity to students (museum studies professors: you should have a creative practice of your own)
- Open up both individual courses and overall course requirements to interdisciplinary cross-pollination, encouraging museum studies students to take courses outside their home program and non-museum studies students to join in museum studies learning
- Provide many opportunities to observe both museums and non-museums (amusement parks, shopping malls, libraries, movie theaters) for inspiration; continually ask students to refine and redefine their thinking based on those observations

- Make room in the grading rubric for creative risk-taking
- Develop a learning environment where students actively participate in the care and feeding of the class's creative culture
- Encourage open-ended, divergent thinking, not one right answer
- Provide opportunities to work iteratively on a project, improving it over successive revisions instead of turning it in after one pass and moving on to the next assignment
- Set an expectation that students will debrief, evaluate, and reflect on their own work as well as other students' work
- Create an experimental lab space, perhaps in the university gallery, where students can regularly prototype a range of different projects throughout the course of a semester
- Consider creativity an essential element in all museum work, not solely for educators or exhibition developers
- Ensure that students leave with a toolkit of creative practices that they can put to use in any museum setting

But perhaps even more importantly, on a macro level, can creative thinking be applied to the overall concept of museum professional training to tackle some of the larger issues that go beyond the what and how of any one course or program? How do we:

- Recruit diverse students, not only so museums can better reflect the diversity of our communities, but also to open up museum thinking to new perspectives? (The field has been talking about this issue for a long time but it continues to be a significant challenge.)
- Better prepare students for the radical change and constant reinvention they are sure to face throughout their careers?
- Address the imbalance between number of museum degrees awarded and number of jobs available (perhaps by thinking more creatively about how museum degrees could be transferable to other fields)?

- Measure the positive impact of museum professional training, and improve programs accordingly?
- Respond to larger societal shifts in education—things like personalized, self-directed, and collaborative learning; alternative forms of credentialing; and massive online open courses?
- Make adequate room for valuable museum workers who enter the field through other paths besides museum professional training?

In addition to formal degree programs, we all might think about creativity's role in informal continuing education opportunities—the workshops and symposia offered throughout the field on an ongoing basis, often by museum professional associations. These training sessions are an opportunity for museum workers to continue to develop expertise throughout their career, to gain exposure to creative practice, and to form networks of support for those who are attempting to seed creative cultures at their home institutions.

For example, New York City Museum Educators Roundtable sponsors a creative variety of professional development programs, including a three-session evening course on improvisation. Meanwhile, the Institute for Cultural Entrepreneurship for Museum Leaders, a collaboration between Cooperstown Graduate Program and the Museum Association of New York, provides a four-day boot camp for museum workers seeking to develop skills for creative problem-solving, change management, and financial sustainability. Participants develop an ongoing cohort of learners, during the institute itself and also through year-long follow-up webinars while each of them works on an entrepreneurial challenge at his or her home institution. According to Gretchen Sorin, Cooperstown's director, the institute has not only benefitted participants, it has also had a significant impact on the approach to teaching at Cooperstown. Could other professional organizations host workshops on developing a creative practice, prototyping, or leading for creativity? Amidst the growing interest in micro-credentialing, is it time for a digital badge in creative practice?

Measuring Our Museums

In an article for the twenty-fifth anniversary of the National Association for Museum Exhibition, Jay Rounds assessed the state of creativity in museum exhibitions, posing a question that could apply to all aspects of museum work: "When technical competence in exhibition development process has reached its highest peak, why is the 'creativity quotient' of the exhibitions perceived to be so low? Is it possible that things can be getting better AND worse at the same time?" In other words, does professionalization and a focus on standards kill creativity by encouraging too much conformity? Rounds continues:

> The dominant design [of, say, an exhibition or a museum] includes the definition of its own usefulness. So organizations become successful in part by promoting widespread recognition and acceptance of the field's dominant design. Trade and professional associations are formed for this exact purpose. As a result, when the staff come to feel that the dominant design has exhausted its potential, they are not free to change things themselves. They are part of a network that is a network precisely because of its shared commitment to the dominant design.[20]

Have we created a network that favors a certain 'dominant design' for everything that museums do, making it challenging for individual institutions or staff members to deviate in search of creative approaches and solutions?

Standards, such as AAM's Accreditation Program or the more recent StEPs program of the American Association for State and Local History, have, without a doubt, provided ways for the museum field to measure its work, and to provide some level of security to donors and funders. But have they encouraged creativity? The answer is far less clear. Despite what might appear to be museums' growing emphasis on audience, it often seems that the standards that receive the most attention are those that are easy to checkmark: disaster plan, check. Collections records, check. Financial balances, check. Far less easy to check off are items like lives transformed, community changed, workplace improved, creative culture encouraged. This may partly be an issue of the way the standards are structured and who develops them, but it is also an issue of museum leadership,

both board and staff, who choose paths that seem easier to quantify and achieve. Moreover, we may be coming to a point where some of our accepted standards are getting in the way of crucial work (or are having unintended consequences)—witness the intense discussion in recent years about the ways the deaccession standards tie the hands of small museums. Is it possible that our current standards are tying our hands in terms of creativity, too? And if so, how can we find a different approach?

In the United States, our voluntary standards emerge from the AAM, increasingly in partnership with other fieldwide organizations such as the Association of Zoos and Aquariums or the American Association for State and Local History. Anne Ackerson, former director of the Museum Association of New York, who worked on New York State's standards, commented, "Standards follow tradition. What pushes standards forward are people [organizations] pushing the envelope."[21] In reviewing the standards, we tried to imagine how a stronger focus on creativity might expand our concept of the purpose they serve.

We are not convinced that simply developing a new set of standards is the way forward toward a creative museum field—that's a conversation we would like to have with all of you. But thinking about what such standards would look like provides a starting point for that conversation. To that end, perhaps a creative museum:

- Not only seeks out diverse information, perspectives, and ideas from board, staff, community—everyone—but then also mixes, cross-pollinates, and shares them.
- Is willing to fail and learn from failure, understanding that managing risk and avoiding risk are two different things.
- Considers change as valuable as continuity.
- Approaches challenges as creative constraints rather than obstacles.
- Values and dedicates resources to curiosity and lifelong learning among its staff and the public.
- Builds creative confidence in staff, visitors, and the community.
- Recognizes the human dimension of work—aims for Seth Godin's open, generous, connected qualities—and has fun, too.

How could you measure such standards, to chart progress on an ongoing basis and better recognize creative successes when they occur?

- Do a 360-degree evaluation of not just your staff, but your organization as a whole. Ask board members, staff, volunteers, visitors, and non-visitors how you're doing. Really listen to the answers.

- Assess your exhibitions and other public programs. How many different formats are used? How many different perspectives are included? (For instance, if a highlight of your calendar is a monthly lecture series, who are the presenters?) Are there alternative voices? Who participates in content development?

- Together set an annual risk goal for the museum overall or each department. Ask everyone to try one risky thing, outside their own comfort zone. Embrace and appreciate those risks, whether they are failures or successes. Institute a best risk award or compile lessons learned from failure.

- Measure institutional creativity through the Center for Creative Leadership's KEYS to Creativity and Innovation assessment (well-respected, but expensive, with a current base cost of $2,000) or track staff well-being and creative confidence levels with a homemade survey. Pay attention to the peaks and valleys of their responses.

- Take an annual census of new things learned by staff or visitors. Record-keeping could be as simple as a bulletin board or a roll of butcher paper in a prominent place in the museum.

But here's the thing: we would rather you be exploring and experimenting and creating and transforming than worrying about an A+ in standards. Yes, act with good intentions—be ethical and smart, and by all means do something meaningful with the public trust you've been given—but don't sweat the rules so much. More than anything, standards are about where we set the bar, together, for our work. That bar should be set very high, at individual museums and across the field. But it needn't be made of steel set in concrete—it should bend and move when there are good reasons for it to do so. And all of you should bend and move with it, toward more interesting, rewarding, yet perhaps unpredictable careers; toward many divergent ways of being an awesome museum; toward an open, generous, and connected field that doesn't simply check the boxes but longs for the endless immensity of creative practice.

Everybody has a creative potential and from the moment you can express this creative potential you can start changing the world.

– Paulo Coelho

Chapter

5

Creative Museums,
Creative
Communities

Museums are uniquely positioned to help members of the public—children and adults—nurture their creativity by providing the raw material that feeds curiosity, by switching people's brains—and their motivation to use them—from subsistence level to overdrive, and by modeling active engagement—with one's environment, with other people, with knowledge, and with ideas. Indeed, as we have argued elsewhere in this book, stimulating creativity could be one of the most valuable public services museums provide in twenty-first-century society. The Partnership for 21st Century Skills has identified thinking creatively, working creatively with others, and implementing innovations as critical skills to prepare students for future life and work, and the Institute of Museum and Library Services here in the United States has adopted the Partnership's framework and developed initiatives based on it.[1] Meanwhile, the 2010 IBM Global CEO Study interviewed 1,500 CEOs from sixty countries, and these CEOs identified creativity as the most important quality for both business leaders and entire organizations.[2] In the twenty-first century, creativity is no longer optional; it is essential.

In light of this emerging trend in society at large, some museums may decide that creativity is a compelling defining objective, such that nurturing creativity in members of the public becomes their guiding mission. But even if that's not your institution's path, all museums—art, science, history, children's—of every size, in both cities and small towns, can find ways to weave creativity throughout their everyday work with their communities.

A core group of museums have already made a commitment to strengthening creativity in their public audiences. As you consider the ways in which creativity might move outward—from your own individual practice, throughout your institution, into your network, and into your community, these museums can provide leadership and inspiration. For example, some institutions have created departments or centers for creativity, including the Lemelson Center for the Study of Invention and Innovation at the Smithsonian National Museum of American History, the Center for Creative Connections at the Dallas Museum of Art, and the Center for Creativity at the Columbus Museum of Art. Through the work of these centers and through other sources like the 21st Century Learners section of the Institute of Museum and Library Services website and The Henry Ford's

OnInnovation.com, there is a growing body of useful online material for encouraging creativity within museum audiences.

Meanwhile, among children's museums in particular, there is increasing interest in making creative play a cornerstone of the museum experience. The research amassed at the Strong Museum in Rochester, New York, provides substantial evidence of linkage between play (for all ages) and creativity in many different settings. Specifically, play builds the "ability to solve problems, negotiate rules, and resolve conflicts; develops confident, flexible minds that are open to new possibilities; develops creativity, resilience, independence, and leadership; [and] strengthens relationships and empathy."[3] In addition to the Strong, the Center for Childhood Creativity at the Bay Area Discovery Museum, the aforementioned Lemelson Center, and the blog of the Children's Creativity Museum in San Francisco also provide a wealth of resources focused on developing creative play in children.

We have done our own thinking about creativity and museum audiences and put together the strategies below to frame discussions and planning at individual museums. You may find these strategies sound familiar—indeed, they are things many museums are already doing for the public. That's one of the reasons why museums are in such a good position to become the creative beating hearts of their communities: because they are halfway there already. But we need to strengthen the link between museums and creativity by incorporating these strategies more often, more actively, and more consciously, with creative practice in mind. And remember that a museum's efforts to encourage creativity don't have to be confined to its building; its contributions to creative communities can happen in many places—not only in museum galleries, but also in the digital sphere and out in the larger world.

Community Inspirations

Working creatively with others has not always been my strong suit. I usually like to draw, paint, bead, or make anything creative in solitude, where I can let my deepest thoughts guide me. Working in a museum has helped me to view creativity as more of a shared process. Curating exhibitions is a creative process that is more interesting as a group effort. One of my most recent favorite projects has been developing an exhibition on lacrosse with youth from my community. Lacrosse has many layers of meaning in Mohawk culture, so it was a great idea as a topic for youth to tackle.

The idea initially came from a casual encounter with a community member. To begin, materials from our collection and community members were shared with a group of youth participants. After that, they were given the reins in deciding the direction that the exhibition would take. They decided that it should be about the origins of the game—in Sky World, as part of our creation—and how that still informs us as Mohawk people. Not the sport.

It was great to be able to have the students' viewpoint—we ended up with an exhibition that was vastly different from what adults would have done. In addition to the well-received exhibition, students' creative abilities were enhanced and highlighted. But my own creative skills were changed as well. I went out of my solitary creative comfort zone to facilitate the creative work of others, by being true to our commitment to let the students' ideas be the focal point and to build the exhibition in the direction the youth laid out for us.

Sue Ellen Herne, Program Coordinator,
Museum at the Akwesasne Cultural Center, Hogansburg, New York

Embrace Free Choice Learning

The notion of free choice in museums supports creativity in two key ways. First, it allows museums to provide more room for experiences that are intrinsically rewarding. People are at their best creatively when they experience a high degree of intrinsic motivation. That is, they are thinking, learning, and creating for the joy of it—not because someone is making them, which is often the case with formal schooling.[4] When our museum audiences have a chance to explore what interests them in a self-directed manner, they are more likely to experience intrinsically motivated learning, paving the way for creativity.

Second, free choice learning supports open-endedness and divergent thinking rather than the quest for a single right answer. Creative ideas are hard to pin down. They don't fit into nice, neat boxes, because often they make entirely new boxes. It can be difficult to predict outcomes, final products, or impact at the outset—if we could predict these things, they wouldn't be new ideas. Therefore, creativity requires exploration, adaptability, and some measure of faith that something interesting will come of the process. Museums support creativity when they give their audiences a chance to experience what it's like to not know exactly where you're going but still have confidence that you will end up somewhere useful and interesting. Let's be clear that this doesn't mean you simply put your entire collection out on the floor and let members of the public fend for themselves in making meaning from it; museum workers play an important role in facilitating and guiding free-choice learning—by providing organization and context, quality information to choose from, and thoughtful questions for exploration. But stimulating creativity requires more than an omniscient expert voice that dictates one right answer and one appropriate next step at each point in the learning process.

The Exploratorium in San Francisco is one of our field's granddaddies of facilitated free-choice learning. As the Exploratorium articulates on their website:

We believe that following your curiosity and asking questions can lead to amazing moments of discovery, learning, and awareness, and can increase confidence in your ability to understand how the world works. We also believe that being playful and having fun is an important part of

the process for people of all ages. We create tools and experiences that help you to become an active explorer.[5]

On a 2012 visit, Linda saw people of all ages engaged in self-directed experimentation. Whether it was investigating how a machine works, making giant bubbles, or exploring the complexities of the human mind, the choices for joyful, independent learning were many and varied. But it's important to understand that these were not wholly random experiments. The museum clearly views its function as a facilitator and engager, and the staff works hard behind the scenes to engineer and maximize the learning experience for visitors. Importantly, the Exploratorium's work is generously shared with colleagues, teachers, and the general public on their website, not just inside the museum. Want to make your own electric current with a dill pickle or learn how to foster prolonged active engagement in exhibitions? Information on both (and much more) is online, creating a ripple effect of self-directed possibilities.

Another example of free-choice learning with a strong creative play element, the Rijksmuseum's new Rijksstudio, is a digital application that allows users to manipulate high-resolution images of works in the collection, and either print them on a variety of materials or download them for whatever non-commercial use they can dream up. The purpose of the Rijksstudio, in the words of Martijn Pronk, head of publications at the museum, is to encourage virtual visitors "to get creative and become artists in their own right by using the downloaded images to make something new."[6] There are 125,000 works to choose from, and in addition to keyword searches users can browse—learning about the art as they go—by topic, historical theme, color, or using the "Master Matcher," which serves up works based on personal interests.

Provide Opportunities for Cross-pollination in Your Museum and in Your Community

Museums can and should be places where our brains get fed a rich, interdisciplinary, all-you-can-eat buffet, which in turn feeds creativity. At this buffet the variety of foods on the plate, and the fact that the peas are bumping up against the mashed potatoes, is essential. Cross-pollination in the service of creativity is about getting outside your comfort zone—your narrow knowledge base and frame of reference—and opening yourself up to a host of possibilities through new information, new approaches, new juxtapositions, and new experiences. Museums are uniquely positioned to aid the associative thinking and idea combination that comes from cross-pollination by exposing people to a broad range of knowledge, artifacts, and points of view from multiple disciplines and cultures, and mixing them in new ways.

The *Mixed Taste* series at the Museum of Contemporary Art Denver is an excellent example of this concept. At these evening programs the museum brings in two experts on wildly different topics, and they each speak for twenty minutes. Pairings from the 2012 series include Dubstep and the Napoleonic Wars, Psychic Animals and Vincent van Gogh, and Pirates! and Russian Conceptualism. At the end there is a Q&A period where the two speakers discuss the topics together, and often come up with strange and fabulous ways of making connections between them.

Museums can also bring cross-pollination out into the community to mix people, knowledge, and environments in new combinations. The Erie Art Museum's Old Songs New Opportunities program provides refugee women living in Erie with accredited training to work in daycare centers, with a focus on sharing these women's traditional songs—with each other and with children in the day care centers. In addition to creating employment opportunities for participants, the program has yielded a growing collection of more than fifty songs in over ten languages, each with a teachable English version, that are now sung in childcare centers throughout Erie. Cross-pollination in this case happens around both child development technique and intangible cultural heritage.[7] Meanwhile, the Grand Rapids Public Museum developed the corporate employee program the Grand

Race to introduce participants to parts of Grand Rapids they would be unlikely to seek out on their own. Modeled after the TV show *The Amazing Race*, it is "part interpretive program and part scavenger hunt." Using the entire city as a frame, the race sends teams out to find clues in ethnic grocery stores, temples, clubs, restaurants, and other businesses, where cultural ambassadors greet them and engage them in discussion. In so doing, the program deepens participants' exposure to the broad range of individual backgrounds and experiences that make cities such excellent places for cross-pollination.[8]

We can look beyond our fellow museums for more examples of cross-pollination to draw from for inspiration. Science Cafe (in the United States) and Cafe Scientifique (in the UK), and other similar events around the world, stimulate cross-pollinations between and among the public and scientists through informal gatherings in cafes and bars. In a relaxed, participatory atmosphere, scientists offer information and answer questions about a wide variety of topics—asteroid mining, radiation, biodiversity, fermentation, persuasive technologies, genetics. By bringing these discussions into everyday life, Science Cafe provides opportunities for people from many fields to expand their knowledge base and fold scientific concepts into their associative thinking. And Conflict Kitchen in Pittsburgh, Pennsylvania, is a take-out restaurant that changes its menu every six months, each time serving food from a different country that the United States is in conflict with. Using a range of methods, including take-out food wrapped in interviews with residents of the featured country and facilitated Skype conversations, the restaurant cross-pollinates cultures, ideas, and communities, resulting in "questioning, conversation, and debate with our customers."[9]

Meanwhile, our collections provide endless rich opportunities for cross-pollination if we spend time modifying the lens through which we see them. Do the dinosaur bones always have to be exhibited with other dinosaur bones? Does the Victorian-era stuff always have to be grouped with other Victorian-era stuff? Can we change up the material, geographic, and thematic categories we typically use to sort objects? Can we take artifacts out of their normal frame of reference and collide them with objects from completely different spheres? Why not show, side-by-side, several artifacts that at face value have absolutely nothing to do with each other, and ask people to find hidden connections?

Try This:
Pollinating Conversations

Colleague Tegan Kehoe suggested arranging tables in your cafe so that more than one social group can sit together, and then placing ice-breakers or conversation starter cards on them. No cafe? Consider other places in the museum where you can create spaces for conversation and cross-pollination. The Newseum's headline-filled bathrooms must generate all kinds of discussions over the sinks. How else can you encourage strangers to talk and share?

185

A number of British museums recently joined forces for *First Time Out*, a project where curators dug deep into their collections, each finding an object never or rarely displayed to the public. These objects were first highlighted at their home museum, and then traveled to another museum to be interpreted in a completely different context and encountered by an entirely new audience. For example, one museum interpreted a porcelain dish through the lens of its collector; another through the lens of natural history, identifying the birds depicted and tying them to an understanding of Darwin's work.[10]

It's been twenty years since artist Fred Wilson surprised the museum-going (and the museum-making) world with *Mining the Museum* at the Maryland Historical Society, an installation compelling us to see familiar objects in surprising new ways and revealing stories previously untold. Wilson's work helped shape, but unfortunately did not fully transform, our field's efforts to find and tell new stories based on the objects in our collections, addressing issues of class, race, and gender. His inspiration encourages us to keep pushing further. By shifting, comparing, and surprising with objects, museums help their communities find patterns across a global spectrum, and show them it's okay to expand and reframe their thinking in their everyday lives outside the museum as well. In an interview for *Museum News*, not long after completing *Mining the Museum*, Wilson shared his thoughts on why artists undertake this work and how museum workers could make the same kinds of powerful connections:

> Even the most standard exhibition can be more human. Because you are human. The people who organize exhibitions are human. If they tap into that and not into the systems of display and scholarship, tap into what led them to get excited about museums in the first place, and put *that* out there along with the scholarship, that is how to reach people. That is what art does: artists aren't afraid to risk opening themselves up, because they have to.[11]

Encourage and Enable Curiosity

Curiosity is an internal drive for knowledge and understanding that, when humming at full capacity, constantly generates new material for associative thinking and idea development. Creative people are curious people, seeking out information and inspiration everywhere they look. What better way to nurture curiosity—and its siblings, surprise, delight, imagination, play, and wonder—than through museum experiences? All of those moments of discovery build lifelong learners who actively look for opportunities to stretch their minds and use them for shaping new ideas.

This is a particularly important issue for school-aged children. There has been much attention paid recently to the ways in which our formal education system inhibits creativity (see Ken Robinson's work or David Kelley's TED Talk on creative confidence for a more detailed discussion of this issue). As a counterbalance to the formal education system's intense focus on standards and testing, the awesome moments of self-directed exploration that museums provide through school tours or other programming have become incredibly important in developing the curious citizens of the future.

In a 2006 article for *Curator* Daniel Spock writes that museums "stand for the value of curiosity for its own sake. Museums have to be seen by curious people as places where curiosity finds reward and reinforcement, or they have truly lost their purpose."[12] Spock argues that nurturing curiosity is a more important—and truer—role for museums than imparting information (education with specific learning outcomes). Some museums are better than others at cultivating curiosity: they build environments for open-ended play (for people of all ages, not just children), they emphasize questions instead of answers, they regularly surprise their audiences, and they provide tools for exploration and discovery. We should all try to be those museums.

Try This:
The Creative Process at Historic Houses

At the Mark Twain House in Hartford, Linda was inspired by learning that Twain, each night, told a story to his daughter using the objects on the mantelpiece. Same objects, same order, but a different story every night. For Twain, perhaps it was a nightly creative tune-up, with the mantelpiece serving as his creative constraint.

Many historic sites across the country (indeed the world) are associated with creative people—the homes of writers and artists like Twain, Harriet Beecher Stowe, Georgia O'Keeffe, and Jackson Pollock, to name a few. They provide rich opportunities to illuminate for members of the public—in situ—elements of the creative process: the ways in which these individuals of different time periods gained inspiration, incubated ideas, and evaluated their work; the tools they assembled and the environments they constructed to enable their everyday practice. All it takes is a little reframing of stories and rooms to develop interpretation that focuses on the creative process and answers the age-old question asked by curious people: How did he or she do it?

Interpretation of the creative process does not have to be narrowly confined to famous artists and writers; other kinds of historic sites can demonstrate the creative process as well. What if the interpretation at a historic farm addressed the ways in which a farmer sought out new ideas, tried them out, and creatively adapted new farming techniques to his own local circumstances? What if you shared not just the quilt on a bed, but a half-made quilt and a facilitated tour conversation about aesthetic choices and inspirations? By exposing the everyday rhythms of a creative life of the past, you can inspire creative lives today. If you work with a historic site, explore the stories of creative individuals in their natural habitats and experiment with new ways of sharing them.

189

Jay Rounds has written about the "curiosity-driven visitor," intrinsically-motivated individuals who come to the museum not because they have a particular topic in mind they want to learn about but because they are interested in acquiring knowledge for knowledge's sake; they seek "wide but shallow learning." Such visitors sometimes frustrate museum staff in tracking studies because they don't take in exhibitions in a focused, systematic, or comprehensive manner; they are more like foragers, exploring here and there until they hit upon something compelling, constantly assessing whether they might find something of greater interest somewhere else in the museum. Rounds links this visit type to associative thinking and creativity. And he calls for more research to understand how museums might help curiosity-driven individuals maximize the "Total Interest Value" of their museum experiences. This might mean making it easier for visitors to quickly gauge whether a particular exhibition component will or won't satisfy their curiosity, for example.[13]

Rounds's curiosity-driven visitor informed John Falk's concept of the Explorer, one of five visitor types he describes at length in *Identity and the Museum Visitor Experience*. To meet the needs of Explorers, Falk recommends facilitating moments of discovery, layering information to allow them to dig deeper when they stumble upon something they are interested in, and providing plenty of self-directed experiences so they can quickly bail on something that isn't satisfying their curiosity.[14] Museums also need to be aware of the messages they send visitors, intentionally or no, about whether the foraging behavior of Explorers is acceptable. Many people believe that a museum is a place with strict rules for the right way of moving through an exhibition, and may need encouragement and facilitation to get comfortable with a curiosity-driven approach. Is your museum Explorer-friendly? You might consider the following:

- Does your information system—on your website, at the front desk, and throughout the museum— make it easy for a curious person to browse and identify interesting topics to investigate? What would a curiosity-driven front desk look like? Would it even be a desk? What about taking the model of Apple stores, where a facilitator doesn't sit behind the desk, but roams around as you explore and helps you make decisions about what's next?

- Can you provide the tools for a customizable experience? Visitors to the Cleveland Museum of Art (CMA) start their visit in front of a forty-foot touch screen with thumbnails of every piece of art on display in the museum's permanent galleries. They can choose from any of these works to create a personalized tour, or select from a range of existing tours developed by museum staff and visitors. They then use the museum's ArtLens mobile app, either on the visitor's own IPad or on an IPad rented from CMA, to navigate the galleries and experience these works. The app includes a "Near You Now" feature to steer visitors toward pieces of interest, and an image recognition "Scan" feature provides a range of layered content about each artwork encountered. It's okay for visitors to deviate off their original tour to investigate something that catches their eye; ArtLens supports deep learning about anything on view. This visitor interface was intentionally developed to address the needs of curiosity-driven browsers, dramatically reducing the effort it takes to identify objects of personal interest and enabling easy toggling between shallow and deep engagement, while making plenty of room for serendipitous discoveries. ArtLens made its public debut in January 2013; as user data accumulates this project will serve as an important test case for the possibilities of customizable experiences.[15]

- Can you rethink traditional labels? The Minnesota History Center's exhibitions provide label content in dozens, if not hundreds, of surprising ways. You can find labels on clothing going around a dry cleaning rack, inside an oven, or even projected on a bed. In 2009 the Powerhouse Museum in Sydney created an exhibition called the Odditoreum: eighteen particularly strange and curious objects, with unclear meanings, were paired with provocative labels written by Australian author Shaun Tan. An interactive component asked visitors to write their own imaginative labels for the objects, which were then displayed for others to read.[16]

- What are visitors taking the most photographs of at your museum? (And if you're not letting them take photos, why not?) What does that tell you about their interests? How can you take that knowledge and move further in your interpretive strategies?

- Are all staff members encouraged to interact with the public in ways that facilitate curiosity? At a visit to the Getty Museum, Linda noticed a guard step forward to engage a young visitor and his father in conversation about a statue. It wasn't a "don't touch" conversation, but rather one that encouraged these visitors to take a second look and explore the statue on a deeper level.

- When was the last time your museum was surprising? Does your museum actively look for opportunities to surprise the public—in the galleries and in the community?

Teach Deep Observation

Creative people are constantly observing the world around them, questioning why things are the way they are, and looking for patterns. Museums can strengthen observation skills, teaching the public to use all their senses to take in information and find moments of connection. Indeed, encouraging deep observation should be easy for museums—we are all about the fine details of artifacts, right? But there's passive observation and active observation—can you guess which one fuels creativity?

 For art museums, much has been written about Visual Thinking Strategies (VTS) as a method for strengthening observational skills when experiencing artwork. Perhaps less well known (at least outside the art museum community) is the Exercise for Exploring technique developed by the Art Gallery of Ontario and described in a 2005 *Curator* article. In 1993 the Gallery created an intimate booth with a single painting, *The Beaver Dam,* by J. E. H. MacDonald. In this booth visitors are invited to sit in one of two chairs and listen to a twelve-minute, audio-recorded, guided observation exercise focused on the painting. The audio takes visitors through four stages of creativity (described in more detail on pp. 40–43), starting with deep observation of the painting as a means of *preparation*, followed by a period of *incubation* where visitors are asked to engage their imagination and senses with eyes closed. The incubation section of the audio concludes with a one-minute period of silence, designed to pave the way for stage three: *illumination*. Lastly, the Gallery provides comment cards as a means for visitors to reflect on and document their experience, thus enabling the fourth stage, *verification*. By the time the *Curator* article was written, the *Beaver Dam* booth had been in use for ten years and the museum had collected more than 2,000 of the reflection cards,

Try This:
Slow Art Day

"Slow Art Day" (www.slowartday.com) is an international, volunteer-run event with the mission to "help more people discover for themselves the joy of looking at and loving art." On one day each year, participants visit a museum (the network includes everything from the Aspen Art Museum to the Zacheta National Gallery of Art in Warsaw, Poland) to look at pre-assigned pieces of art, spending at least five to ten minutes on each one. They then meet up with a volunteer coordinator for lunch or coffee to discuss the experience. Your museum can sign up online to become a venue and invite your community to participate.

from visitors representing a range of ages and backgrounds. A visitor study found that two thirds of respondents had spent more than six minutes in the guided observation, and one third spent more than twelve minutes. Seventy percent of visitors who participated were able to imagine themselves entering the painting, as well as the sounds, smells, and temperature of the scene. Many also reported transformative experiences. Ninety percent recommended the station be replicated with additional paintings, and many commented that they planned to try deep observations on their own.[17]

The Exercise for Exploring is a particularly successful example of deep observation at play in a museum, but teaching observational skills shouldn't (and doesn't) only happen with art. It's also a natural fit at science centers (observation is a key part of any scientific experiment), natural history museums (taxonomy is all about deep observation), history museums (think about studying all those primary source materials), and archaeology museums (observation aids in analysis of archaeological finds). Any museum can experiment with techniques for developing close observational skills that dovetail with their own mission and educational goals. For example, the Shaker Museum and Library in Chatham, New York, developed a reading group based on primary sources. Called "Shaking Up Sundays," the programs built on the museum's rich collection of resources to focus on topics with contemporary resonance: celibacy, diet and health reform, Spiritualism, communalism, and pacifism. Participants gained new insights from careful reading—the close observation, as it were, of the Shaker archives combined with active, facilitated conversation.

Enable Development of Expertise

Creative people must have a deep and complex grasp of their domain—the discipline or knowledge base they work within, whether it's cardiology, sculpting, electrical engineering, or comparative literature. They must learn domain-specific techniques, theories, and modes of working; study the domain's recognized authorities to understand the contributions they have made thus far; stay current with the literature, both at the center of the domain and at its edges; and fully grasp the domain's existing problems and challenges so they can recognize when an idea is groundbreaking and when

it is not. This information creates a mental map of the domain that should get stronger and more detailed with each passing year.

As storehouses of human knowledge and culture, museums can provide a wealth of resources for the individual seeking greater expertise—everything from collections research to opportunities to sketch master works in the galleries. For example, the Corning Museum of Glass invites artists, designers, and engineers to learn about hot glass though rapid prototyping in the Glass Lab. These collaborators bring a sketch, and the museum invites them to join in—often in public—as the museum's skilled glassblowers create the piece. It's a chance to learn firsthand through experience what the material can and cannot do. Said Rob Cassetti, Senior Director of Creative Services & Marketing at the museum, "In a place like Corning, this has proven to be an exceptionally powerful tool to expand creativity and encourage new thinking."[18]

We don't all have a hot glass lab at our disposal, but consider whether the high school shop class could be inspired by nineteenth-century furniture, whether surveyors could learn from eighteenth-century maps, or today's knitters and crocheters could study technique from the examples in your collection. Consider the Textile Study Rooms at the Victoria and Albert Museum or the Questionable Medical Devices collection at the Science Museum of Minnesota. Both provide tremendous opportunities to examine and understand previously developed ideas, experiments, successes, and failures for these two domains. As more and more museum collections go online, the potential grows for museums to help individuals situate themselves within a long line of thinkers and creators who have gone before them, and to facilitate interactions with those materials—for both novices and scholars—that strengthen expertise.

Aside from collections access to develop expertise, your museum might also consider opportunities to provide supplemental training for professional groups from specific domains. What could apprentice carpenters, plumbers, or electricians learn from your historic site? A number of history museums have begun to explore the traditional ideas of sustainability within a historical context, inspiring new creative ventures and potential community transformations. Citizen science provides opportunities for members of the public to develop expertise in all sorts of areas: butterflies, birds, or even ice. The Center for the Advancement of Informal Science Education has identified three

Try This:
Rethinking Audience Evaluations

To gain a greater understanding of the effect you have on your audience, you may need to re-think the kinds of questions you ask in visitor evaluations. Jane Addams Hull-House Museum asked these questions for those who participated in an Alternative Labeling experience, wherein the museum asks artists to create a label in their own medium for an artifact in the collection. One label, an essay in book form by artist Terri Kapsalis, describes and complicates Jane Addams's travel medicine kit and the tensions in her life between war and peace, sickness and health. Visitors can experience this label by sitting in Addams's bedroom to meditate on the essay while museum staff serves them a cup of herbal tea.

The Hull-House questions:

■ How did this experience make you feel? (In answering this question feel free to use prose, poems, images, references to other cultural or life experiences—anything that conveys your experiences.)

- Although we would not be so presumptuous as to assume that you were dramatically changed by this experience, was there anything about it that might be a catalyst for a new way of thinking, feeling or acting?

- Are there other experiences in your life that have been a catalyst for new ways of thinking, feeling, or acting?[19]

What questions could you ask your visitors to help you understand your museum's impact on their creative lives?

Zombie Survival Camp

Some of our most creative ideas have come from our rather quiet and remote natural setting and (for lack of a better term) free and unstructured "play" with the children who attend different programs or day camps at our site. We are a historical village owned by a municipal parks and recreation department. The site is located at the edge of the city limits in a river bottom floodplain area.

On one hand, our remote location makes it difficult to attract large numbers of visitors to our programs, and the proximity of the river is a concern in flood season. On the other hand, just beyond the manicured interior of the historic village setting there is a wild and wonderful wilderness to explore. A five minute walk through the rugged terrain will bring you to the banks of the Cedar River, and along the way you can find a multitude of natural treasures, including clam shells, beaver dens, fallen logs and hollow trees, coyote tracks, and more. To walk this area with children pretending to be a robber or pirate band, soldiers, or zombie resistance fighters only broadens the interpretive possibilities. Frequently, as we are waiting for all the children to arrive at a day camp program, we let them run the village grounds in free, unstructured play, inventing their own games or going wherever their imagination takes them. In observing the kids, or sometimes even in joining them, I have found some of the most successful vehicles for interpretation.

One afternoon, while wrapping up a day camp program, I asked the kids what their favorite parts of the week had been. All of them mentioned walks or activities we had done in the woods or along the river beyond the village. Then I asked, "If you could go to any kind of day camp

you could imagine, what would it be?" One of the kids said "A Zombie Camp!" I promised him I would look into it—and I did. I was amazed at the possibilities that presented themselves.

It was initially an uphill battle to convince the management of the merits of offering "Zombie Survival Camp" for children at a historic site. What do zombies have to do with history, after all? In reality, not much, but they were wonderful metaphors for many of the key interpretive themes we were trying to present. The possibilities for individual outdoor activities were endless: finding shelter and water, wild edibles, tracking animals, first aid and natural healing, orienteering, geocaching and map-making. In the end, the kids who participated learned a great deal of history and many skills while spending a week imagining that they were hiding out from a zombie attack. The idea got us tremendous press coverage, including a tweet-out from the producer of *The Walking Dead* TV show!

In a nutshell? It's not just my creativity that gets flowing when I am able to walk out into the untouched wilderness just beyond our parking lot. In that space, in the company of children who remind me of my own inner child, all of our imaginations begin to flow and unlimited possibilities present themselves.

Ann Cejka, Program Coordinator,
Ushers Ferry Historic Village, Cedar Rapids, Iowa

types of existing citizen science programs. There are ones where professional scientists design projects and citizens collect data; ones where the public not only collects but also helps refine the project, analyze data, and disseminate findings; and finally, co-created projects designed by scientists and the public together.[20] In each of these three types of projects citizens can develop expertise and a deep commitment to the stewardship of natural resources while scientists gain information that would otherwise be difficult to obtain. But this deep observation and expertise may also work in unexpected ways. Will the knowledge about birds inform a writer's work or the movement of icebergs shape a dance performance?

Serve as a Community Platform for Creativity

Just as museum workers need strong field-wide platforms for museum practice, members of the public need platforms where they can share their creative work, connect, and collaborate. Museums can play a valuable role in nurturing collective creativity by issuing creative challenges, providing spaces and tools—physical or virtual—for collaborative projects, and facilitating conversations among community members. Sometimes this is as simple as making space in the museum to encourage and display the creative contributions of museum audiences for all to see, whether they take the form of artwork, oral histories, or robots. In other cases it can mean offering maker spaces, community curator opportunities, or websites with community-generated content. The Victoria and Albert Museum, recognizing that workers from the design, fashion, and arts industries make up more than 35 percent of their annual visitation, developed a series of V&A Connects evening events designed specifically for this audience, where workers can network, find inspiration, and share ideas.[21] In Minneapolis, the Walker Art Center's Open Field project has hosted and inspired the creative efforts of their community members, ranging from shared, under-the-stars bedtime stories to dance performances to a collaborative drawing club. And the National Building Museum in Washington, DC, hosts an annual mini golf course hole design competition where professionals from the local architecture and building trades team up to test their creativity, designing a course full of fantastical and unique mini golf holes, which members of the public then get to play.

Celebrate Creativity as a Value

Museums play a significant role in cultural production. The public perceives museums to be trusted voices, and seeing something in a museum gives it a certain seal of approval. In her article in the *Journal of Museum Education* special issue on creativity in 2005, Kelly Finnerty calls for museums to "affirm, legitimize, and validate new conceptions of creativity."[22] Let's take that role seriously and use our cultural authority to acknowledge the importance of creativity for our audiences, our society, and ourselves. The public needs to see us praise creative acts, contribute to the body of knowledge about creative learning, and model creative practice. They need to see us talk the talk and walk the walk.

Again, all of the strategies we've shared in this chapter should sound familiar because they are at the heart of what museums do. When we are at our best, we light up people's brains. And lit-up brains are good for creativity. Therefore, it is safe to say museums are already helping some people be more creative, but we need to reach a broader proportion of our communities. Over the past few years the audience research firm Reach Advisors has been developing the concept of museum advocates: lifelong museum-goers who visit a wide variety of museums, report positive experiences at them, understand the contributions museums make to society, and support them philanthropically—museum regulars who already get how museums work and the value they provide. Susie Wilkening and her Reach Advisors team have been tracking curiosity in visitor studies and have found that museum advocates are highly likely to self-identify as curious, lifelong learners and are more likely to be intrinsically motivated in their museum visits: they understand how museums can stimulate their brain.[23] Which has us wondering if these museum advocates aren't also individuals who are on the path toward creativity, whether they realize it or not. Which then begs the question, if we really want to build a world full of creative people, shouldn't we be figuring out how to convert more museum visitors—and non-visitors—into curiosity-driven explorers who become lifelong museum advocates? The Reach Advisors research thus far is converging around several

Embedding Creative Practice in Your Museum and Community

One of the great assets to the work at our museum is intersectional thinking—a large part of our creative process is being smart about connecting in interesting ways, at every stage in the process. For instance, a visitor might come because he or she cares about immigration or contemporary art—but all of sudden he or she realizes, because of the intersections we highlight, that these topics are linked to prison reform or food security.

To make that happen, we do several things. We treat our visitors as people who want to have higher level conversations, and we look to the contemporary art world for inspiration to see things in new ways. Our staff also works to maintain a sense of creativity in our work, which means being playful and experimental, allowing for outrageous ideas to take root. We see our creative work as a privilege that we sometimes must defend from bureaucracy, naysayers, and others, and we trust that it leads to innovation and best practices in the field. Finally, we find inspiration in our visitors' voices. Here's what one participant in our Alternative Labeling experience wrote, "[The] recent birth of [my] son has changed everything. I already imagine bringing him here, sharing the world, teaching and learning from and with him."

Lisa Junkin, Interim Director,
Jane Addams Hull-House Museum, Chicago, Illinois

factors that are crucial to such an effort: continued emphasis on free-choice learning; multi-sensory and immersive experiences that involve a combination of objects, narrative, and emotion; exposing kids to such formative experiences around the age of seven (when they are old enough to dig into museum content but not so old that formal schooling has taken hold); and adults who model curiosity-driven exploration to kids (usually but not always their parents).[24]

As you near the end of this book, you may be asking yourself: Why bother developing my own creativity when it is what we do for the public that has the most impact? But focusing on your community's creativity while ignoring your own creative practice is placing someone else's airplane oxygen mask on them before you attend to your own. You need to develop your own well of creative resources in order to effectively nurture those of your community. Moreover, you deserve all that forward momentum and self-actualization creative practice has to offer just as much as your community does. If we each tend our own creative practice, and then work together to build a dynamic field full of amazing, unique museums, we can have a transformative effect on society. What will you try today?

Afterword Our
Creative
Process

(or Trust Your Own Brain)

Our process of writing this book was itself a creative practice. When we started we only had a general sense of how creativity works, so we operated intuitively, striking out in whatever direction felt right or with whatever idea one of us came up with that sounded interesting. Researching this book had an unintended outcome: the literature we read affirmed that our natural intuition about the most useful way for us to work creatively was in most cases right on target; our brains (and your brain, too) are already wired to take the creative path if we can just get out of their way and let them do it. We certainly made changes in our creative practices based on our new learning, but recognizing the inherent creative power of our own brains has been one of the most personally rewarding parts of this project. Our greatest wish for all of you, dear readers, is that you experience this creative power for yourself.

So how exactly did we do it? First, we actively increased the amount and variety of information we were taking in. We read everything we could get our hands on about creativity, across many different disciplines, and we kept reading and learning about other topics as well, to cross-pollinate. We cannot stress enough how important it is to cultivate wide-ranging curiosity about the world at large—and all the people who inhabit it—to feed the preparation phase of the creative process. Some weeks, particularly when we were stressing about a big writing deadline, we skipped the information intake and then kicked ourselves later because it affected the quality of the work.

Moreover, we not only called upon our own years of observations behind the scenes at museums across the country (and internationally), we also engaged our colleagues in new conversations to broaden our understanding of what creativity means in museums. We conducted one-on-one interviews, held creativity meet-ups at conferences, developed a survey, wrote blog posts to solicit feedback, requested input on specific topics via email from a group of project followers we affectionately call our M&C Peeps, and even teamed up with a handful of museum colleagues to participate in Tina Seelig's first ever online version of her popular Stanford University Crash Course in Creativity. Managing all of these various engagement strategies wasn't easy—it significantly expanded the time and effort required to write the book, so much so that we couldn't always

keep up with the multiple conversations and connections we initiated. But this outreach exponentially increased our understanding of what we were writing about and opened us up to different ways of thinking about creative museums. The creative stories you'll encounter in the book came about through this process, as our colleagues were incredibly generous with stories, feedback, questions, and more. An unanticipated reward of this project has been how these colleagues are helping us build a field-wide cohort of creative museum workers.

We also embraced a flexible, iterative, open-ended process. From our first commitment to the project in April 2012, we met weekly by Skype for several hours at a time, not only to coordinate our work but also to discuss our thoughts and ideas. We regularly used these meetings to adapt and shift course as new concepts or opportunities presented themselves, or to talk over challenges and push each other further in our individual thinking. A lot of our initial expectations about the book changed because of this process. For example, we originally thought the bulk of the text would be comprised of case studies organized by discipline or department. But somewhere along the way in our discussions we realized this project is less about presenting models (that is, focusing on final output and following other people's ideas), and more about understanding how to work creatively (focusing on process and learning how to generate your own ideas). One day Linda said, "I really want people to pull out the book, open it to any page, and immediately try something," which led us to take the real estate we'd intended for case studies and devote it to the copious Try This activities instead. Part of the reason we were able to make this shift is because we never imposed chapter assignments or an order to the writing. Instead, each of us wrote what we felt compelled to write about at any given moment, based on what we were reading, grappling with, or discussing with colleagues, and then once a month we reevaluated the big picture based on the new text.

Here's another example of this iterative process: as part of our book proposal to Left Coast Press we developed a chapter outline that we felt confident would serve as an excellent backbone for the project; four months later we scrapped it completely, and then scrapped it again, until eventually we came to the structure you see here, where creative practice moves outward from individual to institution to field to community. Fortunately Mitch Allen, our editor at Left Coast Press, continued to have faith that something meaningful would come from this process and didn't hold

us to the original plans, a lesson to all directors, trustees, and funders about making space for open-ended outcomes.

Our process was also founded on the value of experimentation and prototyping. We held an electronic brainstorming session (and learned a lot when it fizzled), drew mind maps, tried out creativity exercises on colleagues at conferences and workshops, and organized an experimental peer review process, with twenty reviewers building on each other's comments in Google Drive. We failed. The tone of our first draft was awful. It was preachy and negative, and not very inspiring. A long passage we wrote about a day in the life of an imaginary creative museum fell completely flat with our peer reviewers, singing tree and all. The failures that troubled us the most were when we couldn't convince a colleague that creativity matters, but these conversations helped us strengthen and refine our arguments considerably.

We learned just how important it is to live your own individual creative practice every day. Any project this big challenges your daily commitment and motivation for the part of creativity that is 99 percent perspiration. In the moments where we felt blocked or overwhelmed by our monthly word quota, it was immensely helpful to fall back on the methods that make creativity a practice and not a gift. We stopped feeling guilty about taking an hour in the middle of the day to exercise or work in the garden because we experienced first-hand how turning the volume down on our conscious mind helped the words flow later. Rainey followed Twyla Tharp's prescription for creative habit and developed a regular routine, shifting writing sessions to the early morning before her mind was filled with the day's detritus, starting each session with a ritualized cup of green tea, swearing off emails until lunchtime, and always leaving something to write about on the table at the end of each session to provide a clear starting point the next day. For Linda, the book project coincided with some pretty intense periods of travel, so for her coffee shops often proved the best place to work. Filled with quiet action, music, and not too much distraction, cafes from St. John's, Newfoundland, to Barcelona, Spain, taught her to relish this environment for thinking and writing. Linda also needed the time, sometimes found in cars or airports, to do the kind of turning-over-in-your-mind reflection that is a necessary part of the creative process (her broken car radio proved a blessing in disguise).

And lastly, we gloried in our creative collaboration. Even though we didn't know each other very well when we started this project, we knew each other's writing through our museum blogs. We trusted each other's abilities and understood that our experiences, skills, and perspectives were aligned. On the other hand, we are different enough to create movement and space between us. We later found out that organizational psychology studies suggest two is quite an effective number of people for face-to-face brainstorming sessions, which is really what all those weekly Skype calls were about.[1]

There's no doubt that we will be thrilled when you, our colleagues, hold this book in your hands, but our greater sense of accomplishment comes from a renewed passion for our work, new connections with colleagues, and a joyful sense of an ever-deeper well of inspiration and learning. It's the creative process, just as much as the product, that we take away from this project.

Pocket Guide to Creativity in Museum Practice

Your Creative Practice

Anyone can learn to be more creative.

Pursue a passion.
Build your creative confidence.
Cultivate knowledge and skills in your domain.
Develop a creative habit.
Reflect on your creativity.
Live your creative practice.

There is a lifelong learner at the heart of every creative person.

Diversify your content.
Network inside and outside the museum field.
Regularly look outside of museums for inspiration.
Share the things you're learning with those around you.

Creativity is a process and a practice.

Preparation—Incubation—Insight—Evaluation—Elaboration
Switch between divergent and convergent thinking.
Try something. Fail. Learn. Try again.
Build on and combine other people's ideas.
Seek creative constraints.

Develop a creative practice at work.

Expertise + Intrinsic motivation + Creative thinking = Creative success at work
Support each stage of the creative process.
Tinker—put many ideas into the pipeline.
Reach out and connect with your colleagues so ideas can bump up against each other.

Building Creative Cultures

Creative leaders come from anywhere and everywhere in the organization.

Board members deserve creativity, too.

Creativity is an insurance policy for institutional health.
Incorporate creativity into strategic planning, meetings, director hiring, and supporting staff.

Directors invest in creativity to energize themselves and their museums.

Model your own creative practice, but also value ideas from everywhere.
Facilitate open communication and access to information.
Invest in each staff member's creative potential.
Ask, "How can I facilitate progress for my staff today?"
Provide a mix of constraints and freedom.
"Reward success and failure, punish inaction."
Cheerlead for creativity inside and outside the organization.
Make creativity an expressed value in recruitment.

Every person with a creative practice leaves a mark on his or her museum culture.

Nurture your own creative practice.
Don't self-censor ideas.
Share information widely and often.
Identify like-minded workers and band together.
Question rules and reframe problems (some of the time).
Help your institution experience the transformative power of small successes.

Tools for Creative Cultures

Space is an instrument, not a given condition.

Avoid hoarding, territoriality, silos, hierarchy, and lack of attention.
Create spaces for reflection, collaboration, stimulation, and play.

Fill your space with useful tools, real and virtual.

Keep art supplies and a big workboard close at hand. Replenish frequently.
Experiment with online tools to encourage collaboration and share information.

Incorporate creative processes into daily work.

Observe your target audience.
Prototype something, anything.
Brainstorm with purpose.

A Field-wide Creative Infrastructure

Be open, generous, and connected.
Share what works and doesn't on open platforms.
Build a strong network.
Support (and create) more R&D.
Introduce experimentation, learning from failure, and cohorts into the funding process.
Weave creative practice into professional training.
Use standards as a frame, not an end goal.

Creative Museums, Creative Communities

Protect—and share widely—the joy of being creative.
Embrace free-choice learning.
Provide opportunities for cross-pollination.
Encourage curiosity.
Teach deep observation.
Enable development of expertise.
Serve as a community platform for creativity.
Celebrate creativity as a value—shout it from the rooftops.

The Get Going Game

Stuck on a problem? Feeling overwhelmed? Wondering where to start?

Instructions

Open this book to the next page, place it on a table, close your eyes, spin the book, then stab with your finger to choose something to try.

Better yet, copy the pages, mount them on a wall, blindfold yourself or a colleague, and use a Post-it note or thumbtack to select an activity.

Or cut apart your copies, put all the activities in a hat, and pass the hat at your next staff meeting, setting a date to share your progress with each other.

> Feel free to adapt or embellish the game to reflect your individual or institutional creative identity.

The Get Going Game

Point with your eyes closed or draw from a hat to jumpstart your creative practice.

Sit somewhere outside the museum for an hour. Observe how people use the space.

Begin a meeting in your exhibition space, deeply looking at an object.

Make a list of museum rules. Choose one to explore breaking for greater gain to your public audience.

Designate a space for the Wall of Great Successes (and/or the Wall of Useful Failures)

Start an idea file for your museum.

Experiment with Appreciation-based Exchange, building on only the positive parts of any project currently underway.

Try an idea you've been thinking about but are afraid is too risky. If you fail, try again.

Submit a conference session proposal that pushes the boundaries.

Put up a big white board in a communal workspace. Generously share ideas.

Seek out new information. Join a different museum interest group or read a magazine you would otherwise never pick up. Read any of the books recommended on pp. 64–65.

Plan how you can be more intentional about process at your next brainstorming session.

Prototype something, anything (another way to say "try, fail, try again").

Create a program mash-up of two different topics, ideas, or perspectives.

Put some art supplies out for your next meeting.

Identify some creative constraints for a current project. What if you only had $50 to do a marketing campaign or you had to develop an exhibition the size of an elevator?

Find ways to share your museum's research with colleagues online.

Think of ways to improve your recruitment process to bring in more curious, passionate, T-shaped people.

Enhance an existing program or exhibition to make more room for curiosity, deep observation, or development of expertise.

Answer a question from Twyla Tharp's creativity inventory: What's the first creative moment you remember?

Drink-up, Meet-up, or Show-off with your colleagues.

Ask a new question in an evaluation that explores participants' creative responses.

Find three objects in your collection that illustrate a stage of the creative process.

Notes

Introduction: Why Creativity Matters in Museum Work

1. Lublin and Mattioli, 2010.
2. Brown, 2009, 7.

Chapter 1: Your Creative Practice

1. Kelley, March 2012.
2. Breen, 2004.
3. Seelig, 2012, 14.
4. Cropley, 1992, 10.
5. Treffinger, Isaksen, and Dorval, 1994, 224.
6. Robinson, 2011, 4.
7. Nickerson, 1999, 407.
8. Csikszentmihalyi, 1997, 2.
9. Brown, 2009, 36.
10. Kluger, 2013.
11. Florida, 2012, xi–xiv.
12. Tharp, 2005, 45–46.
13. M. Root-Bernstein and R. Root-Bernstein, April 30, 2012.
14. Erin Carlson Mast and Callie Hawkins. Telephone interview with Rainey Tisdale, August 8, 2012.
15. Csikszentmihalyi, 1997, 347–369.
16. Johnson, 2010, 42.
17. Suse Cairns. Peer Review Comment, March 18, 2013.
18. Brown, 2009, 237.
19. Csikszentmihalyi, 1997, 79–81.
20. Acar and Runco, 2012, 115–139; Puccio and Cabra, 2012, 189–215; Cropley, 2006.
21. Brown, 2009, 17.
22. Ferguson, 2012, Part 1.
23. Kleon, 2012, 137.
24. Stokes, 2005, xii.
25. Stokes, 2005, 7.
26. Tharp, 2005, 114.
27. Michalko, 2006.
28. Kleon, 2012, 54.
29. M. Root-Bernstein and R. Root-Bernstein, February 18, 2012.

30. Tharp, 2005, 213.
31. Kleon, 2012, 130.
32. Johnson, 2010. Video.
33. Kretkowski, 1998.

Chapter 2:
Building Creative Cultures
1. Ryan, Chait, and Taylor, 2013.
2. Stuart Chase. Telephone interview with Linda Norris, June 21, 2013.
3. Nina Simon. Telephone interview with Linda Norris, January 16, 2013.
4. Maeda, 2009.
5. Brown, 2009, 74.
6. Amabile, 2011.
7. Belsky, 2012, 197.
8. Sutton, 2007, 94–103.
9. Sarah Schultz. Telephone interview with Rainey Tisdale, January 7, 2013.
10. Kathleen McLean. Telephone interview with Rainey Tisdale, February 26, 2013.
11. C. Heath and D. Heath, 2010, 27–48.
12. Amabile and Kramer, February 27, 2012.
13. Seelig, 2012, 43.
14. Brown, 2009, 27; Brown, 2005.

Chapter 3:
Tools for Creative Cultures
1. Kelley, 2012, 5.

2. Doorley, Witthoft, and Hasso Plattner Institute of Design at Stanford University, 2012, 51.
3. Gangemi, 2010.
4. Paulus and Brown, 2007; Paulus, Dzindolet, and Kohn, 2012, 248–265; Furnham, 2000.
5. Brown, 2009, 36.
6. Paulus, Dzindolet, and Kohn, 2012, 334.
7. Tharp, 2005, 191.
8. Seelig, 2012, 53–64.
9. Brown, 2009, 83.

Chapter 4:
A Field-wide Creative Infrastructure
1. Godin, 2013.
2. Johnson, 2010, 177–210.
3. Simon, October 8, 2008.
4. Johnson, 2010, 52.
5. Merritt, November 6, 2012.
6. "About ExhibitFiles," *ExhibitFiles*.
7. "Strategic Plan 2011–2015," 2011.
8. Andrea Streat. Telephone interview with Linda Norris, July 9, 2013.
9. Daryl Fischer. Peer Review Comment, May 11, 2013.
10. Johnson, 2010, 62–65, 183–89; Catmull, 2008.
11. "What Is Museums Showoff?" *Museums Showoff.*
12. Woroncowicz et al., 2012.

13. "What Are the Key Challenges California Museums Are Facing?" California Association of Museums.
14. Chan, 2013.
15. "FY13 Program Guidelines, Sparks! Ignition Grants for Libraries and Museums," *Institute of Museum and Library Services.*
16. Anheier and Leat, 2006, 212.
17. Kristin Herron. Telephone Interview with Linda Norris, July 8, 2013.
18. Di Mento, 2013.
19. Durel, 2009, 21.
20. Rounds, 2006, 12–17.
21. Anne Ackerson. Telephone interview with Linda Norris, February 14, 2013.

Chapter 5:
Creative Museums, Creative Communities

1. Partnership for 21st Century Skills, "Framework for 21st Century Learning" n.d.; "Museums, Libraries, and 21st Century Skills," *Institute of Museum and Library Services.*
2. *Capitalizing on Complexity: Insights from the Global Chief Executive Officer Study,* 2010.
3. "About Play," *The Strong.*
4. Csikszentmihalyi and Hermanson, 1995, 67–77.
5. "About Us," *Exploratorium.*
6. Pronk, n.d.
7. "Old Songs New Opportunities," *Erie Art Museum.*
8. Carron, 2010, 51–56.
9. "Conflict Kitchen," *Conflict Kitchen.*
10. "First Time Out," *Wellcome Collection.*
11. Garfield, 1993, 46–49, 90.
12. Spock, 2006, 179.
13. Rounds, 2004, 389–412.
14. Falk, 2009, 218–219.
15. Alexander, Barton, and Goeser, 2013.
16. Chan, 2009.
17. Clarkson and Worts, 2005, 257–280.
18. Robert Cassetti. Email to Linda Norris, June 13, 2013.
19. Lisa Junkin. Telephone interview with Linda Norris, June 27, 2013.
20. "Public Participation in Scientific Research," *Center for the Advancement of Informal Science Education.*
21. "V&A Connects," *V&A.*
22. Finnerty, 2005, 13.
23. Reach Advisors, "Creativity: The Cart before the Horse?" *Museum Audience Insight*, 2009.
24. Susie Wilkening. In-person interview with Rainey Tisdale, December 6, 2012.

Afterword: Our Creative Process
1. Paulus, Dzindolet, and Kohn, 2012, 327–357.

References

A Public Trust at Risk: The Heritage Health Index Report on the State of America's Collections. Washington, DC: Heritage Preservation, 2005.

"About ExhibitFiles." *ExhibitFiles*. www.exhibitfiles.org/home/about (accessed July 2, 2013).

"About Play." *The Strong*. www.thestrong.org/about-play (accessed July 2, 2013).

"About Us." *Exploratorium*. www.exploratorium.edu/about-us (accessed July 2, 2013).

Acar, Selcuk, and Mark A. Runco. "Chapter 6—Creative Abilities: Divergent Thinking." In *Handbook of Organizational Creativity*, edited by Michael D. Mumford, 115–139. San Diego, CA: Academic Press, 2012.

Adams, Megan, and Chip Lindsey. "The House of Muses: Where Inspiration Lives." *The Journal of Museum Education* 30, no. 1 (January 1, 2005): 14–17.

Agars, Mark D., James C. Kaufman, Amanda Deane, and Blakely Smith. "Chapter 12— Fostering Individual Creativity Through Organizational Context: A Review of Recent Research and Recommendations for Organizational Leaders." In *Handbook of Organizational Creativity*, edited by Michael D. Mumford, 271–291. San Diego, CA: Academic Press, 2012.

Alexander, Jane, Jake Barton, and Caroline Goeser. "Transforming the Art Museum Experience: Gallery One," Museums and the Web conference paper, 2013. mw2013. museumsandtheweb. com/paper/transforming-the-art-museum-experience-gallery-one-2/

Amabile, Teresa M., Regina Conti, Heather Coon, Jeffrey Lazenby, and Michael Herron. "Assessing the Work Environment for Creativity." *Academy of Management Journal* 39, no. 5 (October 1, 1996): 1154–1184.

Amabile, Teresa. "How to Kill Creativity." *Harvard Business Review*, September 1998. hbr. org/1998/09/how-to-kill-creativity/ar/1

———. *The Progress Principle: Using Small Wins to Ignite Joy, Engagement, and Creativity at Work*. Boston: Harvard Business Review Press, 2011.

Amabile, Teresa, and Steve Kramer. "Talent, Passion, and the Creativity Maze." *Harvard Business Review*, February 27, 2012. blogs.hbr.org/hbsfaculty/2012/02/talent-passion-and-the-creativ. html

———. "What Doesn't Motivate Creativity Can Kill It." *Harvard Business Review*, April 25, 2012. blogs.hbr.org/cs/2012/04/balancing_the_four_factors_tha_1.html

———. "What Makes Work Worth Doing?" *Harvard Business Review*, August 31, 2012. blogs.hbr. org/hbsfaculty/2012/08/what-makes-work-worth-doing.html

Anheier, Helmut K., and Diana Leat, eds. *Creative Philanthropy: Toward a New Philanthropy for the Twenty-First Century*. 1st ed. New York: Routledge, 2006.

Anthony, Scott. "How Do You Create A Culture Of Innovation?" *Co.Design*. May 3, 2012. www. fastcodesign.com/1669657/how-do-you-create-a-culture-of-innovation

Basadur, Min, Tim Basadur, and Gordana Licina. "Chapter 26–Organizational Development." In *Handbook of Organizational Creativity*, edited by Michael D. Mumford, 667–703. San Diego, CA: Academic Press, 2012.

Bays, Jonathan, Tony Goland, and Joe Newsum. "Using Prizes to Spur Innovation." *McKinsey Quarterly* (July 2009).

Belsky, Scott. *Making Ideas Happen: Overcoming the Obstacles Between Vision and Reality*. New York: Portfolio, 2012.

Bernstein, Sheri, and Marni Gittleman. "The Value of Risk." *Journal of Museum Education* 35, no. 1 (April 1, 2010): 43–58.

Breen, Bill. "The 6 Myths Of Creativity." *Fast Company*, December 1, 2004. www.fastcompany. com/51559/6-myths-creativity

Brown, Tim. "Strategy by Design." *Fast Company*, June 1, 2005. www.fastcompany.com/52795/strategy-design

———. "Tales of Creativity and Play." TED video, May 2008. www.ted.com/talks/tim_brown_on_creativity_and_play.html

———. *Change by Design: How Design Thinking Transforms Organizations and Inspires Innovation*. New York: HarperBusiness, 2009.

Burgess, Jean. "Hearing Ordinary Voices: Cultural Studies, Vernacular Creativity and Digital Storytelling." *Continuum* 20, no. 2 (2006): 201–214.

Cain, Susan. "The Rise of the New Groupthink." *The New York Times*, January 13, 2012, sec. Opinion /Sunday Review. www.nytimes.com/2012/01/15/opinion/sunday/the-rise-of-the-new-groupthink.html

Cairns, Suse. "Let's Play! How to Block Innovation in Your Museum?" *Museum Geek*, June 9, 2012. museumgeek.wordpress.com/2012/06/09/lets-play-how-to-block-innovation-in-your-museum/

Capitalizing on Complexity: Insights from the Global Chief Executive Officer Study. Somers, NY: IBM Corporation, 2010.

Carpenter, Siri. "Body of Thought." *Scientific American Mind* 21, no. 6 (December 23, 2010): 38–45.

Carron, Christian G. "The Grand Race: Making the City a Museum Without Walls." *Museum* (June 2010): 51–56.

Catmull, Ed. "How Pixar Fosters Collective Creativity." *Harvard Business Review*, September 2008. hbr.org/2008/09/how-pixar-fosters-collective-creativity/ar/1

Chan, Seb. "Fictional Narratives & Visitor-made Labels—The Odditoreum." *Fresh & New(er)*, July 9, 2009. www.freshandnew.org/2009/07/fictitious-narratives-visitor-made-labels-the-odditoreum/

———. "Some Thoughts at the End of 2012 and a Year in NYC." *Fresh & New(er)*, January 1, 2013. www.freshandnew.org/2013/01/thoughts-2012/

Clarkson, Austin, and Douglas Worts. "The Animated Muse: An Interpretive Program for Creative Viewing." *Curator: The Museum Journal* 48, no. 3 (2005): 257–280.

"Collaborative Learning Conversations." California Association of Museums. www.calmuseums. org/index.cfm?fuseaction=Page.ViewPage&PageID=897 (accessed June 11, 2012).

"Conflict Kitchen." *Conflict Kitchen*. www.conflictkitchen.org/ (accessed July 2, 2013).

Cropley, Arthur. *More Ways Than One: Fostering Creativity in the Classroom*. Westport, CT: Praeger, 1992.

———. "In Praise of Convergent Thinking," *Creativity Research Journal* 18, no. 3 (2006).

Csikszentmihalyi, Mihaly. *Creativity: Flow and the Psychology of Discovery and Invention*. 1st HarperPerennial ed. New York: HarperCollins, 1997.

———, and Kim Hermanson. "Intrinsic Motivation in Museums: Why Does One Want to Learn?" In *Public Institutions for Personal Learning*, edited by John Falk and Lynn Dierking, 67–77. Washington, DC: American Alliance of Museums, 1995.

Daley, Kristin E. "Taking Care of Your Creativity." *The Journal of Museum Education* 30, no. 1 (January 1, 2005): 23–31.

Damanpour, Fariborz, and Deepa Aravind. "Chapter 19—Organizational Structure and Innovation Revisited: From Organic To Ambidextrous Structure." In *Handbook of Organizational Creativity*, edited by Michael D. Mumford, 483–513. San Diego, CA: Academic Press, 2012.

Davenport, Tom. "Five Ways Pixar Makes Better Decisions." *Harvard Business Review*. July 15, 2010. blogs.hbr.org/davenport/2010/07/how_to_make_good_decisions_les.html

De Dreu, Carsten K. W., Matthijs Baas, and Bernard A. Nijstad. "Chapter 10—The Emotive Roots of Creativity: Basic and Applied Issues on Affect and Motivation." In *Handbook of Organizational Creativity*, edited by Michael D. Mumford, 217–240. San Diego, CA: Academic Press, 2012.

Di Mento, Maria. "Grant Makers Open Up About Failed Projects in Hopes Others Can Learn from Them." *Chronicle of Philanthropy*, June 16, 2013. philanthropy.com/article/ Grant-Makers-Open-Up-About/139761/

Doorley, Scott, Scott Witthoft, and Hasso Plattner Institute of Design at Stanford University. *Make Space: How To Set the Stage for Creative Collaboration*. 1st ed. Hoboken, NJ: Wiley, 2012.

Dunne, Danielle D., and Deborah Dougherty. "Chapter 22—Organizing for Change, Innovation, and Creativity." In *Handbook of Organizational Creativity*, edited by Michael D. Mumford, 569–583. San Diego, CA: Academic Press, 2012.

Durel, John W. "Entrepreneurship in Historical Organizations." *History News* 64, no. 2 (Spring 2009): 20–25.

Dworkin, Aaron. "How Should Cultural Institutions Approach Change?" National Arts Strategies video, July 29, 2012. www.artstrategies.org/leadership_tools/videos/2012/07/29/how-should-cultural-institutions-approach-change/

Ericsson, K. Anders, and Jerad H. Moxley. "Chapter 7—The Expert Performance Approach and Deliberate Practice: Some Potential Implications for Studying Creative Performance in Organizations." In *Handbook of Organizational Creativity*, edited by Michael D. Mumford, 141–167. San Diego, CA: Academic Press, 2012.

Falk, John H. *Identity and the Museum Visitor Experience*. Walnut Creek, CA: Left Coast Press, Inc., 2009.

Ferguson, Kirby. *Everything Is a Remix* (Four-Part Video Series). 2012. everythingisaremix.info/watch-the-series/

Finnerty, Kelly O. "Celebrating the Creativity of the Young Child." *The Journal of Museum Education* 30, no. 1 (January 1, 2005): 9–13.

"First Time Out." *Wellcome Collection*. www.wellcomecollection.org/whats-on/exhibitions/first-time-out-2013.aspx (accessed July 2, 2013).

Florida, Richard L. *The Rise of the Creative Class: Revisited.* New York: Basic Books, 2012.

Furnham, Adrian. "The Brainstorming Myth." *Business Strategy Review* 11, no. 4 (2000): 21–28.

"FY13 Program Guidelines, Sparks! Ignition Grants for Libraries and Museums." *Institute of Museum and Library Services*. www.imls.gov/applicants/2013_sparks_ignition_grants_guidelines.aspx (accessed December 11, 2012).

Gangemi, Jeffrey. "Thinking Design: Creative Spaces—'I Wish I Worked There.'" *Thinking Design*, March 29, 2010. gangemithinkingdesign.blogspot.com/2010/03/creative-spaces-i-wish-i-worked-there.html

Garfield, Donald. "Making the Museum Mine: An Interview with Fred Wilson." *Museum News* (June 1993): 46–49, 90.

Gates, Jeff. "Clearing the Path for Sisyphus: How Social Media Is Changing Our Jobs and Our Working Relationships." In Museums and the Web 2010: Proceedings, edited by J. Trant and D. Bearman. Toronto: Archives & Museum Informatics, 2010. archimuse.com/mw2010/papers/gates/gates.html

Glei, Jocelyn. "The Top 5 Qualities of Productive Creatives (And How to Identify Them!)." *99U by Behance*. 99u.com/tips/6736/The-Top-5-Qualities-of-Productive-Creatives-(And-How-to-Identify-Them) (accessed February 4, 2013).

Godin, Seth. "Open, Generous and Connected." *Seth Godin*, February 14, 2013. sethgodin. type-pad.com/seths_blog/2013/02/open-generous-and-connected.html

Graham, Charlie. "How to Build a Company Culture of Experimentation." *Mashable*, August 3, 2012. mashable.com/2012/08/03/work-culture-experimentation/

Gray, Denise A. "Creative Endeavors in Art: Looking, Thinking, Making, Articulating, and Reflecting." *The Journal of Museum Education* 30, no. 1 (January 1, 2005): 18–22.

Grossman-Kahn, Ben. "Defining Creative Confidence." *Children's Creativity Museum Education Blog*, December 27, 2011. childrenscreativity.wordpress.com/2011/12/27/defining-creative-confidence/

Groves, Kursty, and Will Knight. *I Wish I Worked There!: A Look Inside the Most Creative Spaces in Business*. 1st ed. Hoboken, NJ: Wiley, 2010.

Heath, Chip, and Dan Heath. *Switch: How to Change Things When Change Is Hard*. New York: Broadway Books, 2010.

Hoff, Eva V., Ingegerd M. Carlsson, and Gudmund J. W. Smith. "Chapter 11—Personality." In *Handbook of Organizational Creativity*, edited by Michael D. Mumford, 241–270. San Diego, CA: Academic Press, 2012.

Hunter, Samuel T., Scott E. Cassidy, and Gina Scott Ligon. "Chapter 20—Planning for Innovation: A Process Oriented Perspective." In *Handbook of Organizational Creativity*, edited by Michael D. Mumford, 515–545. San Diego, CA: Academic Press, 2012.

James, Keith, and Damon Drown. "Chapter 2—Organizations and Creativity: Trends in Research, Status of Education and Practice, Agenda for the Future." In *Handbook of Organizational Creativity*, edited by Michael D. Mumford, 17–38. San Diego, CA: Academic Press, 2012.

Jarrett, Christian. "Why the Left-Brain Right-Brain Myth Will Probably Never Die." *Psychology Today*. June 27, 2012. www.psychologytoday.com/blog/brain-myths/201206/why-the-left-brain-right-brain-myth-will-probably-never-die

Jaussi, Kimberly S., and George Benson. "Chapter 23—Careers of the Creatives: Creating and Managing the Canvas." In *Handbook of Organizational Creativity*, edited by Michael D. Mumford, 587–605. San Diego, CA: Academic Press, 2012.

Johnson, Steven. "Where Good Ideas Come From." TED video, July 2010. www.ted.com/talks/steven_johnson_where_good_ideas_come_from.html

———. "The Genius of the Tinkerer." *Wall Street Journal*, September 25, 2010, sec. The Saturday Essay. online.wsj.com/article/SB10001424052748703989304575503730101860838.html

———. *Where Good Ideas Come from: The Natural History of Innovation*. New York: Riverhead, 2010.

Kaplan, Robert S. and Anette Mikes. "Managing Risks: A New Framework." *Harvard Business Review* (June 2012). hbr.org/2012/06/managing-risks-a-new-framework/ar/

"Kathleen McLean and Mark Beasley on Creativity in Cultural Practice." *The Pew Center for Arts & Heritage Blog*, June 4, 2013. www.pcah.us/the-center/blog/kathleen-mc-lean-and-mark-beasley-on-creativity-in-cultural-practice/

Kaufman, Scott Barry. "Does Creativity Require Constraints?" *The Creativity Post*, February 13, 2012. www.creativitypost.com/psychology/does_creativity_require_constraints

Kazanjian, Robert K., and Robert Drazin. "Chapter 21—Organizational Learning, Knowledge Management and Creativity." In *Handbook of Organizational Creativity*, edited by Michael D. Mumford, 547–568. San Diego, CA: Academic Press, 2012.

Kelley, David. 2012. Foreword. In *Make Space: How To Set the Stage for Creative Collaboration* by Scott Doorley, Scott Witthoft, and Hasso Plattner Institute of Design at Stanford University, 5. Hoboken, NJ: Wiley.

———. "How to Build Your Creative Confidence." TED video, March 2012. www.ted.com/talks/lang/en/david_kelley_how_to_build_your_creative_confidence.html

Kleon, Austin. *Steal Like an Artist: 10 Things Nobody Told You About Being Creative*. New York: Workman, 2012.

Klotz, Anthony C., Anthony R. Wheeler, Jonathon R. B. Halbesleben, Meagan E. Brock, and M. Ronald Buckley. "Chapter 24—Can Reward Systems Influence the Creative Individual?" In *Handbook of Organizational Creativity*, edited by Michael D. Mumford, 607–631. San Diego, CA: Academic Press, 2012.

Kluger, Jeffrey. "Assessing the Creative Spark." *Time*, May 9, 2013. business.time.com/2013/05/09/assessing-the-creative-spark/

Konnikova, Maria. "Empathic Sherlock Holmes." *Aeon Magazine*, November 14, 2012. www.aeon-magazine.com/being-human/maria-konnikova-empathy-sherlock-holmes/

Kratz, Scott, and Elizabeth Merritt. "Museums and the Future of Education." *On the Horizon* 19, no. 3 (August 16, 2011): 188–195.

Kretkowski, Paul D. "The 15 Percent Solution." *WIRED*, January 23, 1998. www.wired.com/techbiz/media/news/1998/01/9858

LaBarre, Polly. "What It Takes To Do New Things at Work, Overnight" *CNNMoney*, March 22, 2012. management.fortune.cnn.com/2012/03/22/what-it-takes-to-do-new-things-at-work-overnight/

———. "Inside Stanford's Creativity Factory." *CNNMoney*, August 17, 2012. management.fortune. cnn.com/2012/08/17/inside-stanfords-creativity-factory/

Lehrer, Jonah. *Imagine: How Creativity Works*. New York: Houghton Mifflin Harcourt, 2012.

Ligon, Ginamarie S., Katrina A. Graham, Aliyah Edwards, Holly K. Osburn, and Samuel T. Hunter. "Chapter 25—Performance Management: Appraising Performance, Providing Feedback, and Developing for Creativity." In *Handbook of Organizational Creativity*, edited by Michael D. Mumford, 633–666. San Diego, CA: Academic Press, 2012.

Lubart, Todd I., and Robert J. Sternberg. *Defying the Crowd: Cultivating Creativity in a Culture of Conformity*. New York: Free Press, 2002.

Lublin, Joann S., and Dana Mattioli. "Strategic Plans Lose Favor." *Wall Street Journal*, January 25, 2010, sec. Theory & Practice. online.wsj.com/article/SB1000142405274870382240457 5019283591121478.html

Mackenzie, Ian. "Why Crowdfunding Creativity Is Just the Beginning." *Shareable: Life & Art*, July 9, 2012. www.shareable.net/blog/why-crowdfunding-is-just-the-beginning

Maeda, John. "Characteristics of the Creative Leader (versus Authoritative Leader)." *Creative Leadership*, March 15, 2009. creativeleadership.com/2009/03/15/ characteristics-of-the-creative-leader-versus-authoritative-leader/

———. "How Art, Technology and Design Inform Creative Leaders." TED video, June 2012. www. ted.com/talks/john_maeda_how_art_technology_and_design_inform_creative_leaders.html

Marion, Russ. "Chapter 18—Leadership of Creativity: Entity-Based, Relational, and Complexity Perspectives." In *Handbook of Organizational Creativity*, edited by Michael D. Mumford, 457– 479. San Diego, CA: Academic Press, 2012.

McCann, John. "Leadership As Creativity: Finding the Opportunity Hidden Within Decision Making and Dialogue." *Lessons Learned: A Planning Toolsite*. National Endowment for the Arts. www. nea.gov/resources/lessons/MCCANN2.HTML (accessed September 1, 2012).

McNerney, Samuel. "Is Too Much Familiarity Bad For Creativity?" *Big Think*, May 17, 2012. www. bigthink.com/insights-of-genius/is-too-much-familiarity-bad-for-creativity

———. "Correcting Creativity: The Struggle for Eminence." *Scientific American Blog Network*, September 10, 2012. blogs.scientificamerican.com/guest-blog/2012/09/10/correcting-creativity-the-struggle-for-eminence/

Merritt, Elizabeth. "More on the Future of Museum Studies." *Center for the Future of Museums*, August 7, 2009. futureofmuseums.blogspot.com/2009/08/more-on-future-of-museum-studies.html

———. "You Get What You Measure." *Center for the Future of Museums*, November 17, 2009. futureofmuseums.blogspot.com/2009/11/blog-post.html

———. "Help Build the Collections of The Universal Museum of Creative Matter!" *Center for the Future of Museums*, October 27, 2010. futureofmuseums.blogspot.com/2010/10/help-build-collections-of-universal.html

———. "Innovation Lab: Nurturing Nonconformity and Half-baked Ideas." *Center for the Future of Museums*, September 29, 2011. futureofmuseums.blogspot.com/2011/09/innovation-lab-nurturing-nonconformity.html

———. "The Strength of Diversity." *Center for the Future of Museums*, August 2, 2012. futureofmuseums.blogspot.com/2012/08/the-strength-of-diversity.html

———. "Olly Olly Oxen Free! A Call for Hidden Research." *Center for the Future of Museums*, November 6, 2012. futureofmuseums.blogspot.com/2012/11/olly-olly-oxen-free-call-for-hidden.html

———. "Where Should Museums Look for the Workforce of the Future?" *Center for the Future of Museums*, February 19, 2013. futureofmuseums.blogspot.com/2013/02/where-should-museums-look-for-workforce.html

———. "High Debt—No Job: What Field Are You In?" *Center for the Future of Museums*, February 25, 2013. futureofmuseums.blogspot.com/2013/02/high-debt-no-job-what-field-are-you-in.html

Michalko, Michael. *Cracking Creativity: The Secrets of Creative Genius*. Berkeley, CA: Ten Speed Press, 2001.

———. *Thinkpak: A Brainstorming Card Deck*. Revised edition. Berkeley, CA: Ten Speed Press, 2006.

———. "Change the Way You Look at Things and the Things You Look at Change." *The Creativity Post*, July 11, 2012. www.creativitypost.com/create/change_the_way_you_look_at_things_and_the_things_you_look_at_change

Mobley, Nancy. "Company Culture: 6 Common Roadblocks to an Exceptional Workplace." *Inc.com*, August 3, 2012. www.inc.com/nancy-mobley/company-culture-road-blocks-to-an-exceptional-workplace.html

Mumford, Michael D., ed. *Handbook of Organizational Creativity*. 1st ed. San Diego, CA: Academic Press, 2011.

Mumford, Michael D., Kimberly Hester, and Issac Robledo. "Chapter 3—Methods in Creativity Research: Multiple Approaches, Multiple Levels." In *Handbook of Organizational Creativity*, edited by Michael D. Mumford, 39–65. San Diego, CA: Academic Press, 2012a.

———. "Chapter 1—Creativity in Organizations: Importance and Approaches." In *Handbook of Organizational Creativity*, 3–16. San Diego, CA: Academic Press, 2012b.

Museums, Libraries, and 21st Century Skills. Washington, DC: Institute of Museum and Library Services, 2009.

"Museums, Libraries, and 21st Century Skills." *Institute of Museum and Library Services*. www.imls.gov/about/21st_century_skills_list.aspx (accessed December 11, 2012).

Nickerson, Raymond S. "Enhancing Creativity." In *Handbook of Creativity*, edited by Robert J. Sternberg, 392–428. Oxford: Cambridge University Press, 1999.

———. "How to Discourage Creative Thinking in the Classroom." In *Nurturing Creativity in the Classroom*, edited by Ronald A. Beghetto and James C. Kaufman, 1–5. Oxford: Cambridge University Press, 2010.

No Idea Is Too Ridiculous: an Experiment in Creative Practice. Philadelphia: Pew Center for Arts & Heritage, 2010.

"Old Songs New Opportunities." *Erie Art Museum*. www.erieartmuseum.org/folkart/oldsongs.html (accessed July 2, 2013).

Oldham, Greg R., and Markus Baer. "Chapter 16—Creativity and the Work Context." In *Handbook of Organizational Creativity*, edited by Michael D. Mumford, 387–420. San Diego, CA: Academic Press, 2012.

Packer, Jan. "Learning for Fun: The Unique Contribution of Educational Leisure Experiences." *Curator: The Museum Journal* 49, no. 3 (2006): 329–344.

Paletz, Susannah B. F. "Chapter 17—Project Management of Innovative Teams." In *Handbook of Organizational Creativity*, edited by Michael D. Mumford, 421–455. San Diego, CA: Academic Press, 2012.

Partnership for 21st Century Skills. "Framework for 21st Century Learning," n.d. www.p21.org/overview/skills-framework (accessed September 23, 2013).

Paulus, Paul B., and Vincent R. Brown. "Toward More Creative and Innovative Group Idea Generation: A Cognitive-Social-Motivational Perspective of Brainstorming." *Social and Personality Psychology Compass* 1, no. 1 (2007): 248–265.

Paulus, Paul B., Mary Dzindolet, and Nicholas W. Kohn. "Chapter 14—Collaborative Creativity—Group Creativity and Team Innovation." In *Handbook of Organizational Creativity*, edited by Michael D. Mumford, 327–357. San Diego, CA: Academic Press, 2012.

Phelps, Andrew. "Agile, Social, Cheap: The New Way NPR Is Trying To Make Radio." *Nieman Journalism Lab,* April 27, 2012. www.niemanlab.org/2012/04/agile-social-cheap-the-new-way-npr-is-trying-to-make-radio/

Pink, Daniel H. *A Whole New Mind: Why Right-Brainers Will Rule the Future*. Rep Upd ed. New York: Riverhead Trade, 2006.

Pronk, Martijn. "Interview: Rijksmuseum Digital Collection Project." *Museum-iD*. www.museum-id.com/idea-detail.asp?id=389 (accessed July 2, 2013).

"Public Participation in Scientific Research." *Center for the Advancement of Informal Science Education*. caise.insci.org/news/79/51/Public-Participation-in-Scientific-Research (accessed July 2, 2013).

Puccio, Gerard J., and John F. Cabra. "Chapter 9—Idea Generation and Idea Evaluation: Cognitive Skills and Deliberate Practices." In *Handbook of Organizational Creativity*, edited by Michael D. Mumford, 189–215. San Diego, CA: Academic Press, 2012.

Reach Advisors. "Creativity: The Cart before the Horse?" *Museum Audience Insight*, May 27, 2009. reachadvisors.typepad.com/museum_audience_insight/2009/05/creativity-the-cart-before-the-horse.html

———. "Curiosity and Learning Motivations." *Museum Audience Insight*, July 13, 2009. reachadvisors.typepad.com/museum_audience_insight/2009/07/curiosity-and-learning-motivations-.html

Reisman, Leah. "Exploding Boundaries for Deep Impact: Innovation in Experience at The Tinkering Studio[TM] at the Exploratorium." *CA Museum Community Online*. www.calmuseums.org/_data/n_0001/resources/live/Reisman_Opening.D.Bartels.pdf (accessed August 7, 2012).

Reiter-Palmon, Roni, Ben Wigert, and Triparna de Vreede. "Chapter 13—Team Creativity and Innovation: The Effect of Group Composition, Social Processes, and Cognition." In *Handbook of Organizational Creativity*, edited by Michael D. Mumford, 295–326. San Diego, CA: Academic Press, 2012.

Ridge, Mia. "Thinking Aloud: Does a Museum's Obsession with Polish Hinder Innovation?" *Open Objects*, May 6, 2011. openobjects.blogspot.com/2011/05/thinking-aloud-does-museums-obsession.html

Robinson, Ken. *Out of Our Minds: Learning to Be Creative*. 2nd ed. Oxford: Capstone, 2011.

Robledo, Issac C., Kimberly S. Hester, David R. Peterson, and Michael D. Mumford. "Chapter 27—Creativity in Organizations: Conclusions." In *Handbook of Organizational Creativity*, edited by Michael D. Mumford, 707–725. San Diego, CA: Academic Press, 2012.

Rodley, Ed. "Museums and Digital Badging." *Center for the Future of Museums*, December 18, 2012. futureofmuseums.blogspot.com/2012/12/museums-and-digital-badging.html

Root-Bernstein, Michèle, and Robert Root-Bernstein. *Sparks of Genius: The Thirteen Thinking Tools of the World's Most Creative People*. Boston: Mariner Books, 2001.

———. "Science Museums and the Arts of Imaginative Thinking." *The Journal of Museum Education* 30, no. 1 (January 1, 2005): 3–8.

———. "Thinkering." *The Creativity Post*, February 18, 2012. www.creativitypost.com/psychology/thinkering

———. "Hobbies: The Personal Path to Creativity." *The Creativity Post*, April 30, 2012. www.creativitypost.com/create/hobbies_the_personal_path_to_creativity

Rounds, Jay. "Strategies for the Curiosity-Driven Museum Visitor." *Curator: The Museum Journal* 47, no. 4 (2004): 389–412.

———. "Creativity: Are Things Getting Better or Are Things Getting Worse?" *Exhibitionist* 25, no. 1 (Spring 2006): 12–17.

———. "On the Uses of Museum Studies Literature: A Research Agenda." *Curator: The Museum Journal* 50, no. 1 (2007): 135–146.

Ryan, William P., Richard P. Chait, and Barbara E. Taylor. "Problem Boards or Board Problem?" *NPQ - Nonprofit Quarterly*, January 2, 2013. nonprofitquarterly.org/governancevoice/36-problem-boards-or-board-problem.html

Seelig, Tina. *inGenius: A Crash Course on Creativity*. New York: HarperOne, 2012.

Simon, Nina. "The Future of Authority: Platform Power," *Museum 2.0*, October 8, 2008. museumtwo.blogspot.com/2008/10/future-of-authority-platform-power.html

———. "Where I'm Coming From." *Museum 2.0*, November 25, 2008. museumtwo.blogspot.com/2008/11/where-im-coming-from.html

Simonton, Dean Keith. "Chapter 4—Fields, Domains, and Individuals." In *Handbook of Organizational Creativity*, edited by Michael D. Mumford, 67–86. San Diego, CA: Academic Press, 2012.

Smith, Monica M. "From the Issue Editor." *The Journal of Museum Education* 30, no. 1 (January 1, 2005): 2.

Soriano de Alencar, Eunice M. L. "Chapter 5—Creativity in Organizations: Facilitators and Inhibitors." In *Handbook of Organizational Creativity*, edited by Michael D. Mumford, 87–111. San Diego, CA: Academic Press, 2012.

Spock, Daniel. "The Puzzle of Museum Educational Practice: A Comment on Rounds and Falk." *Curator: The Museum Journal* 49, no. 2 (2006): 167–180.

Stokes, Patricia D. *Creativity from Constraints: The Psychology of Breakthrough*. New York: Springer, 2005.

"Strategic Plan 2011–2015." Europeana, 2011.

Sutton, Robert I. *Weird Ideas That Work: How To Build a Creative Company*. New York: Free Press, 2007.

Tharp, Twyla. *The Creative Habit: Learn It and Use It for Life*. New York: Simon & Schuster, 2005.

Treffinger, Donald J., Scott G. Isaksen, and K. Brian Dorval. "Creative Problem Solving: An Overview." In *Problem Finding, Problem Solving, and Creativity*, edited by Mark A. Runco, 223–236. Westport, CT: Greenwood, 1994.

"V&A Connects." *V&A*. www.vam.ac.uk/content/articles/v/v-and-a-connects/ (accessed July 2, 2013).

Visser, Jasper. "Cultural Innovation 101, or the Basics of Turning Our World Upside Down." *The Museum of the Future*, January 27, 2012. themuseumofthefuture.com/2012/01/

Ward, Thomas B. "Chapter 8—Problem Solving." In *Handbook of Organizational Creativity*, edited by Michael D. Mumford, 169–187. San Diego, CA: Academic Press, 2012.

Wesson, Stephen. "Look Again: Challenging Students to Develop Close Observation Skills." *Teaching with the Library of Congress*, June 28, 2011. blogs.loc.gov/teachers/2011/06/look-again-challenging-students-to-develop-close-observation-skills/

West, Michael A., and Claudia A. Sacramento. "Chapter 15—Creativity and Innovation: The Role of Team and Organizational Climate." In *Handbook of Organizational Creativity*, edited by Michael D. Mumford, 359–385. San Diego, CA: Academic Press, 2012.

"What Are the Key Challenges California Museums Are Facing?" *California Association of Museums*. calmuseums.org/collaborativelearning (accessed July 2, 2013).

"What Is Museums Showoff?" *Museums Showoff*. museumsshowoff.wordpress.com/about/ (accessed July 2, 2013).

"Where Ideas Come From." *TED Radio Hour*, June 6, 2012. National Public Radio. www.npr.org/2012/06/06/154448804/where-ideas-come-from

Wolfe, Norman. "Strategic Planning Is Dead—Long Live Strategy Execution." *Fast Company*, April 1, 2010. www.fastcompany.com/1603160/strategic-planning-dead-long-live-strategy-execution

Woroncowicz, Joanna, et al. *Set in Stone: Building America's New Generation of Arts Facilities, 1994–2008*. Chicago: Cultural Policy Center at the University of Chicago, 2012. culturalpolicy.uchicago.edu/setinstone/

Yasko, James. "Museum Studies Programs During Hard Times." *Museum*. January/February 2012. www.aam-us.org/resources/publications/museum-magazine/museum-studies-programs

Zheng, Su, Adrian Bromage, Martin Adam, and Stephen A. R. Scrivener. "Surprising Creativity: a Cognitive Framework for Interactive Exhibits Designed for Children." In *Proceedings of the 6th ACM SIGCHI Conference on Creativity & Cognition*, 17–26. New York: Association for Computing Machinery, 2007.

Index

About the Authors

Linda Norris is an independent cultural professional whose work focuses on shaping compelling narratives, improving our professional practice, and listening to communities. She blogs at The Uncataloged Museum and has worked with museums, historic sites, and cultural organizations in the United States, Canada, Europe, and Asia. She was a Fulbright Scholar to Ukraine and is a co-founder of The Pickle Project. Her favorite creative practice? Talking with audiences, friends, and colleagues over local food, wherever she is.

Rainey Tisdale is an independent curator, based in Boston, who specializes in urban and local history. She spent most of the last decade working for the Bostonian Society. She has held fellowships as a Fulbright Scholar in Helsinki, Finland, and as a Community Fellow at Brown University's John Nicholas Brown Center for Public Humanities. She blogs at CityStories and teaches Material Culture in the Museum Studies Graduate Program at Tufts University. Cities—in all their vibrancy and complexity—are her inexhaustible source of inspiration.